THE PUBLISHER AND THE UNIVERSITY OF CALIFORNIA PRESS
FOUNDATION GRATEFULLY ACKNOWLEDGE THE GENEROUS SUPPORT
OF THE AHMANSON • MURPHY IMPRINT IN FINE ARTS.

LÁSZLÓ MOHOLY-NAGY

LÁSZLÓ MOHOLY-NAGY

Painting after Photography

———

Joyce Tsai

UNIVERSITY OF CALIFORNIA PRESS

THE PHILLIPS COLLECTION

University of California Press, one of the most distinguished university presses in the United States, enriches lives around the world by advancing scholarship in the humanities, social sciences, and natural sciences. Its activities are supported by the UC Press Foundation and by philanthropic contributions from individuals and institutions. For more information, visit www.ucpress.edu.

University of California Press
Oakland, California

Library of Congress Cataloging-in-Publication Data

Names: Tsai, Joyce, 1977– author.
Title: László Moholy-Nagy : painting after photography / Joyce Tsai. Other titles: Phillips book prize series ; 6.
Description: [Oakland, California] : University of California Press ; [Washington, DC] : The Phillips Collection, [2018] | Series: The Phillips book prize series ; 6 | Includes bibliographical references and index.
Identifiers: LCCN 2017036817 | ISBN 9780520290679 (cloth : alk. paper)
Subjects: LCSH: Moholy-Nagy, László, 1895–1946—Themes, motives. | Painters—Hungary. | Modernism (Art)—Hungary. | Art and photography—Hungary.
Classification: LCC ND522.5.M59 T79 2018 | DDC 759.39—dc23
LC record available at https://lccn.loc.gov/2017036817

Printed in China

27 26 25 24 23 22 21 20 19 18
10 9 8 7 6 5 4 3 2 1

CONTENTS

ACKNOWLEDGMENTS

THERE ARE THREE central claims in this book. The first is that every work is shaped by the contingencies of lived experience. The second is that institutions can foster models of community that engender new and fruitful possibilities. The third is that light can be discovered, reflected, and refracted even in the darkest of times. These arguments grew out of my own profound sense of gratitude to the many individuals and institutions that have enabled this project throughout its long gestation.

Initial work for this project began at the Humanities Center and the History of Art Department at Johns Hopkins University, where I studied in a vibrant and congenial community of scholars who demanded precision in thought, speech, and writing. I am deeply grateful to Michael Fried and Kathryn Tuma for modeling rigorous and theoretically robust scholarship grounded at all times upon the specificity of the work of art. I was fortunate to enter the program with a cohort of exacting interlocutors and readers, especially Jeremy Arnold, Gülru Çakmak, Tarek Dika, Jason Di Resta, Stefanos Geroulanos, Kate Markoski, Rebecca Pekron, Nils Schott, Martin Shuster, Jannette Vusich, Molly Warnock, Ittai Weinryb, and Mabel Wong. Beyond Hopkins, I found

fellow travelers in Annie Bourneuf, Philipp Ekardt, Brendan Fay, Heike-Karin Foell, Megan Luke, and Leslie Ureña.

I first looked at László Moholy-Nagy's paintings at the National Gallery of Art, when I was working as an intern for Leah Dickerman and Jeffrey Weiss. Jay Krueger exposed me to questions of conservation that continue to guide my inquiry. My early research on Moholy's paintings in American and European collections was funded by the Dedalus Foundation. I later returned to the Gallery to complete my dissertation at the Center for Advanced Study in the Visual Arts, where I tested out the first iterations of my argument on its members, as well as on NGA curators, conservators, and staff. My work benefited immensely from the atmosphere of convivial and responsive criticism across disciplines. I especially want to thank Elizabeth Cropper, Peter Lukehart, and Therese O'Malley for their steadfast support at crucial junctures in this project. Judith Brodie, Faya Causey, Harry Cooper, Dario Gamboni, Janna Isreal, Joan Kee, Evonne Levy, Christopher Maines, Michele Matteini, Albert Narath, Andrei Pop, Kristen Romberg, Mechtild Widrich, Tobias Wofford, and Rebecca Zorach each helped me distill vague intuitions into supportable claims and allowed me to see how my own project might intersect with materials from other periods and places. I am deeply indebted to Roger Taylor for helping me begin to see photographically with technological specificity. The NGA Library has provided long-standing support for my publications and curatorial projects. I thank Lamia Doumato, Greg P. J. Most, and Yuri Long for their help over the years.

I wish to thank the University of Florida for providing me with a warm and supportive space to advance my ideas in the seminar room, presentations, and in informal conversation with my colleagues Robin Poynor, Glenn Willumson, and Maya Stanfield-Mazzi. Melissa Hyde, Elizabeth Ross, and Victoria Rovine were especially generous mentors who offered practical, intellectual, and personal sustenance over the course of the manuscript's development. I thank the School of Art and Art History and the College of the Arts for granting me leaves and funding that permitted me the time to write and research.

The Phillips Collection and George Washington University afforded me the opportunity to develop new avenues of thought while I was a postdoctoral fellow at the Center for the Study of Modern Art. I had the luxury of thinking in the presence of the marvelous collection in Dupont Circle and was fortunate to be in D.C. while S. Hollis Clayson, Lynne Cooke, David Lubin, James Merle Thomas, and Andrés Mario Zervigón were in residence at CASVA. I benefited enormously from their conversations and advice. Bibi Obler was a generous collaborator and encouraged me to expand my thinking on the avant-garde and domesticity. At the Phillips Collection, I thank Klaus Ottmann and Vesela Sretenović not only for their hospitality and intellectual engagement, but also for their thoughtful comments on my manuscript. I am grateful for the Phillips Book Prize and the University of California Press for their support, without which this book would not have been possible. Thanks to Nadine Little, Maeve Cornell-Taylor, and Jennifer González for their support and stewardship of this project at the Press.

The community of Moholy scholars, curators, and conservators has been especially important for this project. I am deeply indebted to Eik Kahng for her faith in my work on Moholy. She entrusted me with guest curating the exhibition *The Shape of Things to Come* (2015) at the Santa Barbara Museum of Art and with organizing its accompanying catalog. Work on the show ultimately transformed my sense of Moholy's artistic enterprise, which continued to evolve when Carol Eliel, Karole Vail, and Matthew Witkovsky invited me to participate in a series of meetings as they planned their exhibition *Moholy-Nagy: Future Present*. I learned a great deal from new research conducted by Julie Barten, Matthew Battles, Francesca Casadio, Angela Chang, Teri Hensick, Jennie King, Maria Kokkori, Christopher Maines, Jeffrey Schnapp, and Lena (Carol) Stringari.

Presentations on Moholy throughout the years at the Zimmerli Art Museum, Harvard University, College of William and Mary, University of Chicago, Eikones, Smithsonian American Art Museum, the Guggenheim Museum, Rice University, School of the Art Institute of Chicago, and the College Arts Association yielded many critical questions that helped to refine my thinking. I thank Graham Bader, Matthew Biro, Oliver Botar, Brigid Doherty, Maria Gough, Gordon Hughes, Steven Mansbach, Christine Mehring, Libby Otto, Charles Palermo, Victoria H. F. Scott, and Ralph Ubl for their invitations and illuminating questions.

Michelle Kuo, Prudence Peiffer, Ingrid Pfeiffer, Anke Finger, Danielle Follett, Robin Schuldenfrei, and Jeffrey Saletnik provided me with publication opportunities that were important in helping me formulate and revise my argument. My thanks to each for their nuanced comments on prior work.

The work I have pursued would not have been possible without László Moholy-Nagy's daughter, Hattula Moholy-Nagy, and the Moholy-Nagy Foundation. Everyone in this field has benefited from Hattula's deep knowledge, along with her commitment to scholarly research and to encouraging new perspectives on her father's oeuvre. Her groundwork over the years ensures vibrant new accounts of Moholy's work to come.

This book was finished at the University of Iowa and drew upon research and travel funds from the College of Education and the University of Iowa Museum of Art. The sense of interdisciplinary community fostered by the Obermann Center for Advanced Studies and generous conversations with Jenny Anger and Jennifer Buckley contributed to the book's completion. I thank Eileen Bartos, Jane Friedman, Dan Jakubowksi, and Paul Tyler for their thoughtful editorial assistance in the preparation of the manuscript.

On a personal note, this project began a lifetime ago with Joshua Robert Gold. Many of the ideas presented here were sparked over a decade of shared looking and thinking. I was at home with his brilliant sense of humor, intellectual passion, and commitment to art, literature, philosophy, history, and politics. We were newlyweds at the start of the project, but he passed away in 2009. My grief was shared by family, as well as by our friends and colleagues, many of whom are named here. Before, during, and after, my family—the Golds, Tsais, and DeVanes—have been extraordinarily supportive. I have drawn upon the steadfast friendship of Ashley Jones, Jilan Kamal,

Lynette Roth, Theresa Schlafly, and Tessa van der Werff, who buoyed me in turbulent times. Peter and Linda Parshall extended me shelter in the warmth of their home. I am grateful for their encouragement as well as for the literal and metaphorical nourishment each has offered me over the years. That this book came into being at all is a testament to the collective efforts of this remarkable extended community. Needless to say, all its flaws are my own.

The perspective with which the book concludes, that homecoming is at all possible after catastrophe, is indebted to Benjamin Mitchell DeVane, who has created a home for love, thought, and Grace.

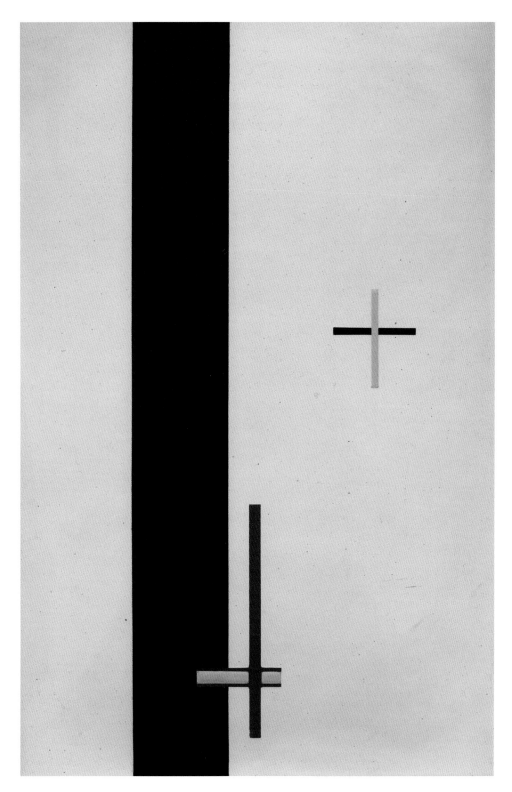

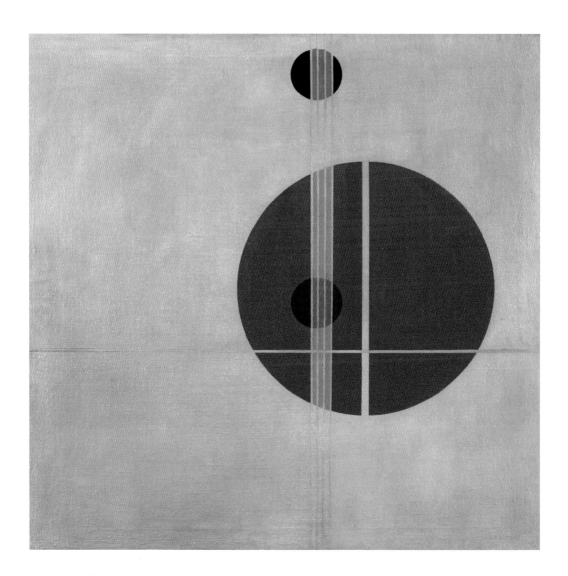

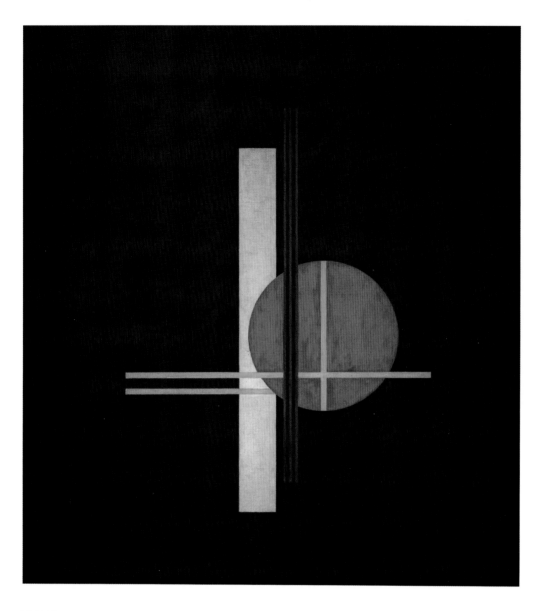

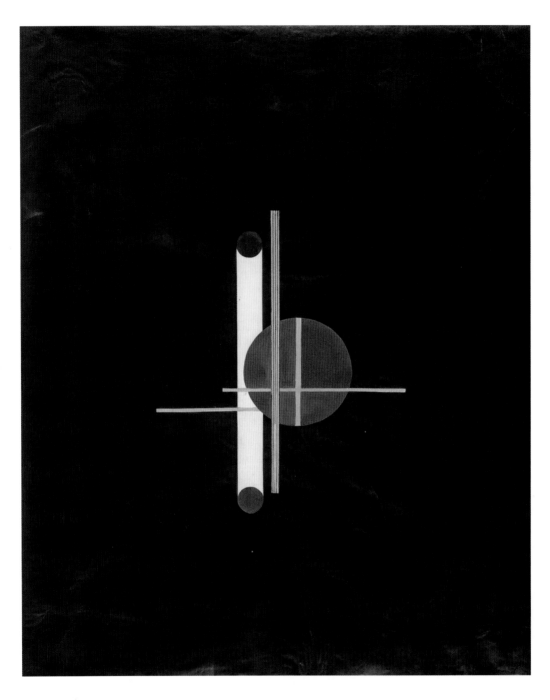

PLATE 4
László Moholy-Nagy, Q, 1922–23. Collage with watercolor and pen and black ink over graphite on carbon paper, 59 × 46.4 cm. Alisa Mellon Bruce Fund, National Gallery of Art, Washington, D.C. © 2018 Estate of László Moholy-Nagy / Artists Rights Society (ARS), New York.

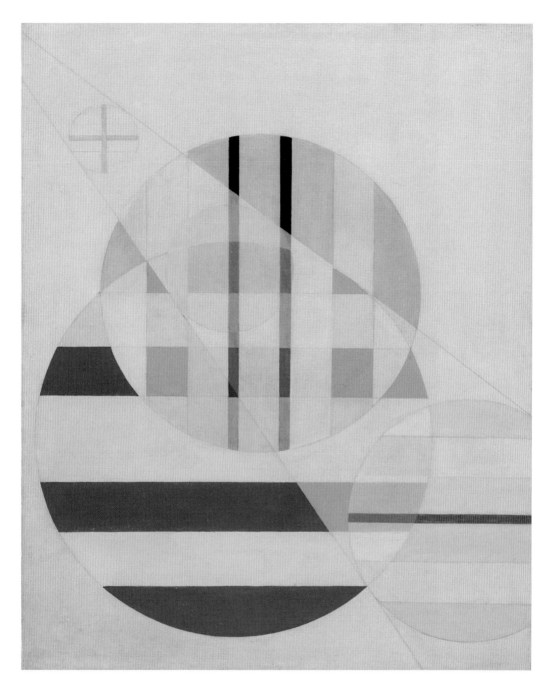

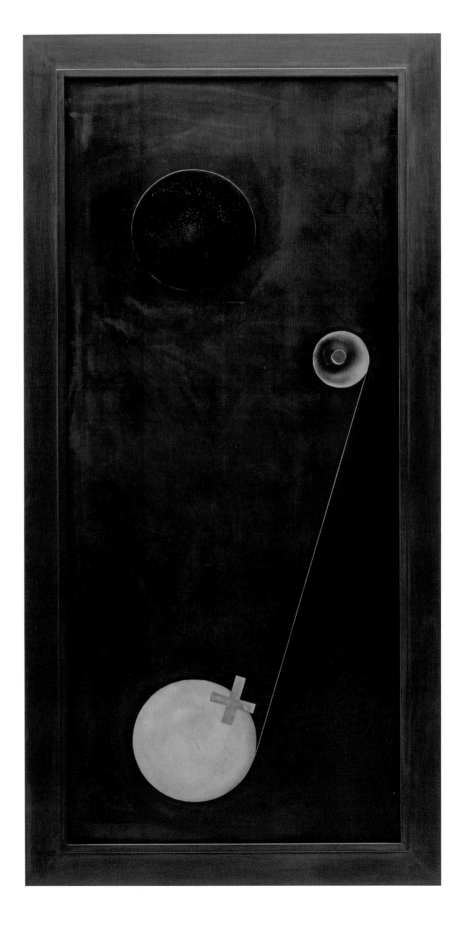

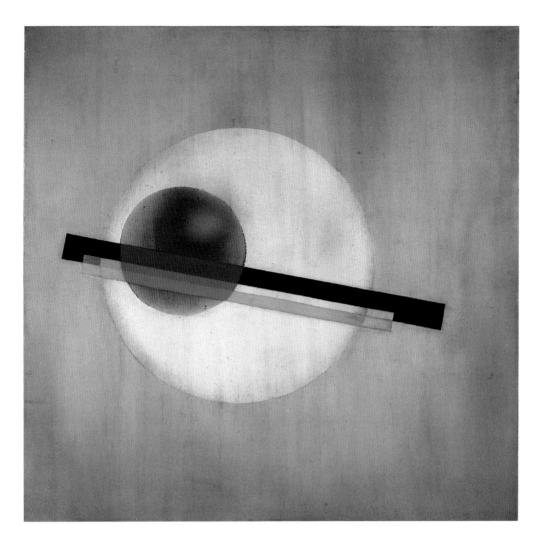

PLATE 6
László Moholy-Nagy, *T1*, 1926. Oil, sprayed paint, incised lines, and paper on Trolit, 139.8 × 61.8 cm. Solomon R. Guggenheim Founding Collection, By gift 37.354, Solomon R. Guggenheim Museum, New York. © 2018 Estate of László Moholy-Nagy / Artists Rights Society (ARS), New York.

PLATE 7
László Moholy-Nagy, *AL 3*, 1926. Oil, industrial paints, and pencil on aluminum, 40 × 40 cm. The Blue Four Galka Scheyer Collection, Norton Simon Museum, Pasadena, CA. © 2018 Estate of László Moholy-Nagy / Artists Rights Society (ARS), New York.

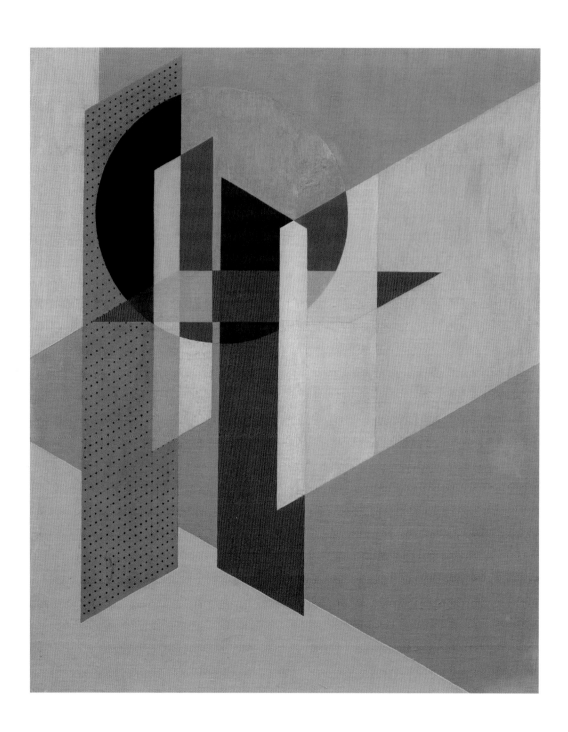

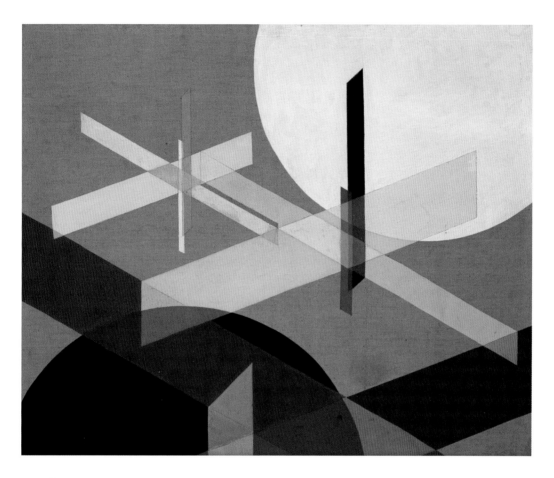

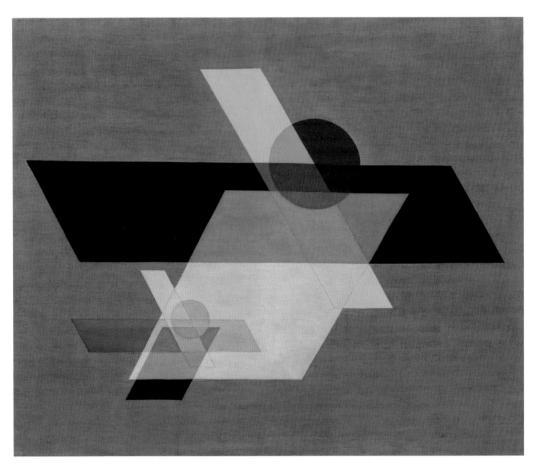

PLATE 10

László Moholy-Nagy, *A II* (*Construction A II*), 1924. Oil and graphite on canvas, 115.8 × 136.5 cm. Solomon R. Guggenheim Founding Collection, Solomon R. Guggenheim Museum, New York. © 2018 Estate of László Moholy-Nagy / Artists Rights Society (ARS), New York.

PLATE 11

László Moholy-Nagy, *Z VI*, 1925. Oil, ink, and graphite on canvas, 95.2 × 75.6 cm. The Fredric Wertham Collection, Gift of his wife Hesketh, Harvard Art Museums / Busch-Reisinger Museum. © 2018 Estate of László Moholy-Nagy / Artists Rights Society (ARS), New York. Photo Credit: Imaging Department © President and Fellows of Harvard College.

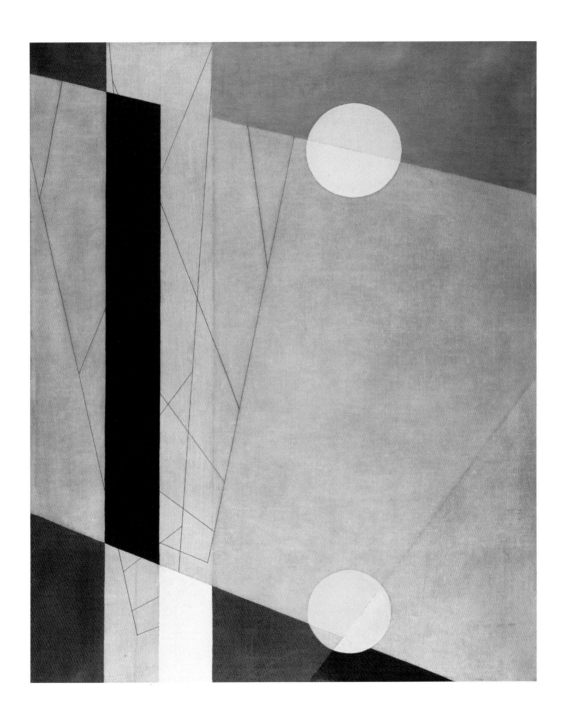

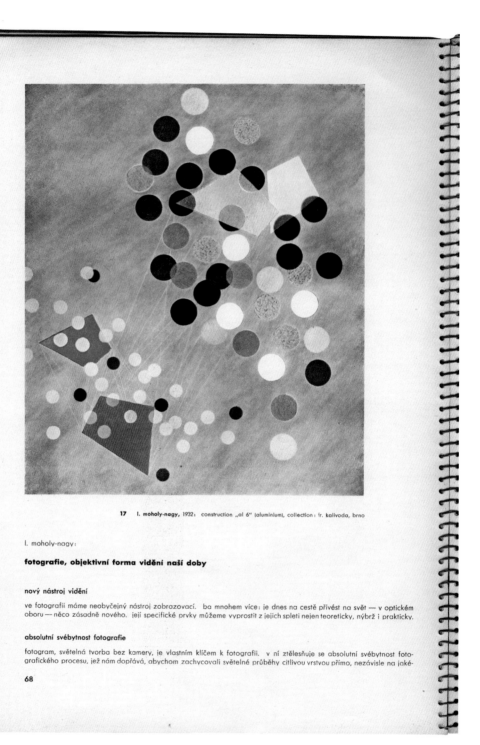

17 l. moholy-nagy, 1932: construction „al 6" (aluminium). collection: fr. kalivoda, brno

l. moholy-nagy:

fotografie, objektivní forma vidění naší doby

nový nástroj vidění

ve fotografii máme neobyčejný nástroj zobrazovací. ba mnohem více: je dnes na cestě přivést na svět — v optickém oboru — něco zásadně nového. její specifické prvky můžeme vyprostit z jejich spleti nejen teoreticky, nýbrž i prakticky.

absolutní svébytnost fotografie

fotogram, světelná tvorba bez kamery, je vlastním klíčem k fotografii. v ní ztělesňuje se absolutní svébytnost fotografického procesu, jež nám dopřává, abychom zachycovali světelné průběhy citlivou vrstvou přímo, nezávisle na jaké-

68

PLATE 12

László Moholy-Nagy, *Construction "AL 6,"* 1932. Color reproduction, published in *Telehor* 1–2 (1936): 72. David K.E. Bruce Fund National Gallery of Art Library, National Gallery of Art, Washington, D.C. © 2018 Estate of László Moholy-Nagy / Artists Rights Society (ARS), New York.

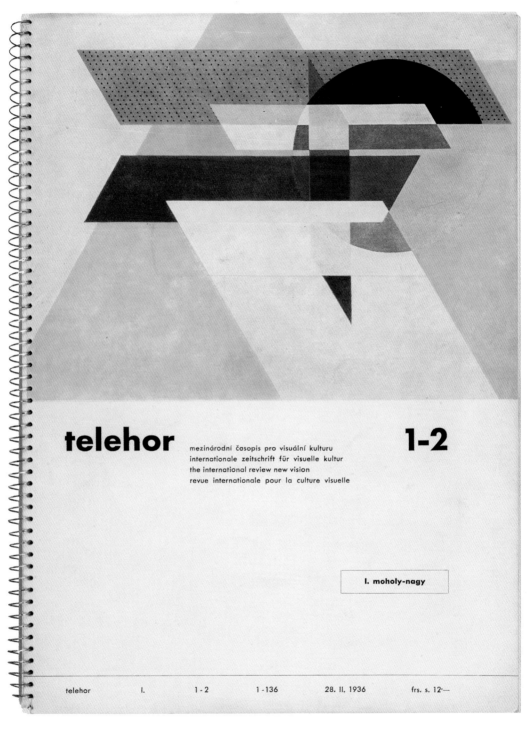

László Moholy-Nagy and František Kalivoda, cover for *Telehor*, nos. 1–2, 1936. Color offset print, 29.5 × 21 cm. David K.E. Bruce Fund, National Gallery of Art Library, Washington, D.C. © 2018 Estate of László Moholy-Nagy / Artists Rights Society (ARS), New York.

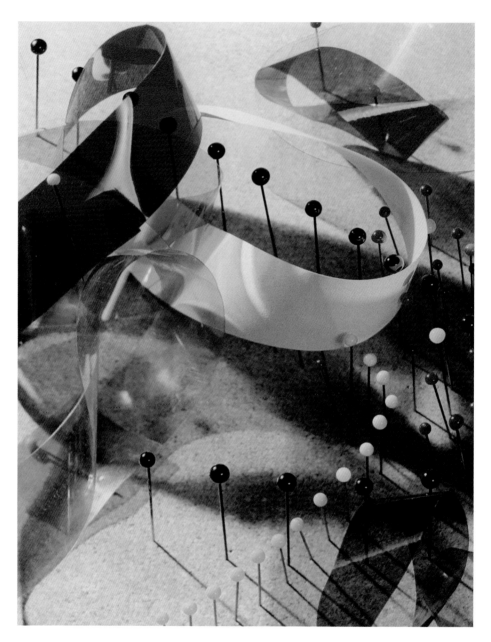

PLATE 14

László Moholy-Nagy, Study with pins and ribbons, 1937–38. Color print and assembly (Vivex) process, 34.9 × 26.5 cm. © 2018 Estate of László Moholy-Nagy / Artists Rights Society (ARS), New York. Courtesy George Eastman House.

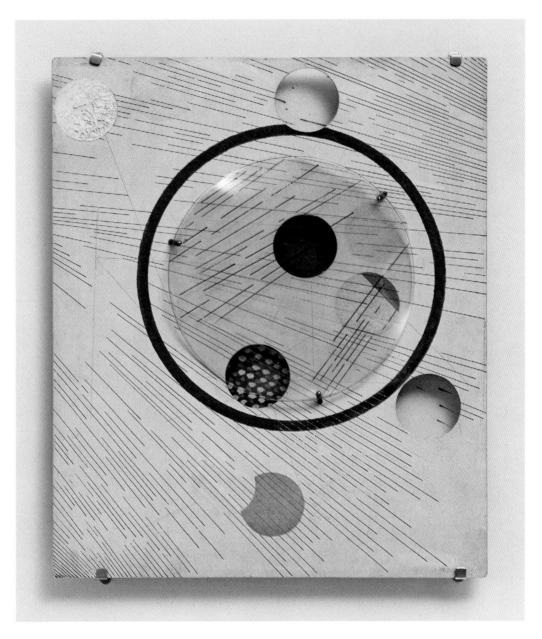

PLATE 15

László Moholy-Nagy, *Space Modulator Experiment, AL 5*, 1931–35. Aluminum and Rhodoid, 86 × 70.8 cm. Private collection. © 2018 Estate of László Moholy-Nagy / Artists Rights Society (ARS), New York.

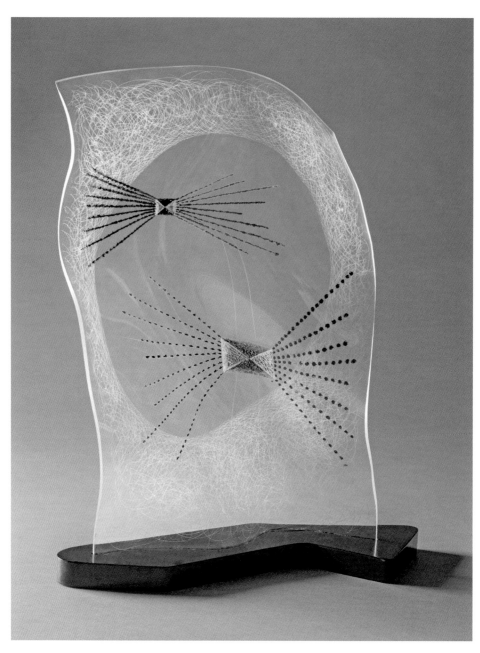

PLATE 16

László Moholy-Nagy, *Vertical Black, Red, Blue*, 1945. Oil and incised lines on Plexiglas, on original base, (a) Sculpture: 43.18 × 29.21 × 10.16 cm; (b) Base: 2.54 × 36.2 × 12.07 cm; (a–b) Overall: 45.72 × 36.2 × 15.88 cm. Purchased with funds provided by Alice and Nahum Lainer, the Ducommun and Gross Acquisition Fund, the Fannie and Alan Leslie Bequest, and the Modern and Contemporary Art Council (M.2012.135a–b), Los Angeles County Museum of Art, Los Angeles. © 2018 Estate of László Moholy-Nagy / Artists Rights Society (ARS), New York. Photo: © Museum Associates / LACMA.

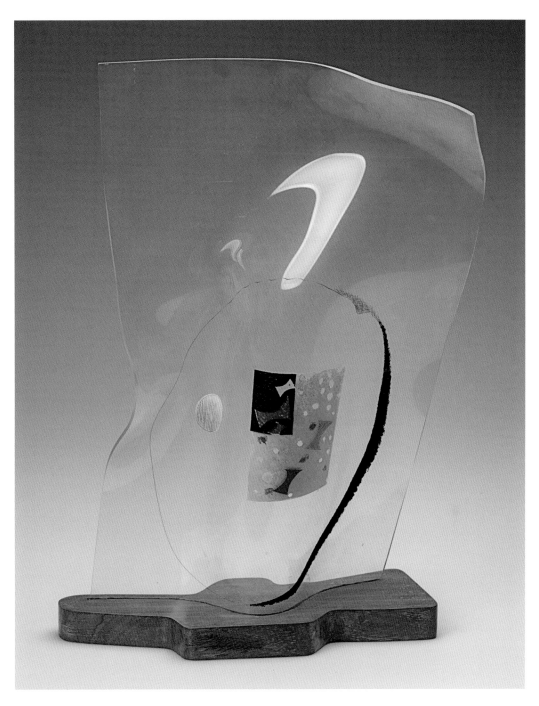

PLATE 19
László Moholy-Nagy, *CH for Y Space Modulator,* 1942. Oil on yellow Formica, 154 × 60 cm. Estate of László Moholy. © 2018 Estate of László Moholy-Nagy / Artists Rights Society (ARS), New York.

PLATE 20

László Moholy-Nagy, *B-10 Space Modulator*, 1942. Oil and incised lines on Plexiglas (in original frame, 42.9 × 29.2 × 6 cm; framed, 82.9 × 67.6 cm), Solomon R. Guggenheim Founding Collection, Solomon R. Guggenheim Museum, New York. © 2018 Estate of László Moholy-Nagy / Artists Rights Society (ARS), New York.

INTRODUCTION

BAUHAUS DESSAU, 1926. László Moholy-Nagy stands against a white background, a board propped up against an exterior wall (fig. 0.1). His expression is serious. He looks away from the camera nearly in profile, his jawline contoured by the dramatic light cast by the bright sun. Posing with his hair slicked back, he wears rimless glasses and a jumpsuit. It's a perfect portrait of the artist as engineer, legible as part of the genre that Alexander Rodchenko first established with his own jumpsuit picture in his workshop in 1924 (fig. 5.6). Lucia Moholy, László's first wife, made the portrait. She shot many of the most iconic images of the Bauhaus in Dessau and orchestrated the dissemination of photographs in the press to highlight the modernity of the school and its faculty.[1]

Another shot, perhaps another day, but Moholy is just as coiffed, just as carefully dressed though now in a starched shirt and striped tie (fig. 0.2). This time, Lucia's camera has caught him seemingly off guard. A broad smile spreads across his face, revealing the boyish roundness of his cheeks. His right hand interjects,

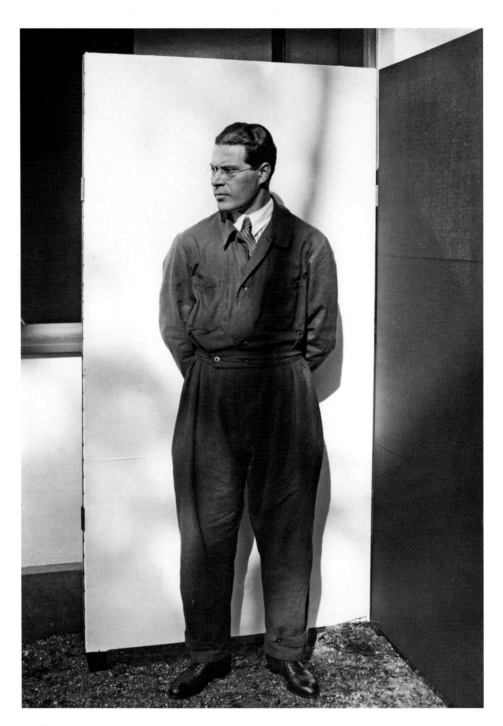

FIGURE 0.1

Lucia Moholy, *László Moholy-Nagy*, 1926. Gelatin silver print, 22.3 × 15.3 cm. Ford Motor Company Collection, Gift of Ford Motor Company and John C. Waddell, 1987 (1987.1100.229). The Metropolitan Museum of Art, New York. © 2018 Artists Rights Society (ARS), New York / VG Bild-Kunst, Bonn. Image © The Metropolitan Museum of Art; image source: Art Resource, NY.

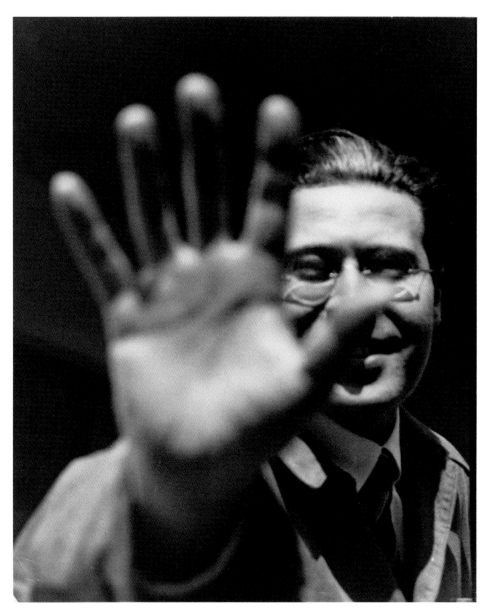

as if in mock protest, palm open and out of focus. The final print centers hand and face, composed by cropping.

Lucia's portrait features prominently on the cover of *Photography in the Modern Era*, an indispensable anthology of translated primary texts from the twenties and thirties by the likes of her husband, Rodchenko, and others, selected and edited by Christopher Phillips.[2] Published in 1989 to accompany the groundbreaking exhibition *The New Vision* at the Metropolitan Museum of Art in New York, her 1925–26 portrait of László has come to denote a way of seeing that defined the photographic project of the interwar avant-garde.[3] The picture breaks the traditional rules of photography and, in so doing, foregrounds the specificity of the camera's vision. Contrasted with the focused, half-hidden face, the interposed right hand opens and blurs as if to reveal the focal length upon which the workings of camera photography depend.

László Moholy-Nagy's right hand appears time and again in a number of works that he made in the mid-twenties (fig. 0.3). In a 1926 photogram, the ghostly imprint of his right hand has been caught on developing paper against a ground marked by the presence of wire grids. His hand is outstretched, laid upon a paintbrush. Exposed a second time, the fingertips move to become ensnared with the outline of the brush head as if substituting fingers with bristles within its spectral silhouette. As Renate Heyne and Floris M. Neusüss argue in their 2009 catalogue raisonné of his photograms, this image shows "the artist's hand at rest, idle, in a certain sense, while his picture is painted by the light."[4] Unlike so many of his photograms that transform everyday objects of the world into mysterious, luminous forms whose indexicality offers no guarantee of their legibility, this direct capture of hand and brush imprints an iconic image. The clarity of hand and brush read as a programmatic declaration, allegorizing a new way of making.

At the time he executed these works, Moholy was seen as an artist eager to relinquish the brush in favor of exploring other means of artistic production.[5] He was appointed to the Bauhaus in 1923 in part because of his growing reputation as an artist willing to embrace new materials and to work through the possibilities of nascent technology. In 1924, he exhibited his *Constructions in Enamel* at the highly influential Sturm Gallery in Berlin and advertised the fact that they were made not by hand but by machine, ordered from a sign factory (plate 1). In this suite of works, he actively countered the traditional attachment to the traces of the artist's hand in sensuous, expressive brushwork. In his artist's statement, he argued that individual expression should be abandoned and a new aesthetic vocabulary established, one that aims for clarity and simplicity so transparently communicable that such artwork might even one day be ordered by telephone.

A year after the exhibition, Moholy's book *Painting, Photography, Film* was published as part of the Bauhaus Book series in 1925. In its opening paragraph, Moholy writes, "This book is an apology for photography."[6] Many, including other faculty members at the Bauhaus, perceived his slim volume as nothing less than an opening salvo launched

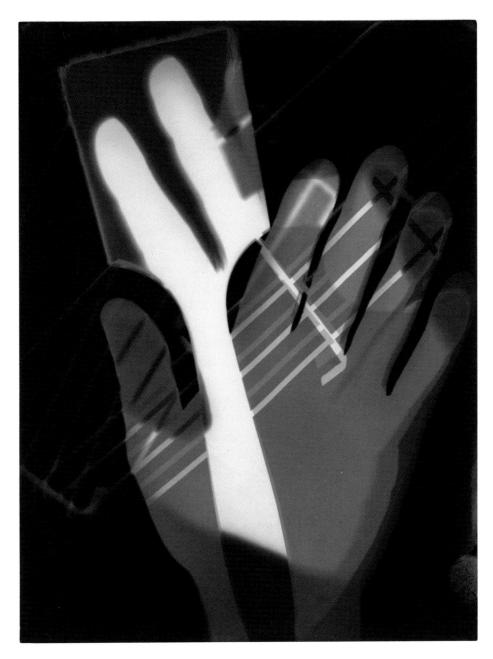

FIGURE 0.3

László Moholy-Nagy, *Fotogramm*, 1926. Gelatin silver print, 23.9 × 17.9 cm. Gift of Ford Motor Company and John C. Waddell, 1987 (1987.1100.158). The Metropolitan Museum of Art, New York. © 2018 Estate of László Moholy-Nagy / Artists Rights Society (ARS), New York. Image © The Metropolitan Museum of Art; image source: Art Resource, NY.

in a battle against painting. Arguing for the necessity to go beyond paint on canvas, Moholy's book encourages artists to work toward painting in pure light, projective light displays, and even the transmission of electronic images. Over the course of the twenties, Moholy became closely identified with the project of New Vision photography. The camera captures the world with a detail and ease unrivaled by anything a painter could hope to achieve, he argued. But more importantly, through its publication of microscopic, macroscopic, time-lapse, X-ray, and other photographs, his book offers views of the world that our biological eye simply cannot see on its own. According to Moholy, the artist has the power to unlock vision wholly unprecedented in human history through technology, which has the power to tap our latent sensory potential as human beings in a modern age. In 1928, Moholy abandoned painting altogether in order to work with the technologies he described in theory. With so many opportunities on the horizon, he believed that the artist had the responsibility to serve as the pioneer in these fields. In addition to working on photography, stage set designs, curatorial projects, filmmaking, and publishing endeavors, he joined with a mechanic, an architectural draftsman, and the German industrial conglomerate AEG (Allgemeine Elektrizitäts-Gesellschaft) to develop what he called *Light Prop for an Electric Stage*, a machine meant to introduce a massive transformation of theater.

Moholy returned to painting just two years later, a move many interpreted as a retreat from the radical claims of the twenties. In one sense, the title *Painting after Photography* refers to how he addresses his own problematic return to painting after his professed commitment to photography. In another, it also seeks to illuminate how painting served, both in his early and late career, as a vehicle to pursue the possibilities that he imagined new media could bring to fruition. He developed a conception of painting that is profoundly anachronistic, at once a remnant of the past and a postulate of the future. The relationship that Moholy describes at various points in his career between painting and photography is not fixed but fluid, their associations richly varied, and his faith in both challenged at several junctures. Their material and discursive invocation serves as a shorthand for a whole range of debates that the interwar avant-garde engaged. For example, painting comes to stand in for art, photography for technology more generally—they represent seeming antipodes of the work of man and that of machine or the product of creative intuition and objective precision. Painting and photography describe at times entire worldviews, or, conversely, are merely two instruments both capable of contributing to an ultimate shared aim.

Even before Moholy's polemics, the invention of photography challenged painters to justify their continued practice. Against cold mechanical capture, defenders of painting appealed to the specificity of the medium to sustain the artist's vision, executed by the warm, living hand. But such a conception of painting would appear insufficient, complacent, and of little consequence to avant-garde artists in the tumultuous years of the First World War and its wake. Under attack was the model of painting that

remained embedded within an emulative tradition, wedded to narratives, tied to a mimetic relationship to nature, and attached to the fantasy that the sensuous fullness of the world could be captured on canvas, preserved in paint. On the side of reception, painting presupposed a romantic, contemplative subject, whose enculturation through art prepared his or her participation within a community—religious, political, or otherwise. The interwar avant-garde launched an assault on painting in order to dismantle ways of making, being, feeling, and knowing that seemed increasingly irrelevant and anodyne in the face of the experience of modernity at a moment of crisis.

Such an orientation was widely shared among Moholy's peers. El Lissitzky summarized that perspective in his manifesto "Proun," which was written in 1920 in Moscow, but circulated two years later in German translation in the pages of *De Stijl*. The title "Proun" was his Russian acronym for "Project for the Affirmation of the New," and the essay elaborated on this project. "Painting has met its demise just as the church and its god, for which [painting once] served as proclamation; just as the palace and its king, for which it served as throne; just as the sofa and its philistine, for which it represented the holy image of happiness."[7] El Lissitzky linked the decline of painting with the institutions it represented and that once enabled its production—religion, state, and the bourgeoisie. The revolutionary future demanded the evisceration of past systems. "Proun" declared the necessity of freeing the artist from the solipsistic mentality of the easel painter in order to instill a new mode of making guided by the collective, a mode that was forward thinking, technologically advanced, and scientifically rigorous.[8] There was no need for painting as an everlasting testament to "human culture." Instead, the artist had to become an agent of the new. The artist's task was to convert his or her creative energies into vehicles of modernization that would contribute to economic, scientific, and technological progress.

While manifestos declaring the end of easel painting proliferated in the interwar period, few artists truly abandoned working with brush, paint, and canvas. In 1920, the year he formulated his manifesto, El Lissitzky was photographed in his studio dressed in his painter's smock with pipe in hand and a Proun work on the easel, surrounded by others hanging on his studio wall (fig. 0.4). Even as Moholy would write in *Painting, Photography, Film* that traditional painting had become nothing more than a thing of the past, he too would be photographed facing his easel, working intently on one of his abstract paintings (fig. 2.15).

This might appear paradoxical. However, for these artists, the activity in which they engaged differed profoundly from the painting they denounced in their writings. Painting as a noun, understood as an autonomous work of art, precious as cultural reserve, and evidence of individual artistic genius, had to give way to its redefinition as gerund, as practice. In the new artistic and theoretical framework built by El Lissitzky, Moholy, and others, painting became part of a multimedia arsenal that could be deployed in the production of objects that afforded new possibilities to the viewer. Instead of a viewer entranced by the virtuosity of an individual artist's work, the

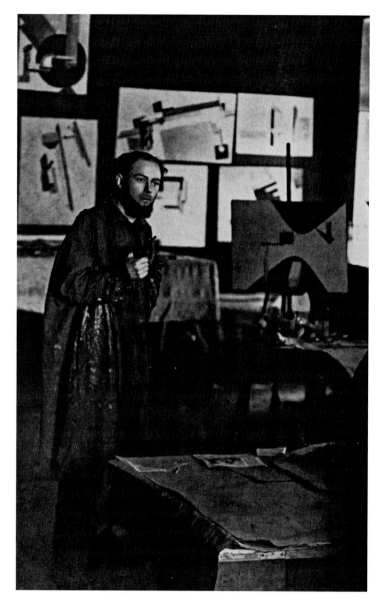

FIGURE 0.4
El Lissitzky in his studio at SVOMAS (Free State Art Studios), Vitebsk, with Proun
pictures, 1920.

abstract designs and structures made by paint, brush, and canvas were meant to give
rise to a new collectivity and help shape a new perceptual responsiveness that would
have revolutionary political consequences.[9]

But painting, at that point, would serve only as a beginning. Over the course of the
twenties, both Moholy and El Lissitzky would increasingly explore media that held

out the potential to reach a broad, mass audience through graphic, set, and exhibition design as well as film, photography, and photomontage.[10] Moholy hoped to invent ever more sophisticated means with which to habituate the viewer to the pace and perceptual demands of the modern, industrial age. In pursuit of the resources necessary to realize such a dream, Moholy abandoned his brush and paints to develop the technology needed for his light machine. At the end of the twenties, he believed that henceforth his responsibility as an artist would be to focus on the requirements of his era, to contribute to and benefit from the wealth of technological opportunities still waiting to be explored. *Light Prop,* he imagined, would be the first of many projects that he would pursue in partnership with technical experts and industry.

Moholy prophesized a future of art, made without the intervention of brush and hand—automated, electrified, luminous, kinetic. At stake was the development of instruments that would give the artist the ability to hone the perceptual acuity of his viewing public. In so doing, he speculated, the artist could become an agent of modernization, transforming not only the individual visitor at the picture gallery but also millions of viewers with technologies such as film, photography, and even television, which captured the avant-garde imagination with rumors of its imminent arrival as early as 1919, in a description by its inventor, Dénes Mihály. It is no accident that the height of Moholy's posthumous reception would coincide with a period marked by impassioned debates about painting's continued viability. What resonated most powerfully with critics writing in the sixties and seventies was the strength of his photography, the theoretical acuity of his writings, and the conceptual brilliance of his most experimental projects—his *Constructions in Enamel,* posthumously renamed *Telephone Pictures,* and *Light Prop,* also posthumously anointed *Light-Space Modulator.* The reputation he established in the twenties as a visionary theorist and artist enthusiastically pursuing the potential of photography and new technological media gained him a new audience in postwar artists. This later generation sought to liberate art from the strictures of modernist painting by exploring creative horizons afforded by novel technologies and production methods. In the sixties and seventies, they proposed short-circuiting the gallery system by turning to broadcast television, sculpting with fluorescent tubes of light, and dissolving the materiality of the work of art altogether by staging happenings and performances.

In both of these historical moments, the stakes—of painting or not—went far beyond internecine debates about the virtues of one medium over another. There was a shared belief that technology could resolve myriad problems, big and small. Picking up the camera and laying down the brush was a political and polemical statement, for the embrace of new technology (and the rejection of old means) expressed optimism regarding the capacity of human-made instruments to permit their creators to take control of their fate. After the First World War, this sense of optimism came as a response to an experience of the battlefield in which the transformative power of technology was proven, not as the generative instrument of human liberation but as an

annihilating slave master. The future Moholy hoped to achieve could only come when the avant-garde appropriated the power of technology for its revolutionary ends.

Light Prop, however, was the exception, not the rule. The kinds of projects Moholy envisioned required investments of capital and expertise difficult to assemble under the best of circumstances, even more so as the Great Depression unfolded. There was little willingness among industry leaders to entertain the proposals of a lone avant-garde artist. But far more problematic, Moholy witnessed the transformation of the public sphere through the use of new technological media. The promotion and spread of radio, the coordinated deployment of mass media, and the creation of public spectacles with the use of light technology was deployed not toward revolutionary ends but toward the consolidation of the fascist state. Faced with this new reality, Moholy returned to painting and continued to paint until his untimely death in 1946.

Moholy anticipated how puzzling his return to painting might appear and justified it in a text published in 1936: "Since it is impossible at present to realize our dreams of the fullest development of optical techniques [light architecture] we are forced to retain the medium of easel painting."[11] The explanation he offers casts painting as a compromised, compensatory practice, pursued at a historical juncture in which imperfect technologies could not yet deliver on their promise. But more importantly, in the political situation in which he lived, the very idea that the avant-garde could appropriate technology for its progressive, revolutionary ends proved impossible in practice. Access to the resources, infrastructure, and expertise required for technological experimentation could only be bought at a high price—the artist would have to compromise his vision to conform to the expectations of what Moholy called "chance patrons."[12] What becomes a persistent theme in his art and writing in exile is the rift between present conditions and future possibilities.

We are far more familiar with Moholy the visionary, always oriented toward a future illuminated with endless possibilities. But in his late work, he had to develop strategies to allow that optimism to survive in altered forms amid the darkest of times. Painting returned as a strategy to divine future potential avenues of technological exploration in purely speculative forms. Yet Moholy's late paintings are also significant for how they attempt to restitute the hand to the scene of artistic production. They allow the hand to register not as evidence of expressive genius, but as the trace of warm human presence. The survival of human touch could not be assumed in the thirties and forties. For Moholy, as well as other interwar artists and intellectuals, new analytic frameworks, practices, and strategies had to be devised to envision how humanity might endure the catastrophes of the Second World War.

This study is organized around five case studies of works produced at distinct moments in his career: his *Constructions in Enamel* (1923), his paintings executed at the Bauhaus (1923–28), *Light Prop for an Electric Stage* (1930), *Z VII* (1926, reproduced in 1936), and, finally, the painted plastic works he called *Space Modulators,* which were made during his years in British and American exile starting in 1937. The first three chapters

feature some of the most famous works in his oeuvre, responsible for establishing the notion of his antagonism toward painting. The last chapter and conclusion address objects that have, until recently, been jettisoned from the reception of his work precisely because they disrupt our conventional wisdom concerning artistic and technological progress. By attending to the ways Moholy mobilized painting in practice and as a discursive construct from the twenties to his years in exile, we witness the redefinition of the medium as an incubator of things to come, and as a refuge for human being.

1

NEW VISION

In 1922 I ordered by telephone from a sign factory five paintings in porcelain enamel. I had the factory's color chart before me and I sketched my paintings on graph paper. At the other end of the telephone the factory supervisor had some kind of paper, divided into squares. He took down the dictated shapes in the correct position. (It was like playing chess by correspondence.) One of these pictures was delivered in three different sizes, so that I could study the subtle differences in color relations caused by the enlargement and reduction.

—LÁSZLÓ MOHOLY-NAGY, "ABSTRACT OF AN ARTIST"

THESE FEW LINES DESCRIBE the origin of Moholy's manufactured street-sign paintings, popularly known as his *Telephone Pictures* (plate 1). We visualize him at his desk, relaying a set of instructions into the mouthpiece of an old-fashioned telephone. The story is persuasive. The instructions, it would seem, would have been easy enough to communicate, the compositional elements translated into coordinates using the graph paper upon which he sketched his design. One transmitted design is scaled to fit three panels, each twice the size of the next. Their stark appearance seems to confirm Moholy's account. We picture the workmen painting the panels by numbers, the final product to be fired in an industrial kiln. The story is believable not only because the artist himself offers it, but also because the process detailed and the end result appear so seductively simple.

The episode has become notorious in the history of modern art, in that what Moholy describes is heretical. He removes the artist's hand from the making of these works: neither his touch nor his presence is necessary to authorize these new pictures. His

hand refuses to prove the virtuosity of his genius, and instead the artist's role is recast as that of dictating a concept, which is transmitted to the manufacturer through the technology of the telephone. Painting is no longer a skilled activity pursued in the mysterious atelier, but one that could be completed according to a set of instructions on the factory floor.

The revised edition of *The New Vision* in which "Abstract of an Artist" appears was published posthumously in 1947 as a part of the series Documents in Modern Art, edited by Robert Motherwell. The volume circulated widely as a mainstay of postwar studio art education. Moholy's telephonic experiment held particular appeal for artists and critics who sought to undermine the attachment to authorial subjectivity identified with Abstract Expressionism. A critic at *Artforum,* writing on the occasion of the Moholy retrospective in 1969, described *Telephone Pictures* as "almost a forecast of more recent approaches to utilizing industrial processes."[1] They were invoked as the premise for the planned inaugural exhibition for the newly established Contemporary Art Museum in Chicago. Curated by Jan van der Marck, the show invited American and European artists to phone in instructions "to those entrusted with fabrication of the artists' projects or enactment of their ideas."[2] The show was organized in order to "record the trend, incipient then and pervasive today, toward the conceptualization of art," and, moreover, "to test the potential of the remote control creation" of a group exhibition.[3]

In postwar art, *Telephone Pictures* served as the progenitor to practices that sought to break out from the amber of tradition, to prevent the demands of medium specificity from calcifying into set forms. Before Andy Warhol would adopt industrial manufacture as his favored metaphor for his artistic production, before Donald Judd delegated the production of his custom boxes to the Bernstein Brothers, and before a motley crew of artists would work with engineers at Bell Telephone Labs under the aegis of Experiments in Art and Technology, Moholy, it would seem, was the first to dial in and order his work factory-direct.[4]

The pictures were certainly manufactured at a factory, but we now know that it was highly unlikely that Moholy called in the order.[5] In fact, the most common title given for these works, *Telephone Pictures,* only came into use after his death.[6] When they were first shown in 1924, his artist's statement highlighted the industrial origin of the pictures and argued that such objects demonstrate the *potential* for art to be produced by phone. They bore the title *Constructions in Enamel.* In the Sturm Gallery's newsletter from the same year advertising the exhibition, Moholy emphasized that the works on view exemplify the values of "technical exactness" and "total precision." The textual and visual rhetoric of *Constructions in Enamel* suggests aims that go well beyond celebrating the sheer novelty of telephone art.[7] Instead, Moholy sought to achieve, as Brigid Doherty has argued, "'structural objectivity' in painting."[8] For Moholy and other artists working in the wake of the First World War, especially those active at the Bauhaus and engaged with Constructivism, the stakes for such an enterprise were none other than the translation of subjective experience into objectively verifiable and universally legible

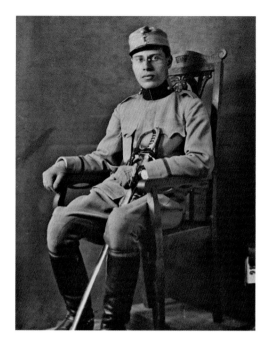

structures.[9] *Constructions in Enamel,* exhibited with Moholy's works on canvas, were meant to make a polemical case for the rigor and precision of his approach.

The path Moholy took to arrive at *Constructions in Enamel* was circuitous. He, along with many of his contemporaries, began his early forays into the visual arts initially as an Expressionist and later became linked, however briefly, with Dada before becoming a Constructivist. These designations are often understood in stylistic terms. That is to say, each of Moholy's phases might be categorized by identifying the formal affinities that his work bears to characteristics of different movements. His Expressionist period, then, is marked by an attachment to figuration that carries the gesture of his hand, his Dada work by an embrace of compositional chaos, and his Constructivism by an adoption of geometric abstraction.[10] This early moment in his career might be read as a period in which the young artist matures by working through one style to the next. But this linear narrative of his artistic development leaves out one experience that perhaps most significantly shaped his artistic project in ways that are visible in *Constructions in Enamel.*

Like other avant-garde artists of his generation, Moholy was a veteran of the Great War (fig. 1.1). He served on the eastern front as an artillery reconnaissance officer in the Austro-Hungarian Army, a role that required him to translate what he saw into precise, transmissible numerical and cartographical data. He had to adapt to modern warfare in a comprehensive way, to inhabit technologized seeing so completely as to respond immediately and with agility to its discoveries. *Constructions in Enamel* were meant to exemplify an artistic vocabulary so precise that it could be reproduced without any loss in transmission. They embody an ideal of exactitude and transparency that was born of

the requirements of modern warfare. However, Moholy redirects the deployment values, strategies, and techniques he internalized in battle toward ends shaped by his engagement with Expressionism, Dada, and Constructivism. As this chapter argues, these three movements were important to Moholy not merely as stylistic way stations, but as conceptual foundries that supplied him with a strategic arsenal crucial to his artistic enterprise. He worked to undermine the expectations of painting in order to transform it into an exacting instrument, capable of training the senses for a modern world.

We might say that Moholy became a painter in the First World War, and that his initial training took place on the front. He was twenty when he enlisted in the military in 1915, and he was deployed a year later to the Carpathian Mountains in Galicia, on the border of present-day Ukraine and Poland.[11] In his free time as a soldier, he drew hundreds of life studies on military-issued postcards of his compatriots at work or rest. One postcard features a soldier reading in a chair in his stiff uniform, sketched in a three-quarter view, head cast downward, his aquiline nose and prominent brow rendered with a single curved line and patches of shadow. The drawing is quick and evocative, capturing the bend of the waist and the angled body with a few dark strokes of pencil. Moholy suggests depth and volume by varying the shading pressure of the graphite just enough to separate thigh, knee, and crossed leg. He sent this particular picture to his close friend Iván Hevesy, who was studying art history in Budapest at the time. It was one of many postcards he sent Hevesy during his time on the front, each time soliciting his friend's opinion on the artistic merits of these new sketches (fig. 1.2).[12]

In the summer of 1917, a bullet shattered Moholy's left thumb, leading to an extended period of convalescence, and ultimately rendering him unfit for battle. Released from the front, he continued service as an instructional officer in the reserves for the rest of the war. As a reservist, he returned to Budapest to resume his university study in law but he approached it halfheartedly, preferring instead to cultivate his new love of art. With the little money he had, he bought illustrated books to copy from their pages. He spent more time with avant-garde artists and writers in cafés than with his legal tomes, his entry into these circles in part mediated by Hevesy, who would quickly become important as a critic in his own right. Moholy attended exhibitions and studied the theoretical writings and work reproduced in the pages of international journals to learn the language of contemporary art. In November 1918, he took painting lessons offered by Róbert Berény, a prominent artist and former member of the Hungarian avant-garde group The Eight.[13] In the earliest surviving portraits and nudes made after his classes with Berény, it becomes apparent how much he emulated his teacher and the artists shown in Budapest. In an early self-portrait, Moholy enveloped his face in thickly rendered, vibrational marks laid down in his frenetic hand in a manner similar to the drawings of his teacher and others— like József Nemes-Lampérth and Béla Uitz, among the artists whom he named as having had a profound impact upon his early work (fig. 1.3).[14] By September 1918, he would list "fine art painter" (*Kunstmaler*) as his profession in official documents.[15]

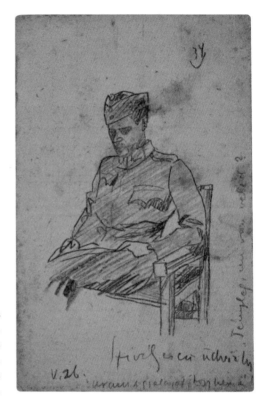

Moholy became close with the artists and intellectuals who would form the core of Hungarian Activism, a movement that took its name in homage to the German socialist Expressionist journal *Die Aktion (The Action).* Centered upon the journals *A Tett (The Action)* and later *Ma (Tomorrow),* both founded by Lajos Kassák, the Activist movement integrated Expressionism's spiritual orientation with a Futurist enthusiasm for technology, but was decidedly anti-war.[16] *Ma* was not just a journal and press but also had an associated gallery space. It provided an important platform around which the political, theoretical, and artistic contours of Hungarian Activism could begin to coalesce.[17] The group also responded to the heightened sense of revolutionary possibility that swept across Europe as the war drew to a close. When the Hungarian Soviet was established in the spring of 1919, artists associated with the Activists published a manifesto affirming their commitment to the creation of a new "communist culture" through the transformation of art, its institutions, and the artist as well. As one of the signatories, Moholy presented himself as an artist of the revolution.[18]

The Hungarian Soviet would collapse a few months later, and in its wake an exodus of leftist avant-garde artists and intellectuals ensued, with Moholy arriving in Berlin by way of Vienna in the spring of 1920. The immediate postwar period was tumultuous—

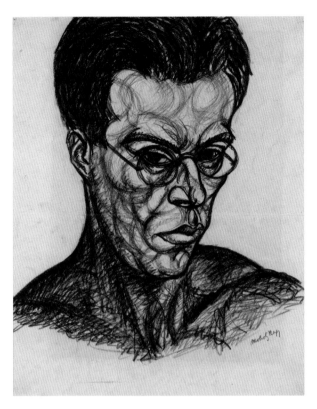

FIGURE 1.3
László Moholy-Nagy, *Self-Portrait*,
ca. 1917–19. Black crayon on paper, 38.7
× 30.5 cm. Estate of László Moholy-
Nagy. © 2018 Estate of László
Moholy-Nagy / Artists Rights Society
(ARS), New York.

Moholy arrived in Berlin just as an attempted military coup was narrowly averted, and it represented only the most recent instance in a string of political conflicts in the young Weimar Republic that gave rise to incidents of violence in the streets. He was deeply concerned in these years about how his artistic and political commitments could be reconciled—in what sense could the artist contribute to the pressing political and economic challenges that confronted Europeans in the aftermath of the First World War? Even as he publicly affirmed his commitment to the revolution, Moholy would ask himself privately, "May I claim for myself the privilege of art when all men are needed to solve the problems of sheer survival?"[19]

Despite his doubts about the role of art in revolutionary politics, Moholy remained preoccupied with traditional aesthetic problems that belonged in the domain of what he understood as that of the "fine art painter"—those of style, expression, and pictorial values. Upon his arrival in Berlin, Moholy lamented to Hevesy that with the exception of the Expressionist Oskar Kokoschka, whom he deeply admired, "the Germans do not have one single decent painter." Recounting in the same letter a recent exhibition at the Sturm, Moholy writes, "a man called Kurt Schwitters is exhibiting pictures made from newspaper articles, luggage labels, hair and hoops. What's the point? Are these painterly problems? Aside from this, it is not even new."[20]

Moholy's dismissal of Schwitters follows an argument outlined by Daniel-Henry Kahnweiler a year earlier. In the pages of the highly influential journal *Das Kunstblatt*, Kahnweiler points out that Picasso and Braque were the first pioneers of integrating everyday materials into artwork. They did so to transform the representational, pictorial values of painting and sculpture.[21] By contrast, Kahnweiler contends, Schwitters's assemblages are unoriginal and unmotivated, nothing more than a Dadaist appropriation of Cubist innovations. Moholy's letter reasserts that position, casting the uncertainty he felt toward Schwitters's work in language that demonstrates his familiarity with contemporary artistic discourse. The sentiments are hardly unique for an artist at the start of his career—Moholy had to grapple with both the art of his time and the burden of tradition in forging his own signature style.

However, a few brief months after his letter to Hevesy, Moholy would reverse his position and embrace the new art he saw in Berlin. He began working in a manner clearly informed by the Merz assemblages he had recently maligned. His quick turnabout drew criticism from Hevesy, who viewed the shift in Moholy's work with the suspicion that he too eagerly and arbitrarily came under the sway of new influences.[22] Moholy's turn to Dada did, after all, take place with remarkable speed. Within months of his arrival in Berlin, he began producing set designs for director Erwin Piscator's proletarian theater, a project that brought him in contact with John Heartfield and George Grosz. Deepening his ties to Berlin Dada, he befriended Raoul Hausmann and Hannah Höch as well. Over the course of 1921, his contacts with the Dadaists would only solidify further when he became the editorial representative of *Ma* in Berlin.[23] The journal was increasingly highlighting Dadaist poetics, typography, and imagery in its pages. In 1921–22 it featured work by members of the movement from Berlin, Zurich, Cologne, Paris, and New York. Moholy's own engagement with Dada became all the more evident in a woodcut published in *Ma* in the March 1921 issue, which adopted the chaotic energy present in the early photomontages and drawings of Grosz and Heartfield (fig. 1.4).[24] He also began making assemblages with found mechanical parts and stenciled letters and numbers—works recalling those of Schwitters's, with whom he briefly shared a studio.[25]

Moholy's turn to Dada might be understood as a result of his entry into a new circle of influence, his rejection of Expressionism representing little more than his expedient recognition that the movement might have become passé. However, what Dada offered Moholy was not a new style but the critical strategies to allow him to overcome an entire worldview attached to an Expressionist aesthetic indebted to romanticism, exemplified by his hero Kokoschka, which claimed a relationship between the factical world and its transformed appearance on paper or canvas. Deviation from naturalistic depiction through the use of skewed perspective, exaggerated colors, roughly hewn lines on wood printing blocks, as well as thick, gestural marks on canvas, offers evidence of the intensity and specificity of the artist's vision. Moholy internalized the conceit that the artist's idiosyncratic rendering of the world imbues it with meaning and depth, which is physically imparted by the expressive hand.

N. Nagy László: Fametzet

Dada wholly rejected these assumed links among the world, artist, meaning, and
expression. In the aftermath of the Great War, anything that claimed to present the
world as meaningful—from Expressionist painting and illustrated magazines to news-
papers and propaganda posters—became targets of Dadaist disdain. According to the
Dadaists, news media and high culture alike were deployed by governments in 1914 to
incite action and demand patriotism. The crafted text, the painted image, and the
expertly laid-out magazine, when mobilized in concert, compelled men to join forces
and willingly risk their lives for an empty cause. In this respect, they differed little
from ticket stubs, instructional manuals, street signs, and advertisements, materials
that are pervasive in Dadaist work. They all operate as ready-made signals and ciphers
that determine the traffic of the modern world.

It is no accident that many of the Dadaists had worked directly and indirectly in the
service of war. Even if John Heartfield escaped the front by feigning madness, he also
produced propaganda cartoons for the German government, which enlisted the aid of
his brother Wieland Herzfelde and George Grosz as well.[26] Hannah Höch tended to
injured soldiers as a Red Cross nurse.[27] Otto Dix and Max Ernst both served on the
western front as artillerymen throughout nearly the entirety of the war.[28] Moholy too
served in some of the most catastrophic battles on the eastern front. Dada grew in
opposition to the war but it also learned war's lessons. Modern warfare required both
the worker and soldier to perform under duress and to internalize habits of seeing and
being that could match the frenzied pace of industrial production and the tempo of
battle. The worker producing for the front and the soldier fighting in the trenches had

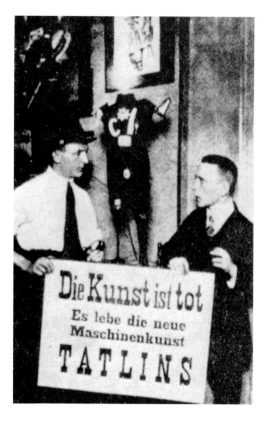

FIGURE 1.5
George Grosz and John Heartfield at the *First International Dada Exhibition* with placard reading, "Art is dead, Long live the new machine art of Tatlin," in front of their *The Petit-Bourgeois Philistine Heartfield Gone Wild: Electro-Mechanical Tatlin Sculpture*, 1920. © 2018 The Heartfield Community of Heirs / Artists Rights Society (ARS), New York / VG Bild-Kunst, Bonn.

to learn to read and see without interpretation, so habituated to act that their training instilled another kind of reflex. In order to survive, war demanded the destruction of contemplation, autonomous reflection, and subjective expression. Dada's much vaunted nihilism turned out, in this respect, to be a form of realism. Trained to the beat of the machine and the percussive explosions that syncopated the field of battle, the new man had no use for the values or even temporality of the work of art as traditionally conceived. Dada transformed art from a spiritual sanctuary of contemplation into an object that provokes immediate somatic responses—disgust or laughter, outrage or fear.[29]

Dadaists mimed the tactics of war and replicated its effects.[30] They adopted the screeching jingoism that characterized wartime propaganda in their own violent manifestos. Ernst took mechanical parts gleaned as if from wartime weapons manuals to create comically impotent anthropomorphic machines. Such ideas would take sculptural form in the parodic assemblages of Grosz and Heartfield, seen in *The Petit-Bourgeois Philistine Heartfield Gone Wild: Electro-Mechanical Tatlin Sculpture* (1920). A dress form serves as the scaffolding for a body without head or arms, a peg for a leg, and dentures wedged in its castrated crotch (fig. 1.5). Dix would take a similar tack in his large-format painting-collage, the *Skat Players* (1920). Using a range of ready-made

collaged and painted elements, Dix portrays three veterans with faces gruesomely mutilated and prosthetic parts grafted arbitrarily to substitute for missing limbs (fig. 1.6).

But Dadaist work did not only mirror the horrors of war. Höch's photomontage *Cut with the Kitchen Knife through the Last Weimar Beer-Belly Cultural Epoch in Germany* begins with the deformation of the ready-made photographic image and, as the title suggests, violently dismembers the ruling order (fig. 1.7). In her deft and humorous arrangement of the photographic fragments, the work enacts figurative violence against the establishment, while it also interjects images of women, leftist political heroes, teeming masses, and Dadaist practitioners as agents of revolutionary action.[31] These examples are hardly stylistically cohesive, but what they shared was a commitment to destroying or disrupting the status quo and a desire to generate a visceral response to shock viewers out of complacency. With tradition and convention destroyed, the possibility of a new present and alternative future could be postulated in its place.

Moholy created work that might have shared formal affinities with that of the Dadaists during his involvement with the group, but the movement had a far more profound impact on his theoretical orientation and prepared the ground for his turn to Constructivism. In that respect, Moholy was not alone. Dada sought to annihilate tradition, convention, and the burdens of falsified histories. It denied the virtuosity of the individual, and rejected the possibility of subjectivity in the wake of the war. It revealed the impossibility, to use Moholy's own formulation, of remaining a fine arts painter under such conditions. Dada created the tabula rasa upon which the Constructivist project of creating a new revolutionary culture was possible. It is no accident that Dadaism and Constructivism, movements that appear so formally divergent, included artists who were often active in both concurrently.

The link between the two movements is perhaps most apparent in "Call to Elemental Art," signed by Moholy, Raoul Hausmann, Hans Arp, and Ivan Puni and published in *De Stijl* in 1921. This text is often hailed as a foundational text for International Constructivism, inaugurating a new geometric, abstract style.[32] However, the stylistic diversity of the manifesto's signatories gives an indication of the heterodoxy of the project at hand. Puni was the only Russian of the group and the only artist with any link to the Suprematists and Constructivists at the time of publication. Moholy, Hausmann, and Arp were then more closely identified with Dada than with any other movement.

The manifesto opens with the demand that artists attend to the necessities of the present moment and work in a manner that neither derives from the past nor claims transcendent permanence.[33] The task of the artist is to manifest the "forces" that pervade an era in his work in a way that must "yield to the elements of form-creation [*Gestaltung*]." The undersigned demanded that artists "turn away from style," from tradition, from ways of seeing and making still tethered to the past. The artist can no longer adopt an arbitrarily determined, externally derived formal logic and impose it upon a work of art. An attachment to style, the manifesto argues, cannot generate the

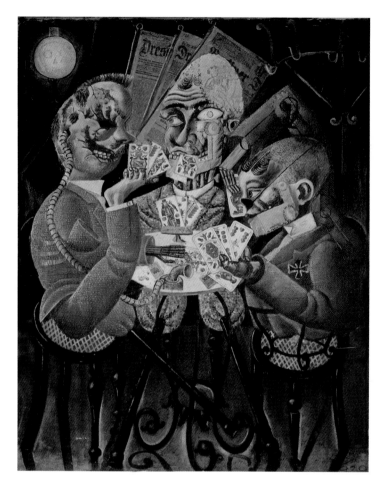

forms through which the dynamics immanent to the present and to art itself can find expression. In order to achieve "the" style, proper to and derived from the structure of its historical moment, and not merely "a" style among many in the artistic field, the manifesto demands a kind of impersonality, an anonymity that ultimately serves to justify a claim to art's capacity to express dynamics immanent in the world. Furthermore, the manifesto's requirement that the artist "yield" to *Gestaltung* denies the artist a role as expressive genius. Instead, the artist should serve as the "pure exponent of the forces that bring the elements of the world to form."[34] Only through acuity to such forces can the artist generate dynamics that permit the "renewal of our perception [*Anschauung*]."[35]

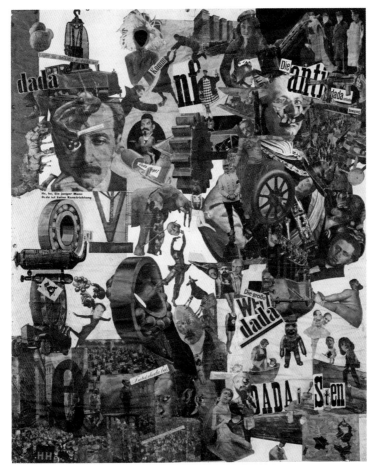

FIGURE 1.7

Hannah Höch, *Cut with the Kitchen Knife through the Last Weimar Beer-Belly Cultural Epoch in Germany,* 1919. Collage, 114 × 90 cm. Nationalgalerie, Staatliche Museen, Berlin. © 2018 Artists Rights Society (ARS), New York / VG Bild-Kunst, Bonn. Photo credit: bpk Bildagentur / Nationalgalerie, Staatliche Museen, Berlin / Jörg Anders / Art Resource, NY.

The use of the term *Gestaltung* here is pointed, and a translation of it merely as *design* or even *form-creation* is insufficient. As Detlef Mertins and Michael Jennings have shown, *Gestaltung* had a polemical valence at the time and was used across several different disciplines, including the natural sciences as well as in industrial design and art. It referred "to form as well as to the process of formation or form-creation or form-giving or even production." The language of *Gestaltung,* with its biological and psychological inflections, was used specifically "to overcome the opposition of mechanism and organism, which had so preoccupied biologists and psychologists of the nineteenth century."[36]

"Call to Elemental Art" announces a set of values that would guide much of Moholy's aesthetic project in years to come. In step with the "Call," Moholy began to experiment

with geometrical forms, initially motivating their organization by invoking architectural metaphors. In February 1922, he had his first exhibition at the Sturm Gallery in Berlin, in which he showed a suite of abstract paintings and prints featuring soaring blocks and daring cantilevered forms that he called *Glass Architecture*, explicitly invoking Paul Scheerbart's book of the same name. Published by the Sturm in 1914, Scheerbart's book was highly influential within the avant-garde. He argued that advancements in building technology would allow for the introduction of a new crystalline habitus, which in turn would create the conditions for an open, hygienic, and thoroughly modern society.[37] Moholy not only adopted these ideas in his works on canvas and paper but also embraced materials and forms resonant with Scheerbart's vision in his sculptures and relief assemblages. Singled out for praise were *Disc Sculpture*, a complex tabletop sculpture composed of gleaming nickel-plated iron, mirrors, and sheets of glass; and *Nickel Construction*, a work that pays homage to Vladimir Tatlin's *Monument to the Third International*, which circulated widely in avant-garde journals of the time (figs. 1.8, 1.9). Moholy translated Tatlin's towering wooden scaffolding into a taut ribbon of gleaming metal, dynamic and nearly kinetic in its energetic diagonal ascent. The architect and critic Ludwig Hilberseimer lauded Moholy's "constructive ambition."[38] He described Moholy's architectonic use of highly polished and industrial materials as expressing an "impersonal collective vision of our technological civilization, of industrialization."[39]

Hilberseimer, a trained architect, was not the first to identify a constructive impulse in Moholy's work. Ernö Kállai had already done so with respect to the work the artist produced in 1921. In his introduction to a selection of Moholy's art published in *Ma* and concurrently in *Horizont*, its German-language sister journal, Kállai described the works as the "organic unification" of the "antipodes" of Cubism and Dada."[40] Kállai maintained that Western Cubism fell victim to the complication of space arising from the fracturing of form and color.[41] Dada, for him, represented a style of pure negativity, put to use as "a murderous weapon of moral and social critique." Kállai wrote that Moholy took up these two positions in order to articulate a new path in his art: Moholy synthesized the anarchic energies of Dada with Cubism's attention to form in order to articulate a vision of affirmative present and future possibilities of the "metropolis and modern technology."[42] Through a synthesis of these two seeming opposites, Kállai explained, Moholy became a "master builder," an artist who demonstrated the "constructive" potential of his age.[43]

The new work Moholy showed at the Sturm in 1922 internalized and intensified the tendencies Kállai identified in his work from the prior year. *Glass Architecture* and his metal sculptures grew out of his desire to overcome style, the problem he took up around the time he signed "Call to Elemental Art" late in 1921. His explicit adoption of architecture as a model and metaphor in the art he exhibited invited his contemporaries to draw analogies between his work and that of the Constructivists. The journal *Vešč-Objet-Gegenstand*, started by El Lissitzky and Ilya Ehrenburg in 1922 as a means to disseminate Soviet Constructivism to an international audience, lauded Moholy's work as an example of such a position in the West. In an article that appeared in the May issue of the

journal, El Lissitzky wrote that "Moholy has prevailed over German Expressionism and is striving to achieve an organized approach. Against the background of jellyfish-like German nonobjective painting, the clear geometry of Moholy and Peri stand out in relief. [They change] over from compositions on canvas to constructions and material."[44]

El Lissitzky's description of Moholy's work came at a moment when Constructivism was emerging as a highly influential position within the avant-garde. It would take shape in response to events that unfolded over the course of 1922. That year, the Young Rheinland, the Dresden Secession, and the Berlin November Group convened the Congress of the Union of International Progressive Artists in Düsseldorf in response to the exclusion of avant-garde artists from the city-sponsored official *Great Art Exhibition of Düsseldorf* that year. Moholy did not attend, but ten paintings and his *Nickel Construction* from his February Sturm exhibition were shown at the *First International Art Exhibition* held at the Tietz department store, organized to accompany the proceedings at the Congress.[45] Meant to demonstrate the solidarity of young, avant-garde artists committed to social and political art, the Congress of the Union of International Progressive Artists actually revealed rifts within the community and catalyzed the formation of International Constructivism.[46] Lectures and presentations devolved into shouting matches between the majority, sympathetic to the aims of the Union, and those self-proclaimed representatives of the opposition, the most vocal of whom included Theo van Doesburg, Hans Richter, and El Lissitzky.[47]

Immediately following the Congress, *De Stijl* published a special issue outlining objections to the aims of the Union of International Progressive Artists. The issue concludes with a declaration by the self-styled "International Faction of the Constructivists" that enumerates the fundamental differences between it and the Union. Signed by van Doesburg, El Lissitzky, and Richter, the text condemns the Union for its well-intended but impotent response to artistic, social, and economic conditions because of its lingering attachment to traditional concepts of art, its roles, and its institutions.[48] Their manifesto affirmed the following:

a) Art is, like science and technology, an organizational method of life in general.

b) We declare that art must cease to remain a dream that sets itself in opposition to the reality of the world, that it stop serving as the means to discover cosmic mysteries. Art is a general and real expression of creative energy that organizes the advancement of humanity, which is to say, it is an instrument [*Werkzeug*] of general processes of work.

c) We must fight to bring this into reality, and we must arrive to this battle organized. Only in this way can our collective energies be liberated. Only then can the fundamental [*prinzipielle*] and the economical [*wirtschaftliche*] join in union.[49]

In the wake of the First World War, the International Faction of the Constructivists argues that for art to remain relevant under present conditions, it cannot concern

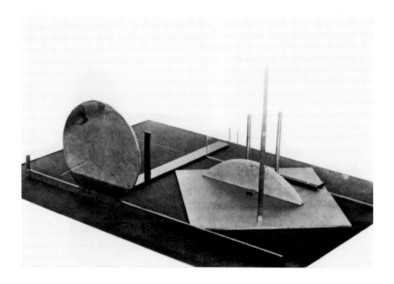

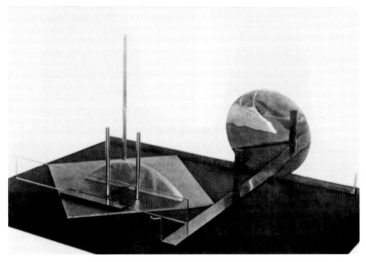

FIGURE 1.8
László Moholy-Nagy, *Disc Sculpture,* 1921, lost or destroyed. Estate of László Moholy-Nagy. © 2018 Estate of László Moholy-Nagy / Artists Rights Society (ARS), New York.

itself with fantasy but with the concretization of reality. It must assert itself methodically and rigorously. On that score, they emphasize in a footnote that the adoption of the term "Constructivist" refers not to the Soviet precursor, but instead is deployed only to heighten the contrast to everything that is "Impulsivist," arbitrary, and subjective.[50] The task of the artist is to integrate art into modern life by engaging with its technologies as well as with the logical, scientific processes they rely upon and enable.

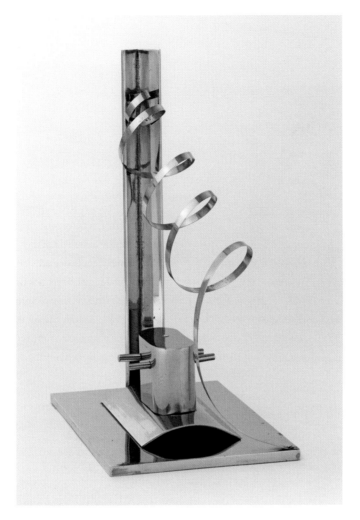

Moholy's own art and thought participated in and helped to direct the discourse of
Constructivism in the West in 1922. He took part in the International Dada-Constructivist
Congress convened by van Doesburg in Weimar later that year. His essay "Production-
Reproduction," which proposed new strategies to transform reproductive technologies
into instruments of creative production, appeared in the June issue of *De Stijl*.[51] His
Book of New Artists also appeared both in Hungarian and in German, authored jointly

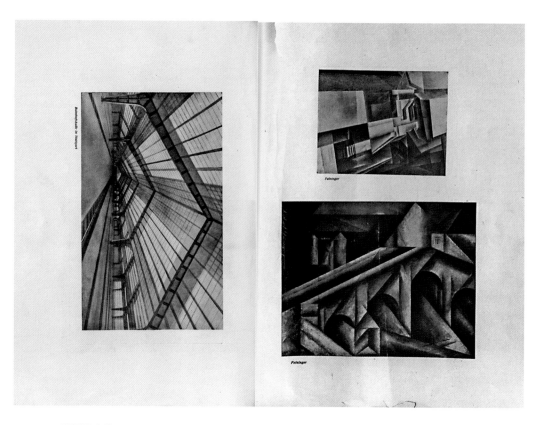

FIGURE 1.10
Architectural drawing of the interior of the Stuttgart train station and two paintings by Lyonel Feininger, published in Ludwig Kassák and László Moholy-Nagy, *Buch neuer Künstler* (Vienna: MA, 1922), n.p.

with Lajos (Ludwig) Kassák.[52] There, Moholy provided a visual argument aimed at revealing structural affinities between recent art and the latest innovations in science and engineering. For instance, Moholy paired Cubist paintings with the crystalline interior of a modern train station; and the ascendant scaffolding of Tatlin's *Monument to the Third International* with the skeletal support of an American aircraft hanger (figs. 1.10, 1.11). The images follow a clear, progressive telos, each artwork and corollary technical achievement ever more advanced, culminating in the work of the Russian Constructivists.

In his layout of the Constructivists in *Book of New Artists*, Moholy placed his painting 19, which was included as part of the Sturm exhibition earlier that year, opposite a sculpture by Rodchenko and installation photo of the *Second Spring Exhibition of the Society of Young Artists* (OBMOKhU) (fig. 1.12). In the black and white reproduction of Moholy's painting, the opaque bands and geometric shapes coalesce into a compact edifice shot through with bars of parallel lines, creating dynamics that echo the open thrust of Rodchenko's ascendant sculpture and the aery Constructivist forms on the

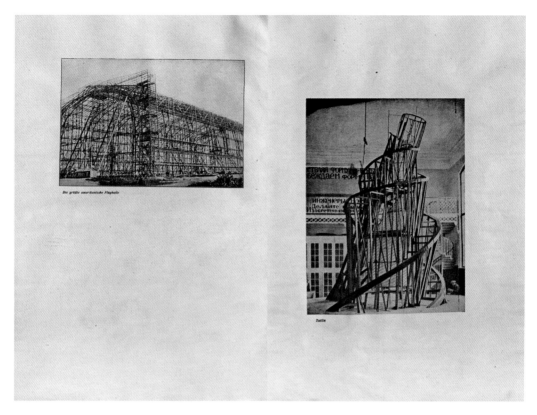

FIGURE 1.11

American aircraft hangar and Vladimir Tatlin, *Monument to the Third International*, 1919, published in Ludwig
Kassák and László Moholy-Nagy, *Buch Neuer Künstler* (Vienna: MA, 1922), n.p.

facing page.[53] *Nickel Construction* follows, paired with one of Moholy's rigorously archi-
tectonic prints. Moholy's art is presented at once as representative of Constructivism
and as the inheritor of artistic practices that internalize the structures and logic of
industrial modernity.

Through these projects, Moholy's work came to the attention of Walter Gropius,
director of the Bauhaus in Weimar.[54] The state-funded art school was first established
in 1919 and distinguished itself from traditional beaux-arts institutions with its call to
integrate art with craft. However, following several years of ongoing and widespread
economic crises in Germany, Gropius voiced his concern in 1922 that the school could
no longer depend upon state funding for its future survival. He suggested that the
Bauhaus had to reorient its mission to bring it closer in line with the interests of
industry as a way to justify the activities of the school to the regional government.
Gropius courted Constructivism as a way to secure an economic path forward. Already
evident in the pages of *De Stijl*, even if the movement was launched in Soviet Russia,
the movement and its aesthetic were identified in the West with a new artistic attitude

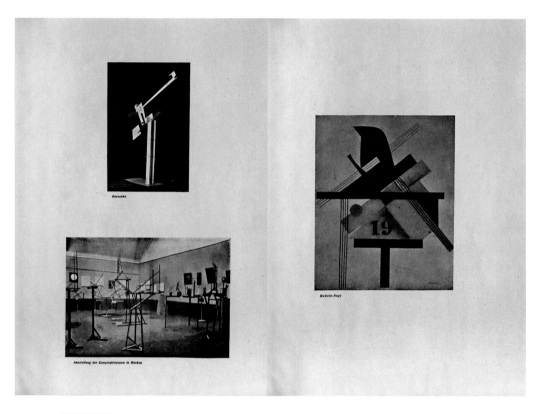

FIGURE 1.12

Alexander Rodchenko, *Construction 2*, 1920; installation view of the *Second Spring Exhibition of the Society of Young Artists*, 1921; and László Moholy-Nagy, *Composition 19*, 1921, published in Ludwig Kassák and László Moholy-Nagy, *Buch neuer Künstler* (Vienna: MA, 1922), n.p.

that appeared far more concerned with practical and even economic demands of industrial modernity than with the rarified pictorial debates of the art world.[55] Moholy joined the faculty in spring 1923 to serve as the form master of the metal workshop and the leader of the preliminary course.

The following February, Moholy held his third exhibition at the Sturm and showed *Constructions in Enamel*. They hung above a platform, clustered as a group but also proximate to paintings on canvas, collages, and watercolors. Installation photographs of his exhibition present a strikingly cohesive show (figs. 1.13, 1.14). Unlike his exhibition at the Sturm in 1922, the works he showed in 1924 broke free from explicit references to architecture as their motivating logic. His pictures are spare, and the dimensions of his supports repeat, as if to suggest a set of standardized formats. The vocabulary of visual elements appears exceedingly simple. Working with little more than bars, sharply sheared circle segments, and arcs, Moholy reconfigured recurring shapes in each picture to articulate a range of spatial possibilities. Forms anchored

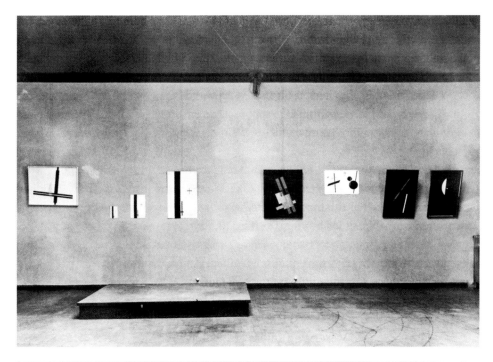

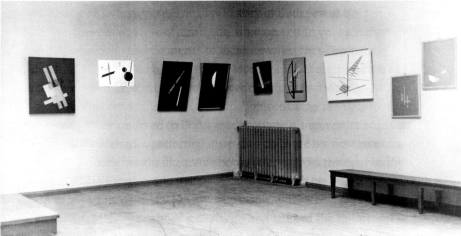

FIGURE 1.13

László Moholy-Nagy, *Constructions in Enamel,* installed at the Sturm Gallery, Berlin, February 1924. Estate of László Moholy-Nagy.

FIGURE 1.14

László Moholy-Nagy, exhibition installation at the Sturm Gallery, Berlin, February 1924, to the right of *Constructions in Enamel.* Estate of László Moholy-Nagy.

tightly together in a cross can be made to levitate in space if the complex is rotated just slightly to undock its tips from the edges of the canvas. The unrestrained force of a red circle might otherwise dominate a composition, but in his painting *Q 1 Suprematistic,* Moholy pins that powerful feature behind a diaphanous vertical, striped yellow ribbon. Two smaller black discs assert themselves in a space between the red field and the yellow bar (plate 2). These simple forms, painted without modulation, nonetheless generate an expansive sense of depth simply by virtue of their arrangement. Other pictures make use of the high contrast between dark ground and colored figure to create the illusion of an incandescent glow emanating from his brilliantly painted shapes. On the same wall as *Constructions in Enamel,* Moholy tacked up a pair of unframed watercolors executed on white paper, breaking up an arrangement of three paintings on dark ground. The presence of these watercolors injects a degree of informality unusual in a gallery exhibition, as if suggesting that the works might be unpinned and moved to serve as a comparative for other pictures, rearranged or reoriented to produce new effects.

This unorthodox mode of presentation undermines traditional hierarchies of media, upending the privileged position that painting once occupied. As Moholy remarks in an artist's statement for his show in the Sturm's newsletter that year, "In this age of industrial production and technical exactness, we also strive to produce works of art with total precision. Among the new works that I am exhibiting this February at the Sturm Gallery is a series of enamel pictures that were manufactured by machine. To be sure, this manner of manufacturing pictures only comes into play for works created with a will to precise and impersonal technique."[56] Moholy underscores that only designs that convey values of precision and exactitude, and that eliminate the arbitrary, subjective impulse of the individual artist, merit machine reproduction. Put differently, machine reproduction, usually seen as the cheap derivative of an original, is presented as the end and aim of design. In this formulation, the success or failure of each picture rests wholly on how convincingly, in their meticulously handled surfaces and rigorously drafted forms, they might serve the needs of industrial modernity. This point was not lost on his critics. Willi Wolfradt, in a review of Moholy's show, writes that he "excels in a technical hygiene to a degree that it constitutes a kind of artistic sensibility as such, a sensibility that extends to his treatment of his corresponding materials." Wolfradt lauds his "mastery of glass and nickel" and remarks that his "paintings prove themselves as enamel signs."[57]

Moholy withheld his signature and titled his works with letters and numbers, following industrial naming conventions. These spare forms were painted with hands trained to replicate a machined finish. But Moholy did not merely mimic the sound and the look of industry. His exhibition articulated a new standard to which paintings should aspire. Drafted as he prepared and mounted the show at the Sturm Gallery, his book *Painting, Photography, Film* (1925) would go even further in announcing, "Traditional painting has become anachronistic and a thing of the past."[58]

FIGURE 1.15

László Moholy-Nagy, *Malerei, Fotografie, Film* (Munich: Albert Langen Verlag, 1925), 66–67. © 2018 Estate of László Moholy-Nagy / Artists Rights Society (ARS), New York.

The declaration is often taken as Moholy's wholesale rejection of the medium. But what he argues for is a fundamental reconsideration of the task of painting in the age of photography and film, a task he performed in exhibitions and in the pages of the book itself. In the show, through the controlled exploration of color and form across media, conventional and industrial, he presents painting as the experimental laboratory for the discovery of structures relevant to the modern, industrial age. In the book, the one time he reproduces an actual painting in its pages, it is not as a retrograde object. Instead, a white abstract canvas faces an inky photogram, their compositions rhymed but distorted; the twinned forms read like imprints pulled from each other, revealing subtleties and gradations in light and dark not indigenous to their respective media. The juxtaposition goes beyond formal similitude, allowing him to demonstrate the contributions that painting can make to enhance vision, already transformed by photography (fig. 1.15).[59]

"Traditional painting," then, refers to far more than the sum of its means and materials—brush, pigment, and canvas. Instead it stands in for obsolete ways of seeing that can take hold in any medium. Moholy demonstrates this claim in the first paired illustrations in his book (fig. 1.16). The first edition opens with Alfred Stieglitz's photograph of a street in New York City. Printed to produce a painterly effect, the horse-drawn carriage, the wide boulevard, and frontal figures all coalesce into an image that

could easily be conflated with an Impressionist canvas of nineteenth-century Paris. Paired with a composite photograph of a zeppelin set against a dramatic sky, sun glinting off the rough seas below, Moholy's captions condemn both for imitating painting's stylistic habits and forms.[60]

The pairing does not simply criticize the painterly photograph as stylistically outdated. The zeppelin, we should note, was quintessentially modern. The first commercial airline featured zeppelins, not planes.[61] They were the first successful platforms for aerial reconnaissance because of their steadiness in flight. The military utility of the zeppelin was recognized early on, even before the First World War; and once hostilities commenced, they were used by the Germans not only for reconnaissance but also in bombing campaigns against the British and French.[62] The photograph of the zeppelin Moholy selected exemplifies the absurdity of imposing the conventions of painting upon the photographic depiction of such a modern invention. The heavenly clouds and breaking waves frame the airship in improbably dramatic light. Despite the use of photographic technology, the resulting image converts this signal achievement in flight into nothing more than a motif in what Moholy called in the caption a "'romantic' landscape." "It has taken about a hundred years," the caption continues, "to arrive at the appropriate deployment of photography's own means."[63] Throughout the book, Moholy demands that we attend to the specificity of techno-

FIGURE 1.17

László Moholy-Nagy, *Malerei, Fotografie, Film* (Munich: Albert Langen Verlag, 1925), 46–47. © 2018 Estate of László Moholy-Nagy / Artists Rights Society (ARS), New York.

logically mediated vision. For Moholy, we must recognize that the aperture of a camera sees differently not only from the biological eye, but also from vision burdened by convention, accrued over generations and developed in historical epochs no longer relevant to our own. To see and to photograph according to what the technology reveals trains the viewer to no longer rely on outmoded habits of seeing and thinking.[64]

The book is organized in two parts, the textual argument in the first thirty-seven pages and a series of captioned illustrations, paired as full facing pages, in the concluding ninety. Despite the separation of text from images, the latter adhere to the progressive narrative laid out in the first half of the book and are meant to "clearly elucidate the problems explored in the text VISUALLY."[65] The photographs included in his illustrations exemplify approaches, perspectives, and genres that would be privileged by partisans of New Vision photography, but the images do far more than simply codify a style. They demonstrate the specific capacity of the camera to capture moments that our naked eye could never see: the dancer in mid-leap and the motorcyclist racing along a particularly tight curve on a track (fig. 1.17).[66] Microscopy and macroscopy unlock worlds otherwise foreclosed, from the tiny flea to the cosmos beyond (figs. 1.18, 1.19).[67] The use of photography—including the use of photosensitive paper without a camera, the exploration of positive-negative reversals, multiple exposures, and photomontage techniques—yields unprecedented visual relationships that challenge and

FIGURE 1.18

László Moholy-Nagy, *Malerei, Fotografie, Film* (Munich: Albert Langen Verlag, 1925), 44–45. © 2018 Estate of László Moholy-Nagy / Artists Rights Society (ARS), New York.

FIGURE 1.19

László Moholy-Nagy, *Malerei, Fotografie, Film* (Munich: Albert Langen Verlag, 1925), 56–57. © 2018 Estate of László Moholy-Nagy / Artists Rights Society (ARS), New York.

expand our perceptual faculty by refusing to allow the reader/viewer to fall back on existing frameworks to determine their reception.

Moholy's discussion of film emphasizes the extent to which the capture and transmission of moving images fundamentally alter our sense of time, movement, and space. The ambling viewer with feet on the ground sees wholly differently than the pilot of an airplane, flying unmoored above the earth. Our world is one in which the eye cannot rest and must become accustomed to constant motion. Here, too, what Moholy means by *film* is not confined to the instrument or support, narrowly conceived, but pertains instead to the dynamic comportment such technologies enable.

Moholy's book recasts the artist as optical *Gestalter,* responsible for generating visual materials to train and hone perceptual faculties. An artist's work must address "psycho-physical effects" in the production of "stimuli," and, in the end, contribute to the "hygiene of the optical."[68] Building upon arguments he first laid out in "Production-Reproduction," he writes that the "construction of man is the synthesis of all of his functional mechanisms [*Funktionsapparate*]." In a given epoch, "man becomes most perfect when his constituent functional mechanisms—the cells as much as the most complicated organs—are trained [*ausbilden*] to the limits of their ability to perform [*Leistungsfähigkeit*]."[69]

Painting, Photography, Film rejects the idealist subject, an autonomous actor who becomes progressively more civilized through art. Instead, Moholy puts forward the conception of the human being as an ever-improvable biological entity whose psychological and physiological capacity can always be optimized through the application of appropriate stimuli. The language Moholy adopts throughout this book borrows freely and heavily from biocentric discourse as well as psychotechnics, a field that emerged in the teens and twenties seeking to maximize worker productivity by researching the psychic and physical conditions that determine action and response.[70] Of central concern was the problem of attention—how the worker can be trained to focus with reliable accuracy and speed when engaged in repetitive tasks. Put differently, as Frederic J. Schwartz has argued, the pursuit of optimizing attention was for psychotechnics always predicated on overcoming fatigue.[71] This field became highly influential in avant-garde graphic design, and its impact is readily apparent in Moholy's *Dynamic of the Metropolis,* the curious work that brings *Painting, Photography, Film* to a conclusion.

Moholy describes *Dynamic of the Metropolis* in his introductory text as a film scenario developed in 1921–22 with Carl Koch, who is best known for his association with the Berlin Institute of Cultural Research (*Berliner Institut für Kulturforschung*), an organization that funded several ambitious early animation projects. Moholy states that *Dynamic of the Metropolis* "does not seek to teach, nor moralize, nor describe: it seeks only to operate visually, only visually."[72] He continues, "The elements of the visual do not necessarily relate to one another according to a logical bond; nevertheless, through photographic-visual relationships, they become integrated into a living relationship

with spatiotemporal phenomena and activate [*einschalten*] the viewer to engage the dynamic of the metropolis."[73] As Moholy explains, the institute did not have the resources to realize their concept, so they presented the script to several major studios. It was met each time with bewilderment. "However interesting the idea, film people could not discern the plot in the script."[74] Of course, the project was developed precisely to counteract film's dependency on devices that are not its own, to liberate it from narrative forms and dramatic action. So experimental and ahead of its time, he muses, the *Dynamic of the Metropolis* would require new funding mechanisms outside the studio system.

Even though the film was never made, Moholy employed the script and the format of the book to present to the viewer an impression of the film by translating it into typophoto, a fusion of text and photographic image meant to transform reading from a static, linear, literary activity into a visual experience capable of generating tactile and kinetic effects. In the fourteen pages that follow, insistently asymmetrical grids are plotted irregularly in heavy black bars of varying thickness, some continuing to the edge of the sheet while others end abruptly just short of the edge. Within this syncopated scaffolding, Moholy intersperses images, symbols, and text in a variety of fonts, some functioning as captions, others as camera instructions or technical descriptions of action on-screen. Recurrent boldface terms like "TEMPO" run along the page, at times vertically and at other times horizontally, functioning far more like percussive exclamations (fig. 1.20). Akin to the thump of a drum or the gunshot announcing the start of a race, the printed word used in this manner can halt the eye, or speed and redirect its action according to the visual beat it creates. The pace and movement of seeing is further determined by Moholy's use of arrows and signals, bullet points, charts, and geometric shapes, which impede direct passage from left to right and instead force the eye to ricochet across the page. The eye cannot rest but must remain alert, constantly shifting focus with increasing speed.

Moholy also remarks on one page of the film scenario, "Man cannot perceive a great deal in life. Sometimes it is because his organs do not respond quickly enough, because, for example, a moment of danger demands too much of him. Almost everyone shuts their eyes faced with the enormous descent of a roller coaster. But not the film camera."[75]

The camera permits the capture not only of images that are too fleeting for the body to perceive, but also of images we refuse to see out of fear. Moholy argues, "generally, we do not see objectively" (fig. 1.21).[76] When we regard an infant or wild animal, for example, our embodied observation of each is loaded with "a series of other associations." We might say that the associations are cultural, affective, and deeply subjective. "In film, it is different."[77] Below this theoretical statement, the script continues and describes a series of shots that subject the reader/imagined viewer to a variety of dizzying images; for example, exposing them to the furious cycle of a carnival ride, the tire of a speeding vehicle, the unyielding turns of an enormous factory gear, a train station filmed with a camera that swivels both vertically and horizontally, and a high

FIGURE 1.20
László Moholy-Nagy, *Malerei, Fotografie, Film* (Munich: Albert Langen Verlag, 1925), 116–17. © 2018 Estate of László Moholy-Nagy / Artists Rights Society (ARS), New York.

FIGURE 1.21
László Moholy-Nagy, *Malerei, Fotografie, Film* (Munich: Albert Langen Verlag, 1925), 122–23. © 2018 Estate of László Moholy-Nagy / Artists Rights Society (ARS), New York.

jumper's body whirling in flight replayed ten times. Immediately adjacent to this series of images, Moholy's typophoto proclaims, "**OUR** HEAD CANNOT DO THIS," as if to say, without the mediation of film, our minds and bodies could never survive this sequence of revolutions without the nauseating effect of the spins.[78]

The film rewinds and replays at different points. The script is punctuated by the recursive presence of a terrifying lion's head, shots of an amusement park ride, death-defying feats of circus performers, military marches, and corpses identified in a morgue generated by double exposure as ghostly apparitions and filmed swimming slowly in a body of water.

Moholy dates this project to 1921–22, significant because it refers to a moment in which he worked at once within Dadaist and Constructivist contexts. Moholy's introductory remarks employ language that recalls how both movements established new conditions for the subject. Logic, as the Dadaists exposed, can no longer bind, and plots—or, more generally, narratives that have shaped past histories—have little relevance to present demands. Film, a technically demanding, resource-intensive medium, does not permit individual effort. This is the promise and peril of film, as Walter Benjamin would describe in his famed essay "The Work of Art in the Age of Its Technological Reproducibility," drafted a decade later.[79] Resources required for film are well beyond the means of an individual. To recoup the investment, studios have no choice but to attempt to reach as broad an audience as possible.[80] Because film is technologically advanced and requires both collective effort and mass audiences, it could serve as the perfect means to habituate the modern subject to see in accordance with the requirements of the present. In so doing, it could reconfigure perception to prepare for the needs of the future.[81]

Dynamic of the Metropolis certainly seeks to hone the ability of the eye to see with speed, to become accustomed to myriad perspectives, to give itself over to shifting images, and to learn to adjust quickly from brilliant light to artificial darkness.[82] But beyond merely training somatic response, the proposed film also demands that the viewer overcome existential fear. The appeal of riding in a roller coaster or watching the trapeze artist or race-car driver is that each provides a controlled experience of danger. Each orchestrates a confrontation with death made all the more satisfying in the defiance of it. The sports match and the military march produce the fantasy of battle as abstract and organized, clean and without casualties. In real life, even as we create controlled environments to overcome our fear of finitude, the embodied eye still shuts down and the gut churns when confronted with something as trivial as an impending dip on an amusement-park ride, let alone the actuality of one's mortality in the face of war, however sublimated. Objective sight, freed from blinding affective associations and the debilitating fear that overwhelm the biological system, requires the unflinching eye of the mechanical aperture.

Moholy's film scenario, transformed into an example of typophoto, imagines that technology could be used to produce ever more intensive visual stimuli that would allow the subject to overcome the physical and psychical limits of the biological body.

However indebted Moholy might have been to the discourse and practice of psycho-technics, his work reveals what Schwartz describes as a willful blindness to its central principle—that embodied seeing fatigues, that attention cannot be endlessly sustained, and that the body will cease to function under duress. The claim that technology could be used to train, hone, and seemingly infinitely perfect our perceptual faculties was made not only by Moholy but by other interwar avant-garde artists, especially those most closely identified with New Typography and New Vision photography.[83] Within the discourse of photography, avant-garde theorists and practitioners including Franz Roh, Jan Tschichold, Werner Gräff, Umbo, and others each extended this argument and suggested that the camera and photography might come to supplement if not supplant the merely biological eye. What emerges in these positions is a techno-utopianism distinctive to the interwar avant-garde. It imagines that technological progress could ensure human progress by eliminating biological impediments. It is a position, as Schwartz maintains, that can only be made in bad faith. Perhaps even more troubling, such an argument risks subordinating human values to those of the machine.

In her reading of Umbo's iconic self-portrait from circa 1930, in which the artist's bespectacled eyes are caught behind the shadow cast by his camera, Rosalind Krauss shows that the camera threatens to replace "the activity of sight with the instrument of recording, producing for us the image of the real body becoming subject to the domination of the prosthesis of vision" (fig. 1.22).[84] Far from simply augmenting the fallible human eye, which can capture little more than subjective impressions, the camera can come to replace it. To see with camera vision is to adopt its logic as one's own. When the camera becomes primary, the body that carries that instrument of seeing becomes the interchangeable prosthetic. Put differently, the body itself becomes exchangeable and expendable, enslaved to the imperatives of the technology itself.

What Krauss describes is a logic that reigned supreme upon the field of battle. This is hardly accidental. The interwar avant-garde linked the experience of war and the desire to make use of technology as a way to bypass if not entirely overcome the fragile body. The utopianism of such an idea, Krauss argues, has a much darker side—it threatens to transform living beings into mere cogs in the machine. Moholy's own techno-utopianism was shaped by his experience of war, but I want to insist that he was hardly blind to the threat Krauss identified. Out of these early years, culminating in *Constructions in Enamel,* Moholy sought to redefine the relationship between art and technology and, by extension, between man and machine.

Among the hundreds of postcard sketches Moholy produced, several attend closely to the surveillance technology used in the trenches. They reveal in some detail aspects of the day-to-day operations in his unit. One such drawing shows an officer with his face obscured by his binocular periscope, the giant rabbit-eared contraption peering above an embankment (fig. 1.23). The instrument and face fuse together, mirroring the twin

FIGURE 1.22

Umbo (Otto Umbehr), *Self-Portrait at the Beach,* ca. 1930. Gelatin silver print, 29 × 21.8 cm. The Museum of Modern Art, New York. Digital Image © The Museum of Modern Art / Licensed by SCALA / Art Resource, NY.

periscope's own stereoscopic vision, which allowed its user to gauge depth. Another shows a man listening intently at his post, ear hidden beneath a headset. The postcard is labeled *Telephone Operator, Galicia, 1917* (fig. 1.24).

Moholy served as a reconnaissance officer within an artillery unit. Part of his duty was to ride ahead on horseback to secure viable routes for his comrades and for the howitzers for which they were responsible.[85] A fully outfitted howitzer weighed well over two thousand pounds but could be disassembled for transport by a train of men, horses, and wagons, navigating paths that had to be wide and stable enough to support their weight, which was no small task in the unforgiving terrain of the Carpathian

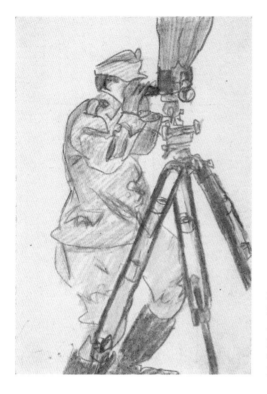

FIGURE 1.23

László Moholy-Nagy, *Soldier Looking through Periscope,* ca. 1915–19. Colored pencil and pencil on paper, 13.7 × 8.9 cm. Estate of László Moholy-Nagy. © 2018 Estate of László Moholy-Nagy / Artists Rights Society (ARS), New York.

Mountains.[86] Moholy learned to see with technical instruments and translated what he observed into data that could be inserted into discrete equations. Fatigue, for example, had mathematical expressions: training manuals produced by the Austro-Hungarian military included formulae to be used to predict the expected rate of exhaustion of both men and horses when hauling heavy loads along particular inclines.

Reconnaissance had to identify enemy locations and did so through the use of optical tools. Aerial photography also became an increasingly important part of the information collection arsenal of the artillery unit. Field glasses, binoculars, and periscopes could augment the eye and shrink distance. Detected features had to be measured through the use of tools like clinometers (the angle of slopes) and theodolites (horizontal and vertical angles). The gathered data would be recorded in several forms, at times as numbers to be plugged into tables, drawn as maps, or sketched as landscapes. Training manuals included extensive sections that provided proper standard marks and scales to be used in the making of a map, instruction on how reconnaissance landscapes should be drawn, and even guidance on penmanship. What the officer saw had to be translated into a legible script or transmissible image, graphically conveyed by standardized lines, dots, dashes, and hatchings.[87] Unlike Moholy's postcard drawings, maps and field views were not meant to be expressive but instead to translate what was observed into visual data using uniform notations.[88]

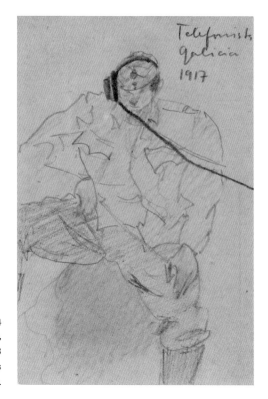

FIGURE 1.24
László Moholy-Nagy, *The Telephone Operator*, 1917,
postcard. Estate of László Moholy-Nagy. © 2018
Estate of László Moholy-Nagy / Artists Rights
Society (ARS), New York.

Reconnaissance was not, however, purely visual. It involved the whispered reports of spies and information coaxed from prisoners of war in the interrogation room. Some soldiers were trained to interpret the low thuds picked up with primitive assemblages composed of microphones wired outside trenches, the data used to estimate locations and distances of blasts. In addition, data had to be relayed across units, contributing to the advancement of telegraphy and telephony in those years. The work of reconnaissance did not end with the start of battle. Because modern artillery is predicated upon indirect fire, their aim and trajectory postulated mathematically but unobservable from artillery batteries, it was the task of reconnaissance to ensure the accuracy of fire in the field during battle. A mislaid trajectory wasted shells, and worse, might lead to casualties from friendly fire. Observation in battle allowed for any necessary recalibration of the gun's aim.

Moholy arrived in Galicia when his superiors in the Central Powers were convinced that the technological and material advantages they had secured would almost certainly assure victory over the Russian forces on the eastern front.[89] Press photographs showed high command visits to newly built, tidy observation posts. An album given to the archduchess of Austria included a photograph that showcased the technological sophistication of Hapsburg artillery reconnaissance in Galicia (fig. 1.25). The photograph features

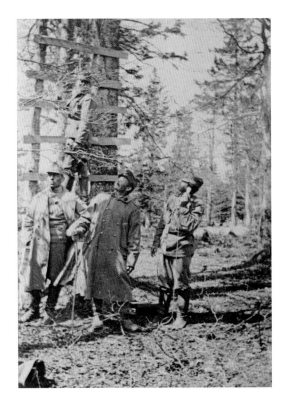

FIGURE 1.25
"Artillery observation posts with field
telephone" in Galicia. Photograph and
description from the commemorative album
War Memories, given to Marie Therese von
Braganza, ca. 1915. Photograph, 10 × 6.7 cm.
Austrian National Library, Vienna.

a soldier attentively observing from his post, as two officers look skyward; next to them is a field telephone operator on alert with a giant handset, ready to relay the gathered intelligence. Further casting Austro-Hungarian preparedness in a positive light was a report issued in March 1916 by Hapsburg high command emphasizing that the strength of their forward artillery would be enough to defeat the disorganized Russians.[90] Despite intelligence in the spring that all but announced Russian General Aleksei Andreyevich Brusilov's preparations for a major summer offensive, the generals who guided the Central Powers chose not to recognize the seriousness of the threat.[91]

By contrast, Brusilov laid the groundwork for his offensive over the course of several months, intensifying the pursuit of military intelligence to compensate for comparatively limited Russian access to munitions and supplies. He brought in technical experts to train mechanics to serve provisionally as aerial photographers. They correlated the images obtained with reports gathered from prisoners of war, spies, and defectors to create maps of Austro-Hungarian positions with an astonishing degree of accuracy.[92] With this intelligence, they choreographed an approach that economized their use of both shells and infantry along the front. By attacking key nodes in communication, command, and supply networks, the Russians transformed Hapsburg fortifications into unwieldy liabilities.[93]

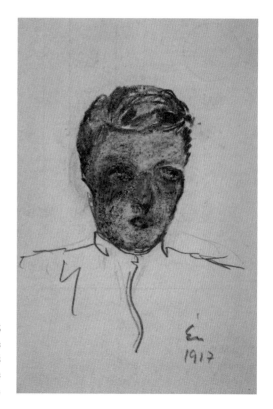

The consequences of Hapsburg blindness and overconfidence were profound. The Brusilov Offensive, which military historians continue to cite as an example of Austro-Hungarian strategic incompetence, forced the Germans to redirect forces west to the eastern front and contributed to a shifting tide in favor of the Triple Entente.[94] In those brief months, the Austro-Hungarian army suffered over 750,000 casualties on the eastern front as a result of the offensive, with another 380,000 captured. The Dual Monarchy never recovered from what came to be known as the "summer of catastrophe."[95]

In the aftermath of the offensive, Moholy sketched several self-portraits, titled *Én (Me)*, on postcards. In one, his gaunt face peeks over his collared uniform (fig. 1.26). His eyes are hidden behind shaded glasses. In another, he pictures himself wounded, bandaged, and eyes unseeing. Years later, he would recall the retreat, describing a "never ending march over soaked ground, mud to the knees, face beaten by wind and hail, half blind, every step more falling than advancing."[96] His happiest moment was the realization that he was saved, not by his commanders, not by fellow soldiers nor by technology, but rather with the arrival of his trusty steed. "I was left behind in the dark on the open field alone, without strength. Suddenly my horse appeared: I wept and kissed him overcome with joy."[97]

Moholy was trained to employ a number of technologies over the course of his work in reconnaissance, from telegraphy and telephony to the use of scopes and

loupes, which undoubtedly impacted his later work. But the more important lesson Moholy learned from the war was the dire consequences of refusing to see clearly what technologized vision laid bare—amply demonstrated in the unimaginable casualties the Austro-Hungarians suffered in battle. Military strategists and avant-gardists alike understood the urgency of training individuals to grasp and respond to the objective truth illuminated by technology.

Writing in 1911, Otto von Stülpnagel, later a German general in the Luftwaffe, remarked that the use of aerial reconnaissance to support artillery units, for instance, "is not nearly as self-evident as it is often characterized."[98] Beyond the physical demands of seeing from a perspective unmoored from the ground, being launched into motion above unfamiliar terrain and forced to contend with constantly changing light and meteorological conditions, the photographer had to learn to spot hidden positions as the pilot avoided ever more advanced antiaircraft fire from the ground. Furthermore, the photographs had to be confirmed and correlated with data and intelligence gathered on the ground for them to serve any tactical purpose. Aerial photography in the service of artillery reconnaissance, Stülpnagel argued, demanded nothing less than the "systematic reconfiguration [*Durchbildung*] of the eye."[99]

The eye was not the only thing reconfigured by the war. The First World War is notorious for the brutality of its newly invented killing machines and for the unprecedented loss of life and limb. However, it also proved the capacity of human beings to accommodate the new technological demands that modern warfare made on its soldiers and civilian workforce. Total war required industrial centers staffed with workers who had to keep pace with the machines they operated. The weapons produced were distributed to the front by rail, and their deployment relied upon intelligence secured and disseminated by new technologies of transmission by telephone and telegraph. These new technologies required soldiers with the physical stamina to carry them into battle as well as the technical expertise to make sense of their complex parts. Modern warfare required both modern workers and soldiers who would survive only if they could internalize new habits of seeing and being that allowed them to perform under a constant state of duress.

In war, human beings became little more than expendable resources necessary for the preservation and operation of the machinery of war. Individual soldiers were sent into the field quite literally as cannon fodder. Technology employed in total war demands human sacrifice, Walter Benjamin would write in the thirties in "The Work of Art in the Age of Its Technological Reproducibility." Instead of serving man as an enabling extension, technology in such a context becomes an annihilating god.[100]

Moholy was no military theorist, nor did he have any love for his experience on the battlefield. However, his own training and service convinced him of the capacity of human beings to see with technical instruments, to make sense of sounds transmitted and rendered audible by electronic amplification, to communicate by telephonic

transmission, and to relay messages through the pulsing abstracted ciphers of Morse code. In order to endure the battlefield, Moholy, like any other soldier, had to see, feel, and respond to the new pace and demands of a technologized world—dizzyingly fast, explosively bright, and completely disorienting. It was here, on the battlefield, where mechanical and structural objectivity—in the first instance, the objectivity that might automatically be achieved through the impassive perspective of the machine; in the second, the development of structures of expression that overcome the vicissitudes of subjective experience and description—are revealed both as urgent necessity and as real possibilities.[101]

However, far from simply advocating the embrace of technology without question, Moholy was deeply concerned with cultivating relationships between man and technology that would contribute to the development of the whole, biological human being. Such a claim might appear a bit naïve, but it resonates powerfully with concerns that were pervasive in the interwar period. Walter Benjamin, in particular, was a close reader of Moholy's and incorporated some of his most famous statements in his own theoretical reflections, especially those pertaining to what seeing with the camera-eye might unlock.[102] For Moholy, and Benjamin as well, one of the most crucial problems that mankind faces in the modern age is the relationship between the human being and technology. Put differently, how can man-made instruments become so wholly adopted that they become organs of new modes of dynamic perception? How can the individual, and specifically the artist, make use of technology in ways that would foster human needs rather than subjugating them to the dictates of the machine?[103]

"Production-Reproduction" is one of Moholy's earliest and most influential texts on this question, which he republished several times in slightly different forms during his lifetime.[104] Published first in *De Stijl* in 1922, it begins by defining the parameters of his inquiry: How might "human [*menschliche*] ways of expressing and shaping in art and related other areas of *Gestaltung* best be understood and furthered"? In answer to this query, Moholy proposes that the key is to understand more fully "the human being himself and the means at his disposal for his formative work [*gestaltenden Tätigkeit*]."[105] Throughout the text, Moholy adopts technical and scientific language in his discussion of the relationships among human beings, their technological instruments, and the media they create. Human beings are "most perfected if the functional apparatus [*Funktionsapparate*]—the cells as much as the most complicated organs—are consciously developed [*ausbilden*] to the limits of their ability to perform."[106] In the next paragraph, he explains that "Art brings about this development [*Ausbildung*]" and does so by bridging "the familiar and the as yet unknown optical, acoustical, and other phenomena and by forcing the functional apparatus to receive them." Human faculties of perception, what Moholy refers to as "functional apparatus," can "never be saturated; they crave ever new impressions following each new reception." For this reason, art must come to fulfill the "permanent necessity for new experiments. From this

perspective, creative activities are useful only if they produce new, so far unknown relations. In other words, in specific regard to *Gestaltung,* reproduction (reiteration of already existing relations) can be seen for the most part as mere virtuosity."[107]

Moholy argues that art is perfectly poised to serve as an "instrument for the refinement of perception" but that it "can only do so if it resists reproducing relationships."[108] For art to become truly productive for the transformation of human sense organs, or, in his language, functional apparatus, "we must attempt to transform the instruments (media) that have only, until this point, served the ends of reproduction."[109] What Moholy then offers is a strategy to redeploy existing instruments and media to ends that would generate unprecedented relationships. In so doing, they would stimulate, challenge, and further develop our senses.

At the core of his strategy are three questions:

To what end is this instrument [*Apparat*] (medium) employed?

What is the essence of its function?

Are we able and is there a value to augment the instrument [*Apparat*] so that it becomes serviceable to production?[110]

These questions make explicit the ends an instrument conventionally fulfills, and then recasts the aim in relation to a more distilled, essential account of the instrument's potential. To elucidate this approach in practice, Moholy offers three examples—the gramophone, photography, and film—to show how reproductive media can be made productive.

The gramophone is usually defined by its capacity to record sound. It translates acoustic waves into inscribed grooves that can be replayed with the aid of a player. The essential feature of the gramophone is not the fact that it records sounds, but that inscription is the mechanism for recording and the source for playback. In order to redirect the gramophone to achieve productive ends, Moholy argues that the human being must "inscribe graphic marks upon the wax recording disc himself without mechanical intervention."[111] When the scratched disc is played, it will "generate audio effects that bear no relationship to existing sounds or tonal relations."[112] These new sounds will be achieved "without the invention or introduction of new musical instruments or an orchestra."[113] "The basis of this work," he writes, "is one of an experimental-laboratory practice: The precise examination of the different sounds brought about by different types (in length, width, depth, and so on) of grooves; examination of man-made grooves; and finally mechanical-technical experiments to perfect a groove manu-script [*Ritzen-Handschrift*] (potentially through mechanical reduction of groove-script records)."[114]

For photography to overcome its conventional use as a medium of visual reproduction, it would have to be redefined in essence as a means to fix light effects on paper.

Instead of allowing photography to simply record existing luminous relationships, Moholy notes, "we will have to utilize the bromide plate's sensitivity to light," not to automatically capture readily visible scenes but, rather, to fix "light displays" that "we ourselves will have formed [*gestaltet*]."[115]

The most productive use of film would likewise go beyond its mimetic capture of movement by understanding it fundamentally as a medium that projects light in movement. The most radical break from its conventional usage as a reproductive device and projective means is to free it from recording a scene and instead direct the camera's focus on the "man-made play of forms" drawn out in animation sequences.

Moholy's strategy for transforming reproductive media into productive means is predicated in each instance on the intervention of the human agent, on the presence and activity of the human hand.[116] The gramophone becomes productive only when the disc bears the inscription of the hand, photography when it captures the light display manually arranged upon its photosensitive surface, and film when it projects animated sequences of forms sketched out by man. Far from subjecting human beings to the dictates of the machine, Moholy emphasizes the experimental interjection of human agency. He also codifies what otherwise might be the accidental discovery of new potential uses (the incidental scratch on a gramophone disc, for instance) into a method to transform existing media into instruments for advancing the development of the human sensorium.

As a soldier, Moholy learned to see with precision and exactitude, to translate his tactile experience of the world into reports, his physical presence in space abstracted into numerical coordinates to be relayed. His eyes switched between lenses and loupes, shifting quickly between viewing landscapes in the distance and studying their representation as minutely detailed topographies on a map. As a young artist, he sought to undermine the visual regime enforced by the military by first embracing the rhetoric of inner vision pervasive in Expressionist circles. He sought to free his hand from the martial primacy of anonymous, mechanical rigor and transparent legibility. What he arrived at after his engagement with Dada, however, was an embrace of the inescapability of the technological conditions of his time. But rather than giving over to the strictures of the machine, Moholy formulated a theory of media that begins with the assumption that technologies have no inherent value. Instruments are made by man for specific ends, but those ends are not permanent and can endlessly be redefined.

Seen in this light, *Constructions in Enamel* offer a fundamental reconsideration of several technologies, painting included. Painting is reimagined, no longer as a prized original, nor as a spiritual refuge for metaphysical longing, but instead as a rigorous field of experimentation that lays bare nonmimetic structural relationships. The gridded sheet used to plot the features of the panels relies on a coordinate system, not to map out positions to be attacked, but to organize planes of color upon a pictorial field. The sign factory itself comes into play not merely in the manufacture of advertising

but to prepare for the eventual mass production of pictures, which would permit the dissemination of painting as instrument for training visual acuity.[117] In the language of "Production-Reproduction," offering the viewer such pictures might "challenge the eye to perform at the limits of its ability."[118]

What Moholy demanded of art and modern design (*Gestaltung*) bears striking affinities to what von Stülpnagel hoped new military training would achieve. War requires, as von Stülpnagel wrote, the "systematic reconfiguration of the eye." Modern warfare must develop new techniques to challenge the senses in order for the soldier to perform under the technological conditions of the battlefield. The propagation of technologized seeing that Moholy advocated with his New Vision colleagues also seeks to advance the development of the senses. However, it does so not by forcing the individuals to accommodate themselves to the requirements of a particular instrument. Rather, in "Production-Reproduction" Moholy argues that the ends that any instrument serves must always be redefined by man. That redefinition can even involve damaging the instrument itself to reveal alternative uses. The productive use of the gramophone is predicated upon the hand scratching the disc, of photography upon breaking open the camera to allow for experimentation directly on the photosensitive plate. This emphasis on the productive destruction of instruments seeks to reassert the primacy of the human being. In this sense, we find that Moholy arrives at his version of Constructivism by way of Expressionism and Dada. Human activity, or here the disruptive intervention of the hand, unlocks new potential for that technology in the future.

At this early moment, Moholy articulates the contours of his art and thought to come, setting up a theory and practice committed to the further development (*Ausbildung*) of human senses. What Moholy means by *Ausbildung* will shift over time. In a theoretical text concerning art, *Ausbildung* cannot help but also evoke its usage in aesthetic discourse, and in particular to the project of the aesthetic education of man. But embedded within his technical and scientific language in the essay, the word is linked with its usage in biology to suggest the development of organs in response to stimuli. The two models stand in tension with each other in Moholy's thought; the first is predicated upon the survival and cultivation of the expressive humanist subject, the second upon its elimination in favor of a picture of human being as improvable biological entity. Both become manifest in the way Moholy will come to understand the relationship between pairs of recurring terms—man and machine, art and instrumentality, as well as painting and photography. Each pair stands at various times as endpoints of a progressive trajectory, as antinomies, or even as analogies.

2

PAINTING PRODUCTIVITY

——————

WE RETURN ONCE MORE to Moholy's *Constructions in Enamel* at the Sturm Gallery in 1924 (fig. 1.13). Hung unframed and clustered together as a group with the bottom edge anchored along an invisible horizontal axis, the three porcelain enamel-on-steel pictures are arranged ascending in size from left to right. Presented above a platform with the left corner directly below the smallest picture, the ensemble invites the viewer to step up to examine the works at close range. The left alignment announces the smallest picture as the starting point, the two subsequent panels as necessary stations toward which to travel. In other words, the installation encourages the viewer to move as if to reenact the path these three pictures took along an imagined conveyor belt on their way to serial production. The enamel panels assert themselves powerfully as a model for future artistic production no longer preoccupied with originals but with the manufacture and distribution of durable reproductions.

The previous chapter argued that *Constructions in Enamel* demonstrate Moholy's willingness to disrupt the traditional

expectations of painting—from what constitutes its appropriate materials to its very purpose—in order to make the medium productive, capable of generating new effects and postulating unexpected potential future uses that could challenge our perceptual faculties in the modern age. The task of this chapter is to show how these same works were exhibited to demonstrate their productive potential in explicitly economic terms as well.

Moholy's exhibition of *Constructions in Enamel* at the Sturm Gallery was his first after his appointment to the Bauhaus in Weimar. It came at a crucial moment of transition at the school, marking its move away from an early emphasis on craft and on the work of the hand in order to embrace modern technology and industrial production. As a part of this initiative, Walter Gropius appointed Moholy in 1923 due to his Constructivist credentials. The Sturm exhibition was important not only for Moholy's artistic reputation but for the Bauhaus's as well; it offered the public a glimpse of the new direction the Bauhaus was to take. In the exhibition pamphlet, *Constructions in Enamel* are attributed to a particular manufacturer: "The enamel pictures were manufactured by machine at the enamel sign factory, Stark and Reise in Weimar (Tanerode, Thuringen)."[1] Moholy includes these details to indicate his willingness to work closely with private industries in the state that funded the school.

The show was sensational, and *Constructions in Enamel* provoked controversy pertaining to the potential significance and value of machine-manufactured paintings. Adolf Behne, writing for *Die Weltbühne,* praised the revolutionary promise of Moholy's project.[2] He begins his remarks by quoting the Dadaist Alexander Partens, who wrote, "One recognizes the good painter in that he orders his pictures from a carpenter by phone."[3] Behne continues,

> with his color-compositions executed on enamel currently at the Sturm, [Moholy] shows the first practical steps to lead us down this path. Grounded by the Ostwaldian color system and a simple coordinate system, every desired composition could actually be created by phone in the factory, and with the help of stencils and other tools, the composition could be produced as often as one would like in the most enduring technique. There is no more original; the painting sinks to a tenth, a hundredth of its price; painting becomes communal property.[4]

Behne begins with a Dadaist premise but concludes with a Constructivist dream. *Constructions in Enamel* integrate scientifically advanced thinking on color with rigorous, rational design and modern production methods. The Ostwaldian color system to which Behne refers, after all, was developed in 1916 by a Nobel Prize–winning chemist.[5] The use of a coordinate system permits the translation of structures into transmissible data, allowing for mass production and distribution. Instead of the much vaunted original, painting becomes commonplace and its monetary value plummets.

In this way, painting in particular but art more generally, will one day permeate everyday life, becoming, in Behne's words, "communal property."

Weeks later, the editors at *Das Kunstblatt* expressed a dissenting, even sarcastic view:

> At the Sturm, Moholy-Nagy showed commercially produced Constructivism. With his inventive mind, spurred by the engineering spirit of our time, he made the discovery that the future of painting rests on tin [*Blech*]. Enamel, which until now was used to enliven rotundas and to blight scenic landscapes, will lend painting a new gleam . . . Since then, another revolutionary discovery was said to have been made in Weimar: that one can compose poetry on the typewriter. This, finally, will lead to the elimination of Goethe and Homer's verse, the product of little more than quilled script.[6]

Playing on the double meaning of *Blech,* referring both to the metal support upon which the pictures were made and to its colloquial meaning, *rubbish,* the text reveals the editors' view of Moholy's eager embrace of the machine—and his dismissal of old masters as nothing more than the "work of the hand" (*Handarbeit*). Far from seeing the revolutionary promise of a future in which paintings would be manufactured for the masses, *Das Kunstblatt* contends that the new ethos brewing in Weimar is a sham.

Behne's celebration and *Das Kunstblatt*'s dismissal of *Constructions in Enamel* hinge upon the works' success or failure as machine-manufactured art. Do they anticipate future practices or represent little more than a passing fad? *Das Kunstblatt* derides Moholy for producing "commercially produced Constructivism," meant to signal the crass exploitation of an avant-garde style for quick profit. But Walter Gropius appointed Moholy to the Bauhaus in Weimar in order to inject the school with Constructivist ideas and, as this chapter will show, to help reform the workshop system to allow it to operate in closer contact with modern industries. Moholy's preparations for the Sturm show took place when the Bauhaus in Weimar came under threat from internal and external forces. Facing dwindling public funding, the school actually engaged in several high-profile projects that attempted to demonstrate the feasibility of "commercially produced Constructivism."

Moholy's paintings at the Sturm, executed even on the most traditional materials, were meant to appear so unified as to suggest their production all at once, as if stamped out at a factory by a future picture-making machine. In this same period, some of the most iconic Bauhaus objects were designed and produced by the metal workshop led by Moholy. Wilhelm Wagenfeld's lamp and Marianne Brandt's teapot, for example, were first shown and published in 1924—both are available for purchase to this day and embody the elegant economy of form associated with Bauhaus modern.[7] Moholy's art and his students' work from these years sought to convey the idea that objects of use (including paintings) might be distilled to their most essential features, their

forms reduced to what could most efficiently be produced serially and inexpensively by machine. The resulting objects would then circulate and come into daily contact with the masses to become, as Behne predicted, "communal property." Production at scale would also theoretically generate sustainable profits, allowing the Bauhaus to continue what Gropius characterized as "design research" within the "laboratory workshop."[8] Industrial partnerships, Moholy and Gropius hoped, would ensure both the financial future of the school and the utopian promise of social transformation even within a capitalist system. That transformation was predicated upon their ability to enable the accessible consumption of the products they designed.

The important work of Anna Rowland, Frederic J. Schwartz, and Robin Schuldenfrei has shown that the rhetoric the school espoused was often grossly contradicted by what it produced.[9] Despite the emphasis it placed on the development of industry-ready egalitarian design, the Bauhaus quickly gained an enduring reputation for producing luxurious bespoke modernism, a place where the educated elite, or *Bildungsbürgertum,* could find industrial-looking tea services for their flat-roofed homes. Over the course of the twenties, Moholy would attempt to respond to these contradictions. The transformations that his work underwent in that decade cannot be considered independently from the Bauhaus, or, as I will argue, from the enormous economic pressures the school faced throughout its existence. These pressures left a mark on Moholy's art, his teaching, and his writing.

The Bauhaus was established in 1919 in Weimar through the combination of two distinct teaching institutions in that city, the School of Arts and Crafts (*Kunstgewerbeschule*) and the Academy of Art (*Hochschule für Bildende Kunst*). Against the division of applied and fine arts, Gropius proposed a school that would train craftsmen engaged in the collective activity of building, their hands ready to create objects that would have a place within the larger community. Out of the ruins of war, craft (*Handwerk*) promised to heal the body and soul of a fractured nation. Yet for all the utopian rhetoric, the project was deeply pragmatic. Gropius and state backers of the Bauhaus imagined an institution that would provide practical training to its students and, in the process, produce marketable goods that would sustain the school. The idea was not unprecedented. The direct precursor to the Bauhaus, the School of Applied Arts and Crafts under Henry van de Velde, was financially independent from the state between 1913 and 1915.[10] Furthermore, Bauhaus productivity would, in theory, not only sustain the school but would allow it to pay its students for their contributions, introducing a form of work-study that was unusual for its time.[11]

This ambition to become fiscally self-sustaining was difficult to achieve in the best of circumstances, but conditions immediately after the war proved particularly challenging. There were rampant material shortages; basic supplies, including canvas, were difficult to secure. In addition, the first class of entering students was woefully ill prepared for the handiwork required for workshop production, resulting in wasted

materials due to amateur incompetence that could not be sustained. For this reason, Johannes Itten proposed the creation of a required preliminary course intended to provide students with a perceptual and technical foundation prior to their participation in any of the school's workshops.[12]

Where academic art training was fundamentally emulative and oriented toward vision, Itten's preliminary course sought to develop the spiritual, sensory, and technical abilities of the individual student as a whole. His strategies were at times unorthodox. As a disciple of Mazdaznan, a Zoroastrian spiritual movement that began in the United States, he led his students in yogic breathing and introduced vegetarianism to the Bauhaus community.[13] He devised tactile studies of materials, encouraging students to translate their haptic qualities into line and the rhythm of shapes into color. Such exercises were meant to reactivate the childlike impulse to engage in open-ended, experimental, and playful activity, which would yield new discoveries into the possibilities of materials and their forms. This exploratory, playful approach, rooted in the reform movement in early childhood education, became an enduring part of Bauhaus teaching. Perhaps not surprisingly, toys became one of the most important sources of revenue for the Bauhaus, especially early in its history. Given the material shortages and limited technical skills of its initial student body, toys were among the few objects the workshops could produce for immediate sale that also served a pedagogical purpose. However, the school's detractors would seize upon this fact as evidence of the frivolity of the Bauhaus as an enterprise.[14]

The charge of frivolity came from several quarters. Within the school, there were students who grew critical of the Expressionist orientation and mysticism that accompanied Itten and his followers. Theo van Doesburg, editor of *De Stijl* and a vocal, influential advocate of International Constructivism, arrived in Weimar in 1921 hoping to secure a position at the school. When no position was forthcoming, he started his own seminar, which drew several disaffected students from the Bauhaus.[15] In 1922, *De Stijl* published a withering condemnation of the Bauhaus by Vilmos Huszár, a Hungarian artist and founding member of the journal. Huszár criticizes the Bauhaus faculty, consisting exclusively of Expressionist painters, for its aesthetic backwardness, its "arbitrariness," and its "crass individualism."[16] Such a faculty could never foster "collective discipline."[17] He goes on to argue that continued support of the school cannot be justified in a state "so economically and politically divided," and that the "unproductivity of the Bauhaus" should be seen as a "crime against the state and civilization."[18] The only path forward, in Huszár's view, is to eliminate the "artistic master" and instead establish the workshops upon "rational foundations."[19] Huszár's essay was used a few months later, in the spring of 1923, by the right-wing opposition party of the parliament of Thuringia in a bid to cut state funding for the Bauhaus. Critics saw the school as a financial drain at a time of rampant inflation and political turmoil—and argued that the dilettantism of its students and teachers failed to contribute to the economy of the state that supported them.[20]

As pressures mounted, Gropius pushed to align the Bauhaus and its activities explicitly with the demands and interests of modern industry in a dual bid to rally continued public support for the school and to attract private investment. This shift was hardly embraced unanimously by the existing faculty, leading to the resignation of a few of its members, including Itten. Gropius took these departures as opportunities, and was determined to hire strategically. In one meeting, he suggested that instead of filling the open positions immediately with painters, they should appoint mathematicians, chemists, and physicists in order to begin exposing students to these disciplines in future semesters.[21] The remaining faculty did not object to the idea out of hand—the need to integrate technical and scientific ideas and approaches found tentative support within the school. In 1922, Gropius had seen Moholy's chromed sculptures at the Sturm as well as his essay "Production-Reproduction" in *De Stijl*. That fall, Moholy had also participated in the Congress of Dadaists and Constructivists that took place in Weimar, organized by Theo van Doesburg. Moholy's growing prominence as a Constructivist led Gropius to propose him as a candidate to replace Itten. The faculty cautiously assented to his candidacy.[22] Thus, in the spring of 1923, Moholy became head of the preliminary course and form master of the metal workshop, roles that had an outsized impact on the character of the Bauhaus. His hiring served as a direct retort to Huszár's critique, as a response to student demand, and, most importantly, as a demonstration of the Bauhaus's willingness to engage modern industry.

Moholy would not teach the preliminary course until the fall of 1923, but he assumed leadership of the metal workshop in April, contributing significantly to projects meant to manifest the school's transformation from craft-centered guild to experimental laboratory for industrial design. Prior to his appointment, the metal workshop had been focused on work in precious metals, but upon his arrival, Moholy introduced industrial materials such as chrome, nickel, and iron, and encouraged students to develop lighting fixtures.[23] One of his first students, Wolfgang Rössger, recalled, "The aim of our work was not to fool around with individual forms but the development of practical, beautiful forms for objects of use appropriate for further industrial manufacture."[24] Immediately, they began preparing for two major events meant to advertise the school's redirection: the Haus am Horn, the model home designed by Georg Muche and Adolf Meyer—to be furnished by the goods produced by Bauhaus workshops—and the Bauhaus exhibition, which would take place later that summer in conjunction with the Werkbund Congress. The Werkbund was a state-funded institution founded in 1907 and dedicated to developing innovative industrial design through collaboration with modern artists and architects. It was responsible, in no small part, for the establishment of the Bauhaus, and the school's success was very much a concern for the Werkbund itself.[25]

Haus am Horn opened to the public in the summer of 1923. Also referred to as the "experimental house" (*Versuchshaus*), the single-family home highlighted innovations in architectural and interior design (fig. 2.1). The floor plan itself postulated new ways of living, with the kitchen, for example, situated next to the nursery to allow

Georg Muche and Adolf Meyer, Haus am Horn, 1923, exterior, published in *Neue Arbeiten der Bauhauswerkstätten* (Munich: Albert Langen Verlag, 1925), 112.

a mother to attend to a child while cooking (fig. 2.2). It assumed a household without domestic help. Its boxy exterior suggested the possibility of prefabricated modular production, introducing the efficiencies of the factory to the building site.[26] Triolin, a newly developed material, was used throughout the house and touted as a cheap, colorful, and easy-to-clean linoleum substitute.[27] Fixtures of metal and glass, produced by the metal workshop under Moholy's guidance, lit the interior. They were meant to look as uniform as possible so that they could be used interchangeably in any room.

A few months after the opening of Haus am Horn was the Bauhaus exhibition, accompanied by a lavishly illustrated catalog on the history and mission of the school as well as the products of its workshops.[28] Moholy designed the catalog: his layout sought to bolster the strategic claims in Gropius's introduction. The text attempts to preserve aspects of the school's original mission while announcing its new direction, framing the Bauhaus project as a critical and practical response to the fragmentation of modern life. Gropius echoes the school's original manifesto: to unify all artistic activities by engaging in the activity of collective building. He attacks the separation of art and life encapsulated in the ideology of l'art pour l'art propagated by academies of the past: "Their orientation toward genius, rather than on the average talent," breeds false hopes and produces graduates ill prepared to face the "reality of materials, technology, economy" and thus incapable of bringing their academic training into a "real relationship to life in its totality."[29] Just as problematic, Gropius observes, schools of applied arts, with their emphasis on traditional handcrafts, inadequately prepare students to participate in modern industry, while an exclusive focus on work with machines transforms work into a "task appropriate only for dead machines."[30] He continues, "So long as the modern economy treats machines as the ultimate end rather than the means through which intellect becomes increasingly freed from the burden of mechanical labor, the individual remains enslaved and society will remain disordered."[31]

FIGURE 2.2

Haus am Horn, 1923, interior view from nursery to dining room to kitchen, published in *Neue Arbeiten der Bauhauswerkstätten* (Munich: Albert Langen Verlag, 1925), 113.

To solve these intractable problems, the Bauhaus created an entirely new institutional framework and pedagogical model. Of crucial significance is the organization of the school around "productive workshops," which, Gropius writes, offer "thorough practical training" linked to the "exact teaching of design elements with the laws of construction."[32] He continues, "The Bauhaus does not seek to be a school for craftsmen" but instead operates in "conscious relation to industry."[33] "Craft [*Handwerk*] of the future," Gropius declares, will serve as the "experimental field for industrial production; its speculative, experimental work will become the standards [*Normen*] for practical execution, production in industry."[34] He predicts that the apprentices and journeymen trained accordingly will be prepared for work in the modern economy because the projects they pursue will impart "heightened technical knowledge" while also forcing them to confront the "hard, inevitable challenges of expending time and means efficiently."[35]

Moholy's design took care to give credence to Gropius's words. The catalog presents the fruits of the workshops' labor in ways that suggest active work as well as tangible, usable objects formed with future manufacture in mind. Moholy applies a consistent template for the texts and images with photographs of each workshop shot to suggest structured spaces of productive activity. The photograph of the carpentry workshop, for instance, features wood shavings and scraps on the floor, left as evidence of concerted effort (fig. 2.3).[36] The photographs of the weaving and printmaking workshops foreground the machinery crucial to their practices (figs. 2.4, 2.5).[37] The

FIGURE 2.3

Carpentry workshop at the Bauhaus, published in *Staatliches Bauhaus in Weimar, 1919–1923* (Munich: Albert angen Verlag, 1923), 73. David K.E. Bruce Fund National Gallery of Art Library, Washington, D.C.

FIGURE 2.4

Weaving workshop, published in *Staatliches Bauhaus in Weimar, 1919–1923* (Munich: Albert Langen Verlag, 1923), 128. David K.E. Bruce Fund National Gallery of Art Library, Washington, D.C.

FIGURE 2.5

Printmaking workshop, published in *Staatliches Bauhaus in Weimar, 1919–1923* (Munich: Albert Langen Verlag, 1923), 139. David K.E. Bruce Fund National Gallery of Art Library, Washington, D.C.

FIGURE 2.6

Ceramics workshop, published in *Staatliches Bauhaus in Weimar, 1919–1923* (Munich: Albert Langen Verlag, 1923), 117. David K.E. Bruce Fund National Gallery of Art Library, Washington, D.C.

FIGURE 2.7

Wall painting workshop, published in *Staatliches Bauhaus in Weimar, 1919–1923* (Munich: Albert Langen Verlag, 1923), 96. David K.E. Bruce Fund National Gallery of Art Library, Washington, D.C.

ceramics workshop is filled with rows of stacked drying parts in the background with finished vessels in the foreground, suggesting the potential of this workshop for serial production (fig. 2.6).[38] Even the most traditional workshops—wall painting and wood sculpture—are shot in ways that highlight the modernity of their means and forms. The wall painting workshop is represented not by completed murals, but by the storage room, filled with the tools of the trade—pails and barrels of pigment and medium, systematically arranged (fig. 2.7).[39] The wood sculpture workshop is depicted with heavy workbenches, implements, and materials along with a recent student project, a sturdy chest with abstract designs, placed unobtrusively in the foreground (fig. 2.8).[40] The photographs of the stone sculpture and metal workshops highlight a curated selection of finished pieces, each included to suggest the emergence of a cohesive modern aesthetic as a group (figs. 2.9, 2.10).[41] Fine arts, or what the catalog described as "free art" by students and faculty, would be relegated to the final section of the book.[42]

FIGURE 2.8

Wood sculpture workshop, published in *Staatliches Bauhaus in Weimar, 1919–1923* (Munich: Albert Langen Verlag, 1923), 84. David K.E. Bruce Fund National Gallery of Art Library, Washington, D.C.

FIGURE 2.9

Stone sculpture workshop, published in *Staatliches Bauhaus in Weimar, 1919–1923* (Munich: Albert Langen Verlag, 1923), 91. David K.E. Bruce Fund National Gallery of Art Library, Washington, D.C.

FIGURE 2.10

Metal workshop, published in *Staatliches Bauhaus in Weimar, 1919–1923* (Munich: Albert Langen Verlag, 1923), 107. David K. E. Bruce Fund National Gallery of Art Library, Washington, D. C.

In a speech kicking off Bauhaus Week, an annual festival spotlighting the school and its achievements, Gropius announced its new direction with the slogan "Art and Technology: A New Unity" emblazoned around the school and even at the Weimar train station.[43] In many respects, these coordinated activities and exhibitions together with the catalog achieved the school's aim of identifying potential partners and garnering new support from the community for continued state funding. Bauhaus events that year attracted over fifteen thousand visitors and elicited a great deal of media attention. The proposed measure to strip the school of funding was defeated in the state parliament, and government funding for the school was extended for another year.[44] Several retail outlets sought to carry Bauhaus products, and the exhibition itself generated a number of direct sales.

These developments, however, coincided with the highpoint of hyperinflation in Germany. In a telling coincidence, Herbert Bayer was tasked with the design of not only the Bauhaus catalog cover in 1923, but also the state of Thuringia's new 100 million–emergency currency.[45] Inflationary conditions led to steep losses from the exhibition—10,000 marks in real terms were generated from the sale of goods, but 20,000 had initially been invested in their production.[46] In light of these numbers, Gropius underscored in a faculty meeting in October 1923 that workshops and even the preliminary course had to create income streams through their activities. Costs, he emphasized, had to be contained, and remnant materials should be reused. He also solicited ideas from the faculty about what the school might produce for sale. Amid these constraints, several, including Moholy, suggested the production of dolls and toys; but Gropius, who feared the return of earlier Bauhaus controversies, warned the faculty not "to allow the production of things that are too frivolous [*spielerisch*]."[47]

The problem of the school's solvency had serious consequences for its mission, including the fate of the wall painting as well as wood and stone sculpture workshops, because none were particularly profitable. In the same meeting, Gropius initiated a discussion concerning the value of sustaining these units. In their defense, Wassily Kandinsky argued for their necessity in teaching and in encouraging the development of form. Gropius, by contrast, retorted, "The Bauhaus is not just a school, but rather, a productive apparatus."[48] Moholy's contribution to this debate was to demand that every workshop respond to a single question: whether their activities had any "contemporary relevance." His own answer would be a resounding no. More scandalously, he suggested that workshops focused on the work of the hand might well be preoccupied with "matters on their way to extinction."[49]

The statement confirmed Moholy's reputation as an artist hostile to traditional media, but it also came at a moment of extreme uncertainty—survival and extinction were very much at stake. The meeting and its discussions occurred just days after the federal government deployed the military (*Reichswehr*) to avert what appeared to them to be a communist insurgency about to take hold in the states of Thuringia and Saxony. In November, just a month later, Gropius's private residence would be raided by the

Reichswehr in an effort to uncover communist sympathizers and activists within the school. And in February 1924, the leftist coalition government that controlled the parliament in Thuringia would lose the election to right-wing parties, bringing into power groups openly hostile to the school. Given the inability and growing unwillingness of the state to invest in the school, the Bauhaus had to seek new allies and, more importantly, new capital that only could come from private quarters.[50] In December 1923, Gropius went as far as to propose the establishment of a limited liability corporation, Bauhaus GmbH, to the president of the state bank of Thuringia. To attract the attention of new investors as well as potential manufacturing and retail partners, the Bauhaus participated in several trade fairs, including the Leipzig Fairs, beginning in 1924.[51]

In this context, Moholy's provocative remark regarding the irrelevance of the wall painting and sculpture workshops appears more pragmatic. After all, what could the traditional domains of painting and sculpture, even in their most public forms as murals or reliefs, contribute in the way of navigating the volatile terrain the Bauhaus confronted? But this crisis of painting and sculpture also represents the logical conclusion to Gropius's proposed new direction for the school. From its beginning, the Bauhaus sought to undermine the categories of fine art and transform the artist from solitary genius into a member of a working collective of craftsmen. With the slogan of 1923, "Art and Technology: A New Unity," as well as the new emphasis on economic productivity, art's raison d'être at the school in teaching and practice became linked to its perceived ability or inability to advance technology and enhance the school's profitability.

The fate of the sculpture and wall painting workshops became so fraught that Gropius solicited written justifications from faculty for their continued operation, due in spring 1924.[52] The responses from the workshop masters are telling in their adoption or rejection of the language that speaks directly to these new realities. Kandinsky, as form master of the wall painting workshop, argued for the development of a "systematic program" to research the power of color, its "chemical-physical" and "psychological properties." Such efforts would lead to both technical and speculative experimental projects. These activities remained essential, even if they did not lead to direct applications and obvious profit.[53] Josef Hartwig, technical master of both the stone and wood sculpture workshops, defended sculpture not as a medium but as a means to understand the qualities of materials, including modern vulcanized rubber, aluminum, and concrete. He reminded the faculty that the workshops cost the school very little—and far from being superfluous, could become immediately productive if brought into collaborative projects with other units.[54] Oskar Schlemmer, form master of wood and stone sculpture, was far less accommodating. Instead of attempting to justify the sculpture workshop, he condemned the folly of the Bauhaus attempting to serve the empty concept of "progress, which is fundamentally capricious in its essence."[55]

On principle, Schlemmer had never been hostile to the reorientation of the school toward industry. As interim form master of the metal workshop prior to Moholy's appointment, he was critical of its initial emphasis on gold and silversmithing. A diary

entry from 1922 reveals his opposition to "luxury" and "the purposeless."[56] The argument that the Bauhaus should apply itself to the development of useful objects for manufacture was wholly in line with Schlemmer's own privately expressed sensibilities. However, the seeming readiness of some to dispense with the stone and wood sculpture workshops in a time of crisis in the name of unifying art with technology, modernizing production, and maximizing profitability led him to question how much more the Bauhaus could contort itself to conform to the dubious demands of "progress" before the enterprise lost all meaning.

Moholy made his remarks against the wall painting and sculpture workshops at the same time he was preparing an exhibition of his paintings and sculptures for the Sturm Gallery in February 1924. With such internal debates on the continued relevance of these media fresh in his mind, the show should be understood as his attempt to demonstrate the continued pertinence of his own practice in these domains amid these new, challenging conditions. To wit, the presentation of *Constructions in Enamel* does not simply affirm his openness to adopting industrial materials and techniques, but also indicates a new use for painting, specifically as a potential product that might one day be manufactured by industry.

He theorizes the purpose of such a venture in *Painting, Photography, Film*, a manuscript he was completing as a part of a new Bauhaus Book series, initially slated for publication in 1924.[57] In a section entitled "Domestic Pinacoteca," he argues that industrial production techniques should be applied to the reproduction of art in order to render it as affordable, accessible, and transformative as books became in the wake of the printing press. Such reproductions should not be treated merely as room decor, but instead would be collected, stored, and brought out for study. Paintings manufactured with industrial materials suggest new ways of looking by exposing the viewer to expertly arranged color combinations and formal structures. In a footnote, Moholy recounts with boundless enthusiasm the names of new artificial materials introduced by the electrotechnics industry as possible future supports for repositories of manufactured pictures. "Turbonit, Triolin, Torlit, etc. etc.," he insists, "are much more appropriate than canvas or wood panel for the production of exactly executed pictures. I have no doubt that these, or similar new materials, will soon dominate easel painting, and we should also expect new, surprising effects produced through its use."[58]

Moholy does not elaborate on what exactly Turbonit, Triolin, and Torlit are. There is little trace of Torlit in the scientific literature, but Turbonit was one of the first truly synthetic materials ever developed, derived from the seemingly alchemical transformation of petroleum.[59] Triolin, newly introduced to the market in the early twenties, was a mix of nitrocellulose and various fillers used in the manufacture of furniture and floor coverings, and, as we have already seen, used explicitly in Haus am Horn.[60] Moholy's mention of these materials by trade names casts him in the role of expert, familiar with the latest developments in the most modern world of electrotechnics.

"Domestic Pinacoteca" imagines a new function for painting and with it a market opening waiting to be filled. But what Moholy proposed was based more on speculation than on actual experience. There is no evidence that he painted on these plastic materials in those early years, nor did he order any works other than the *Constructions on Enamel* for manufacture. Even as he announced that factory-produced art on metal or plastics would overtake traditional supports such as canvas and wood panel, he continued to work with traditional supports to explore the potential effects that might be wrought on those futuristic-sounding industrial materials.

The works on view at his 1924 Sturm exhibition were executed on either white or dark supports, which is hardly an incidental detail (figs. 1.13, 1.14). The works on white ground relate explicitly to the *Constructions in Enamel* on view. Those on dark ground develop designs Moholy imagined might be executed on the industrial plastics he named in *Painting, Photography, Film*, which were almost always opaque and most often black because of the fillers used to ensure durability and flame resistance. Between 1923 and 1924, Moholy made a number of works against dark grounds in which he effaced the trace of his hand, at times varnishing his paintings to mimic the qualities of polished plastic. In these years, his abstract work across media is also striking in its sheer repetitiveness. For instance, a red circle pinned beneath a levitating cross recurs in several works and in numerous different media: for example, as paint on a black wood panel and as a collage arranged against the velvety surface of a sheet of carbon paper (plates 3, 4). The repetition at play across these works does not represent the traditional process of translating sketch into painting, painting into print, and so on; instead, each iteration offers proof of how disciplined his hand had become, no longer subjective and expressive but capable of drafting designs calibrated to meet the precision of industrial production. The exhibition at the Sturm and the arguments advanced in *Painting, Photography, Film* pertaining to the redefinition of traditional media and their uses were Moholy's alone. However, his inclusion of the reference to Weimar in his exhibition pamphlet and the fact that the book was part of the Bauhaus Book series explicitly link these projects to the redirection of the school.

Painting, Photography, Film was one of four Bauhaus Books ready for publication in 1924; the others include *An Experimental House by the Bauhaus in Weimar: Haus am Horn; Theater of the Bauhaus;* and *New Works of the Bauhaus Workshops.* The series itself, according to its prospectus, was to introduce the school's program and the work of its important artists and thinkers. As Adrian Sudhalter has pointed out, it was decidedly not an art book series, but instead was meant to introduce the "research" and "findings" of "informed experts."[61] One volume, however, was also clearly intended as promotional material for potential products.

Designed by Moholy, *New Works of the Bauhaus Workshops* showcased and justified the activities conducted at the school as those in pursuit of design ready for "industrial production."[62] In Gropius's introduction, Bauhaus design work is described as "essen-

tial research" (*Wesensforschung*): "through constant contact with the most advanced technology, with the invention of new materials and new constructions, the creative individual can learn to bring the design of objects into a living relationship with tradition, and from that point develop a new attitude toward design." This new attitude is characterized by the embrace of a "living environment of machines and vehicles"; the refusal to fall prey to "romantic embellishment and wasteful frivolity"; the use of "primary forms and colors, readily accessible to everyone"; and the "economical utilization of space, material, time, and money."[63] The traditional emphasis on craft and the work of the hand at the Bauhaus would continue, but with new purpose. At the Bauhaus, the hand trained in craft would conduct "speculative experiments in laboratory workshops." In the end such pursuit "will yield models and standard types [*Normen*] for productive implementation in factories."[64] The book demonstrates the results of these efforts.

Upon its publication in 1925, the book's immediate purpose is revealed on the title page in all caps and boldface: "The distribution of the copyrighted products [*Erzeugnisse*] illustrated in this book can be arranged through Bauhaus GmbH, Dessau."[65] However much the book offered a philosophy of design, it was also meant as a prospectus for potential investors, manufacturers, and distributors alike. Moholy presents examples from each workshop—including some that had appeared previously at the Bauhaus exhibition, in its catalog, and at Haus am Horn—and frames these works so as to demonstrate their apparent readiness for industrial manufacture. Marcel Breuer's chairs from 1922 are lined up precisely to demonstrate the perfect regularity of their construction, as if already to suggest a factory origin (fig. 2.11).[66] Alma Buscher's cabinets for toy storage are photographed twice, first alone to show the clean, modular lines, and again with children at play, establishing the practical versatility of these simple forms (fig. 2.12).[67] Theodor Bogler's plaster molds for modular teapots from the ceramics workshop are staged to emphasize how the same component parts might be reconfigured to create a varied line of final products (fig. 2.13).[68] Two table lamps, by Wilhelm Wagenfeld and Carl Jucker, are paired on facing pages, the juxtaposition suggesting the use of what appear to be exchangeable, ready-made parts (fig. 2.14).[69]

These lamps have since become the most iconic objects in this book, but already when first shown in 1924 at the Leipzig Fair they attracted immediate international interest.[70] They appear straightforward. A glass or metal disc serves as the base of the lamp, and the electrical wiring runs inside a metal rod, encased within a glass tube. The base for the light bulb and shade is composed of another disc, this time fashioned out of highly polished metal. The domed milk-glass shade caps off the lamp, borrowing its material and form from industrial light fixtures. A thin metal ball chain terminating with a simple finial serves as the switch, no different than those used to light a bare bulb in the most basic cupboard. In his designer's statement, Wagenfeld remarked that his table lamp offered "a model for machine mass-production—[which] achieved in its form both maximum simplicity and, in terms of time and materials, greatest economy."[71]

FIGURE 2.11

Chairs designed by Marcel Breuer, published in *Neue Arbeiten der Bauhauswerkstätten* (Munich: Albert Langen Verlag, 1925), 28.

Wagenfeld's statement and the lamps' form echo Gropius's philosophy of the school—and adopt an aesthetic readily visible in Moholy's art as well. The lamp became and remains emblematic of the Bauhaus after its Constructivist turn. Constructivism originated in young Soviet Russia, in response to the dire material situation of war communism, when privation was the norm. Artists in that context still received support from the state and felt compelled to justify their activities as research. Not only did Constructivist forms seek to economize resources, they also were meant to lay bare the truth of their materials and offer transparency in process and production. Put differently, the forms developed in the Constructivist laboratory had pedagogical and political functions—they were meant to train responsive, modern, socialist subjects.

Constructivist ideas found a ready audience in the avant-garde in the West, and they underpinned the art and texts that circulated in the pages of the journals *De Stijl, Ma, G,* and *Vesch.* The imagined relationships that inhere among the artist, the work of art, and their role in creating new social or political conditions differed significantly, but economization remained one of the key watchwords retained by Constructivism's international variant. What these artists sought to develop was an economy of form that would translate into efficient and low-cost expenditure of labor and materials.

FIGURE 2.12

Cabinets for toys designed by Alma Buscher, published in *Neue Arbeiten der Bauhauswerkstätten* (Munich: Albert Langen Verlag, 1925), 36–37.

The emphasis on economic efficiency translated well in the capitalist West in crisis, and in Germany in particular, where economization of resources was urgently needed in the midst of hyperinflation.[72]

Economic considerations were crucial for the Bauhaus, which was strapped for both capital and human resources. Wagenfeld and Jucker's lamps seem to expose every aspect of their construction and operation. Shorn of excess and ornament, their shared austerity appears to stem from their pragmatic design for use and production, swayed neither by convention nor fashion. The parts all look ready-made, prepared for assembly along a conveyer belt in an immaculate factory.

More than any other work in the Bauhaus catalog, Wagenfeld and Jucker lamps, as material objects and in print presentation, exemplify Gropius's contention that the school trained students to create speculative designs ready to serve as industry standards. However, the lamps also readily demonstrate how Bauhaus objects fell short of their ambition. Very little of the workshop output found an afterlife as mass-produced objects—because, paradoxically, they fell victim to the aesthetic rhetoric they so compellingly telegraphed. The industrial look of the Wagenfeld and Jucker lamps convinced viewers that the prototypes were actually constructed out of existing parts

TH. BOGLER: 4 verschiedene Teekannen aus gleichen Formteilen variiert (gegossen). 1923

FIGURE 2.13

Four different teapots made with the same forms designed by Theodor Bogler, published in *Neue Arbeiten der Bauhauswerkstätten* (Munich: Albert Langen Verlag, 1925), 102.

and therefore must be inexpensive to produce. But instead, cast components had to be special ordered from local shops, leading to a highly fragmented production process. The slick machined look was achieved at enormous cost at the metal workshop, which lacked the most basic equipment needed for serial production, crucially a metal spinning machine and lathe. The polished forms utilized in so many of the workshop's products were individually hammered out, shaped, and burnished by hand.[73] However attractive the lamp or so many other items from the workshop might have been to prospective retailers, the listed price put off all but the most exclusive distributors.

Nearly every workshop faced similar problems. Neither Bogler's modular teapot system nor the furniture featured at trade fairs or in Bauhaus publications was ever adopted by a manufacturer while the school operated in Weimar. In the few cases where factory production was explored, the quality of the goods made—as in the test case of a small vase from the ceramics workshop—was unacceptably shoddy.[74] Yet the efforts the Bauhaus undertook to publicize its production did lead to a glut of orders. Without industrial partners, production took place back at the workshop, using student labor and the school's meager resources. This slow, inefficient way of working led to such massive delays that Gropius would suspend all experimental work at the

K. J. JUCKER und
W. WAGENFELD:
Lampe aus Glas mit Milchglasglocke. Drahtzufüh-
rung innen in Neusilberrohr.
1923/1924 Höhe: 39 cm

W. WAGENFELD:
Tischlampe. Eisenplatte verstählt; Messing ver-
nickelt. Höhe: 39 cm.
1924

FIGURE 2.14

Table lamps designed by Carl Jucker and Wilhelm Wagenfeld, published in *Neue Arbeiten der Bauhauswerkstätten* (Munich: Albert Langen Verlag, 1925), 68–69. © 2018 Artists Rights Society (ARS), New York / VG Bild-Kunst, Bonn.

school in the summer semester of 1924.[75] The workshops, which were to serve in theory as design laboratories and as the training ground for a new generation of craftsmen capable of developing future standards for industry, operated for a time as little more than sweatshops, forcing students to adopt archaic methods to create objects that purported to signal a modern future.

As Moholy's students discovered, without ready access to appropriate tools, the seamless surface so closely identified with the industrial age could only be produced by transforming hands and bodies into instruments capable of unforgiving, repetitive work. Moholy had to approach his paintings in a similar manner. Among the few surviving photographs of Moholy painting is one taken by his first wife, Lucia Moholy, at the Bauhaus in Weimar in the final months of the school's existence (fig. 2.15). He is photographed in the process of painting his canvas *Z II* (1925) (plate 5). The finished work takes up the precise tools of the architectural draftsman and lays out striped circles with the use of compass and straightedge. Overlapping planes create the illusion of patterned circles levitating in space, blanched as if by precisely positioned cones of light. The painting's surface is worked meticulously to mimic the surface of fired enamel. As in works he showed at the Sturm in February 1924, the structural

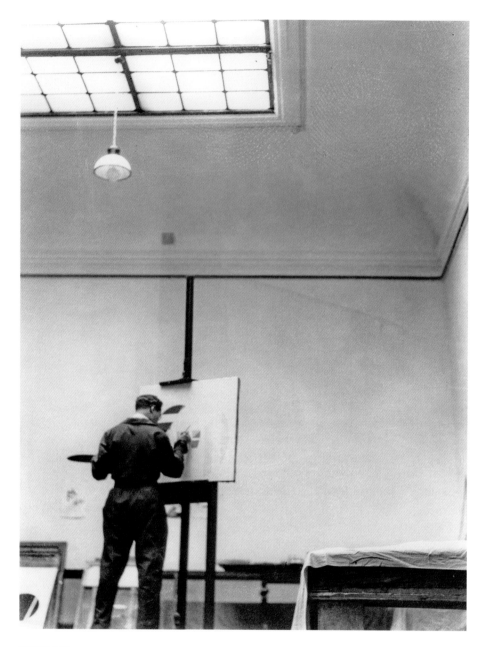

FIGURE 2.15
Lucia Moholy, László Moholy-Nagy painting in his atelier in Bauhaus Weimar, ca. 1924–25. Estate of László Moholy-Nagy. © 2018 Artists Rights Society (ARS), New York / VG Bild-Kunst, Bonn.

configurations he invented in those last months in Weimar seek to create open, dynamic spaces that appear to break free of their material supports.

In the photograph, Moholy faces his easel standing very close to his canvas, shoulders hunched, working in small and precise movements. His view of the painting is necessarily and painfully myopic. *Z II*'s smooth, slick surface seeks to dissolve the materiality of its support and erase the bodily trace of its maker in order to produce the illusion of light cast upon an untouched surface. However, the painting was anything but pristine. The canvas itself was recycled, executed on the back of another of Moholy's abstract compositions featuring floating rectangles and a cross, the presence of which had to be suppressed through careful preparation of the ground.[76]

For all the rhetoric announcing a redefinition of the relationships between art and technology as well as craft and industry, the Bauhaus remained entangled in an old order. Its participation in trade fairs in the spring and fall of 1924 should have offered an ideal opportunity for new partnerships. However, this effort was undermined by two very different approaches to the exhibition and promotion of the school's products within its own organization. Where Gropius sought to present the school's wares as new standards for industrial production, business manager Emil Lange attempted to maximize the price he could secure on the goods on display by highlighting the unmatched quality of each piece and its production by individual craftsmen. The most labor-intensive, and thus most prohibitively expensive, works were given pride of place at the fairs—with the less expensive, more replicable and marketable goods hidden away from prospective buyers and manufacturers. With rampant production delays, work meant to serve as prototypes or samples for further development were also sold as precious originals, reintroducing precisely the hierarchy of values Gropius and Moholy sought to undermine. Worse yet, these efforts did not generate enough income to secure the school's finances.[77] By the end of that year, with no additional funds forthcoming from the state, it became clear that the school would close in the spring of 1925.

There is a detail in the financial records of the Bauhaus in Weimar that offers a perverse summary of their situation. In the summer of 1924, the school finally managed to acquire a spinning lathe and installed it in the metal workshop. This was a major piece of equipment that would have dramatically eased the production of the smooth, polished surfaces readily identified with the industrial aesthetic propagated by the metal workshop under Moholy. But given its dire finances, the Bauhaus could not afford to purchase the motor to run this vital piece of machinery.[78] Without the motor, it stood as little more than set dressing, an expensive prop attesting both to the industrial aspiration of the school and the capital impediments to its achievement. Some of the most iconic Bauhaus objects were designed and made for the first time in this period of uncertainty, as well as the art Moholy presented at his exhibition at the Sturm Gallery. The lamps, tea sets, and paintings alike sought to sustain a vision of newness and modernity, efficiency and economy, clarity and transparency, that was predicated

in reality upon their opposites. The materials used were often reclaimed and recycled, the finished products fashioned in the most painstaking manner, requiring the expenditure of time and resources for which they would find inadequate compensation. The glow of modernity emanating from the sleek surfaces of Bauhaus wares after the technological turn of 1923 in Weimar concealed the many hands ill employed in their production.

After months of negotiation, Gropius secured a new home for the Bauhaus in the industrial city of Dessau. On April 1, 1925, the Bauhaus in Weimar ceased operations and resumed in Dessau the same day. The city was nearly twice the size of Weimar and was home to several chemical and gas plants; the film manufacturer Agfa; and Junkers, renowned makers of radiators, heating systems, and airplanes. The conditions appeared auspicious for the kinds of industrial collaboration the Bauhaus was just beginning to explore. The city offered not just financial support for the school but also promised a new building. In the interim, workshops were housed in provisional spaces around town. The metal workshop, for example, established itself in the storeroom of a shipping company, and it finally obtained the metal spinning machine and lathe so sorely lacking in Weimar.[79] The Bauhaus Book series, planned for summer of 1924, was finally published in 1925. Eight volumes appeared simultaneously, including Moholy's own *Painting, Photography, Film* and *New Works of the Bauhaus Workshops*. The introduction to *New Works of the Bauhaus Workshops* was additionally reissued at the beginning of 1926 and circulated as a pamphlet under the title "Foundations of Bauhaus Production." The pamphlet advertised the school's mission of unifying art with technology, craft with industry. As in the original, it concludes in boldface: "The Bauhaus fights against the cheap substitute, inferior workmanship, and the dilettantism of the handicrafts, for a new standard of quality work."[80]

"Foundations of Bauhaus Production" was directed externally to promote the school as a reliable partner and designer of economical, efficient, and profitable products. However, in private, Gropius expressed alarm at the inefficiency of workshop operations even after their move to Dessau. In a scathing memo from January 1926, less than a year before the school building was slated for completion, Gropius voiced concern that students in Moholy's metal workshop were given too much leeway to pursue projects unsystematically and did not pay enough attention to developing products with "commercial markets. These are above all lamps." Gropius continues, "The general interest of the Bauhaus must stand in the foreground. The acquisition of the metal spinning machine and the lathe in the provisional workshop has proven up to this point unnecessary and premature. The machines stand there as dead capital. Even in this workshop, the leader of this unit must himself collaborate in design proposals; otherwise, the workshop will not shed its appearance of dilettantism."[81]

The particular emphasis Gropius placed on the production of lighting fixtures in the metal workshop was motivated by both financial and symbolic factors. Despite the school's public rhetoric about unifying art with technology and engaging the newest

developments in industry, very few of the workshops were in a position to achieve this aim in any outwardly visible manner. Lighting designs from the metal workshop were the outstanding exceptions. Bauhaus lighting prototypes elicited critical attention in fairs and exhibitions—at a time when electric lighting itself represented the transformative potential of modern industry especially in the years following the First World War. With the spread of electricity in Germany, electrical household goods comprised a burgeoning market. Even if most appliances were out of reach for most consumers, electric lighting was touted as necessary to introducing a new modern hygiene within the home and increased productivity in the workplace.[82] The design of light fixtures required an understanding of evolving standards in an advanced industrial field. It was a domain ready for formal innovations—the fixture had to accommodate the technical requirements of its electrical fitting, direct the light in a manner appropriate for the setting in which it would be used, and blend seamlessly within a new, modern interior.[83] In the short term, the fixtures were also critical for the new building under construction, slated to open within months of Gropius's memo.

Gropius drafted his warning to the metal workshop in the midst of continued crisis. Even with the school's relocation to Dessau, it still suffered from financial difficulties. Building costs went over budget, and income that was to be generated through the Bauhaus GmbH failed to live up to expectations. Machinery acquired at great expense had yet to be brought to life in order to fill the school with work that could demonstrate the Bauhaus commitment to high-quality, reproducible, and functional products. Gropius's tone reveals his fear that the hard-won resources invested in the metal workshop's provisional facilities might represent nothing but "dead capital." Yet in the following weeks, the workshop would produce at a remarkable clip. The students of the metal workshop managed to develop and fabricate all of the lighting fixtures used in the school building as well as in the housing built for the faculty in time for their respective openings.

Commissioned by the city of Dessau and designed by Gropius, the Bauhaus building was completed in late 1926. It declared its modernity and commitment to industry at every turn (fig. 2.16).[84] The uninterrupted facade of glass, donated by the Plate Glass Association, allowed the structure to glow, dissolving the steel and concrete building into a crystalline box by night.[85] By day, it broke down the sense of separation between interior and exterior. For many critics, it realized the utopian promise of glass architecture long advocated by Paul Scheerbart and Bruno Taut. The light streaming into unadorned interiors would banish darkness and, at the same time, model a modern, hygienic way of living and working. The school showcased student designs—such as Marcel Breuer's tubular steel furniture, upholstered with fabrics produced in the textiles workshop, and light fixtures designed and produced by Marianne Brandt, Hans Przyrembel, and Max Krajewski fabricated in Junkers facilities—installed to demonstrate their functional beauty within an integrated space.[86] The school's "white walls, straight black iron terraces," the British journalist Lilian T. Mower remarked, "are as sleek and free of ornament as a racing car."[87] Others likened the building to a "beautiful factory," a

FIGURE 2.16

Lucia Moholy, Bauhaus building, Dessau, 1925–26: View from northwest, ca. 1926. Gelatin silver print, image: 54 × 89 cm. Gift of Walter Gropius, BRGA.20.12, Harvard Art Museums / Busch-Reisinger Museum. © 2018 Artists Rights Society (ARS), New York / VG Bild-Kunst, Bonn. Photo: Imaging Department © President and Fellows of Harvard College.

comparison Gropius actively courted. Behind the curtain of glass, each workshop was on view. The metal workshop in the new building was far better equipped with machinery that made the serial production of parts possible on-site. Visitors might glimpse students producing identical parts machined at their stations, stacked and awaiting assembly. In addition to the production space, there was a separate drafting room where design and development took place.[88] The school became a major attraction in Dessau and the building a living vitrine, demonstrating the production of goods already on display throughout the space as samples presented in situ.

In Weimar, the Bauhaus had speculated on the promise of serial production and mass manufacture; now in the pristine new building and in such close proximity to major industries, that speculative effort seemed to find its fulfillment in Dessau. In the art Moholy produced for gallery exhibitions after the relocation, experiments with industrial materials—initially proposed in theory—materialized in practice. He began working with metallic alloys and plastics developed specifically for electrotechnics, aviation, and construction industries, using materials his own students explored in their design practice. He adopted these materials as the substrates for his paintings, and reported on the results of experiments in the second revised edition of his book *Painting, Photography, Film* (1927) and in other publications as well.

The extent of his research into new materials is remarkable. In 1926, he painted *T1* on Trolit, a plastic material made of cellulose nitrate and gypsum fillers developed

specially for use in high-voltage, industrial contexts (plate 6).[89] On the polished black surface of plastic, Moholy incised three circles, linking two with a precisely inscribed tangent line and overlaying a yellow cross atop the bottom white disc. This simple composition afforded him the opportunity to demonstrate his control of new materials. Upon the smallest circle, Moholy pasted a piece of paper upon which he applied spray paint, introducing the illusion of curved space. Tearing away the center of that circle, he created the eye of a deep, concave recession. At top left, a large red circle is painted over with a darker, perhaps industrial paint. The layers do not bind together readily and instead create areas of resistance that allow the red beneath to show through the dark, encrusted surface. The effect produced is akin to the topography of an unknown planetary body, its features caught as if in an eclipse.

That same year, Moholy executed several paintings on aluminum, a material that was still relatively new, becoming only commercially viable at the turn of the century with the introduction of new mining techniques for its constitutive mineral, bauxite. Extremely lightweight, aluminum was used extensively in the aircraft industry, which had grown quickly and visibly over the course of the First World War.[90] As in his paintings on Trolit, Moholy's aluminum works adopted compositional forms that suggested interplanetary metaphors or structures in flight. *AL 3* was painted upon a square sheet of brushed aluminum, combining traditional oil paints with industrial materials, two circles spray painted in a manner to suggest two spherical bodies in orbit, following black, gray, and brown bars superimposed upon the discs (plate 7).

In the revised second edition of *Painting, Photography, Film*, published in 1927, Moholy reports that his painting on these artificial supports "demonstrate[s] unusual optical effects: it appears that the colors float as if immaterially in a space in front of the surface upon which the pigments are actually applied."[91] In *Von Material zu Architektur* (*From Material to Architecture*, 1929), Moholy argues that this corpus featuring man-made materials allows for an entirely new dynamic in the history of painting: instead of presenting a scene as if viewed through the window of the picture plane, the polished plastic, clear sheets, and shiny metal supports transform each painting's surface into part of "the atmospheric ground in which existing luminous phenomena are drawn into itself."[92] Moholy suggests that new materials make possible an unprecedented conception of space, not to be perceived as mere illusions within the framed canvas, but as environments that extend outward to encompass our own. It is as if these supports permit the painted colors and forms to free themselves from the brute facticity of pigment and support. Advancements in the science of materials thus open up new avenues in the exploration of space.

While the paintings executed on industrial metal and plastic materials in his Dessau years make use of techniques and materials that might be industrial in origin, Moholy did so to realize effects that are ultimately irreproducible by machine and difficult to document photographically. Thus, when he applied spray paint in this period, he did so to enshroud parts of painted circles in shadow. Instead of using the

spray gun to achieve even, unmodulated coverage on *AL 3*, he used it as a way to contour otherwise flatly painted discs (plate 7). The graduated mist creates the fiction of a continuous curved surface that billows out toward us, the result, we might say, of something like sfumato. Spray paint sfumato might at first appear an incongruous, if slightly absurd notion: with its Renaissance pedigree, sfumato would seem to be aligned precisely with the history of painting from which Moholy consistently sought to liberate his art and thought. And yet it might be useful to recall that the term, both as effect and technique, was intimately linked to Leonardo da Vinci and his introduction of a new understanding of the work of art, and of painting in particular, as a space for the ceaseless exploration of perceptual conditions. The production of this effect was predicated upon the application of pigment or charcoal with such a self-effacing hand that gradations shift imperceptibly, without any abrupt, discernible transitions. The importance of sfumato, as Alexander Nagel has shown, is not merely that it represents an innovation in pictorial technique, but that it transforms the work of art into "the site for the elaboration of as yet unrealized ideas."[93]

Moholy was not the first or only artist in the twenties to work with new tools like spray paint or materials such as plastics and aluminum. Among his peers, Naum Gabo pioneered the use of celluloid in his sculptures and reliefs. Not only was Moholy aware of this work, he also included it in the aforementioned *From Material to Architecture,* which would later be translated into English as *The New Vision.*[94] Several works by Gabo executed in celluloid were included in the section on sculpture, including a 1925 mock-up for a monument in front of an observatory (fig. 2.17). Assembled out of precisely cut celluloid sheets, the plastic model expresses the taut, energetic play of tensions sustained with a minimum of contact points and joints. Moholy celebrated such work as examples of how new materials can give rise to the developmental advancement of sculpture — moving beyond the static assertion of volume and toward its kinetic articulation.

We expect Moholy to endow new industrial materials with the promise of new and innovative effects, but if we attend to the language of this book, we discover a striking shift in his rhetoric. In his caption describing the importance of Gabo's proposed monument, Moholy writes, "The properties of materials, their relationship to tension and pressure are—perhaps without explicit intention—examined through a number of different approaches. The analysis of such works can be implemented afterward, and the congenial grasp of creative people . . . can transform this into a pedagogically relevant stimulus [*Anregung*]."[95] The value of Gabo's monument is not that it emerges as a product, as it were, of architecture or engineering, fabricated deliberately with possible forces and counter forces calculated in advance of its production. Instead, Moholy emphasizes how the properties of the material, in this case celluloid, become apparent only after the sculpture is made. Sculpture models a form of inquiry that proceeds freely, without predetermination or even, perhaps, without prior intention. The remark underscores how a spontaneous, specifically artistic approach might yield a new understanding of industrial materials and their potential.

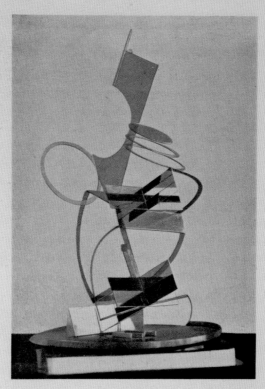

die eigenschaften des materials, sein verhalten auf zug und druck werden — vielleicht ohne deut-
liche absicht — durch vielfältige beanspruchung geprüft.
die analyse solcher werke kann nachträglich durchgeführt werden und der geniale griff des
schöpferischen menschen — neben der reichen geistigen, sinnlich-sittlichen verarbeitung der ge-
samterscheinung — kann sich zu aktueller pädagogischer anregung transformieren.

FIGURE 2.17

Naum Gabo, *Proposal for a Memorial in Front of an Observatory (Celluloid)*, 1925, published in *Von Material zu Architektur* (Munich: Albert Langen Verlag, 1929), 137. David K.E. Bruce Fund National Gallery of Art Library, Washington, D.C. © 2018 Estate of László Moholy-Nagy / Artists Rights Society (ARS), New York.

What is striking about Moholy's argument is how it echoes the defense Josef Hartwig mounted in 1924 for preserving the wood and stone sculpture workshops at the Bauhaus in Weimar.[96] Moholy's assessment of Gabo signals a shift in emphasis and priority in the former's thinking on the mission of the Bauhaus as well as his own pedagogical task. What marks both Moholy's early art and pedagogy—the urgent imperative to design with industrial production as the ultimate aim, to discipline one's own hand to promote the rational, economic use of materials—yields to a far more nuanced scrutiny of this earlier orientation. Just a few pages before the presentation of Gabo's monument, Moholy reproduced one of the most famous installation photographs of the *OBMOKhU* exhibition from the spring of 1921 with the caption "The Constructivists indulged in industrial forms. A technicist monomania ruled the movement."[97] Recall that Moholy used the same photograph in *Book of New Artists* in 1922 to draw attention to the affinities between his own and the Constructivist orientation toward science and industry.[98] In *From Material to Architecture*, we find an attempt to distance himself from an unquestioning orientation toward technology that he came to identify with Constructivism.

When Moholy first started experimenting in industrial materials, he began with manufactured porcelain enamel on steel panels, because he imagined the potential for such durable substrates to serve as mass-producible supports for an object accessible to all, capable of serving as instruments of a large-scale sensorial transformation. The materials he once named in *Painting, Photography, Film* were invoked to signal his technical expertise, to advertise his knowledge of materials in use by advanced industries, and to promote the preparedness of Bauhaus faculty and students to take up the task of designing goods to be manufactured using the latest techniques, ready to assume their place in the modernized home. However, when he began working with explicitly industrial materials in Dessau, Moholy's use of them reveals an interest in the specificity of effects generated with a particular material and not in the design of a feasible future product.

The position he espouses in *From Material to Architecture* differs significantly from the demand he once made that everything be subjected to the yardstick of "contemporary relevance," a standard he once advocated in judging the viability of the wall painting workshop as well as those for stone and wood sculpture.[99] Moreover, the value of his Dessau artworks on new materials has little to do with their immediate utility or profitability as prototypes. Instead, as he suggests in his account of Gabo, they are important as fields of specifically artistic experimentation, particularly generative as pedagogical resources. Pedagogy was very much on Moholy's mind when he was completing *From Material to Architecture*—just a few months after resigning from the Bauhaus over disagreements over the direction the school would take under Gropius's successor.

The move to Dessau and the construction of the new school building and residences were supposed to mark a new beginning for the Bauhaus. The buildings showcased the integrated design of modern architecture with its interiors and fixtures. Put to daily

use by students and faculty, the Bauhaus advertised the capacity of modern design to engender new forms of pedagogy, production, and community. The diary of Gropius's wife, Isa, documents visits to the school when it officially opened in 1926: thousands came on opening day, and the pace of visits hardly slackened in the following weeks. Demands for tours from hundreds of visitors in a day were not uncommon. On December 12, she notes, "over 700 people in the Bauhaus again today; the students are talking themselves hoarse." Press inquiries came in steadily, along with largely positive reviews. The Bauhaus quickly became a modernist icon, the fulfillment of long-held dreams of glass architecture and the use of the most innovative materials, techniques, and technologies in a single building. In the new year, Isa Gropius remarked hopefully, "there are so many publications about the Bauhaus that I'm sure we must make good money out of it."[100] Then a month later, "3 bankers visited from Breslau, Dresden, etc. If only something would come of these constant visits!"[101] These hopes expressed in the private pages of her diary were undoubtedly shared by others at the school. The Bauhaus had become a living diorama behind glass, with the students seen developing new products and working to become productive industrial designers of the future.

Unfortunately, the situation arguably worsened with the opening of the new buildings. Industrial partnerships failed to materialize until late in the twenties. Aided by the new machines, what the workshops did make would be of high quality, but their goods necessarily carried a high price because of the limited capacity for production at the school. The Bauhaus advocated modern design geared toward industrial production, but their inability to forge manufacturing partnerships forced them to operate as a cottage industry, whose survival was predicated on serving a niche, luxury market.[102] Far from becoming synonymous with inexpensive, modern, well-made goods, Bauhaus products were identified with the lifestyles of the educated elites.[103] However exquisite, however expensive, the profits generated from such endeavors were never enough to support the school entirely, which continued to operate with uncertainty about its future.[104]

This perception was only exacerbated by the controversy generated by Törten Estates, an experiment in low-cost, publicly financed housing that Gropius was commissioned to design by the city of Dessau. It soon became apparent that the workers who lived in the estates were at best indifferent, and at worst hostile, to the modern design of their homes. Almost immediately upon completion, flaws in the materials and construction became evident. Residents were quick to complain publicly about the shortcomings of the structure and the inhospitable design; public officials and the press pointed to its cost overruns. Under attack from these external pressures and the sense of turmoil within the school, Gropius resigned early from his contract, and the Swiss architect Hannes Meyer took up the directorship in April 1928.[105]

Moholy resigned—along with Bayer and Breuer—that spring as well, after Meyer had announced the new slogan "Needs of the people instead of the needs of luxury," implying, of course, that the school's previous focus had been the needs of the

wealthy.[106] Moholy's suspicion that he and his work for the school were targeted for attack appeared to be confirmed with the publication of the *Bauhaus* magazine, in which critic Ernö Kállai gave voice to, if not affirmed, criticisms that had circulated in the press. The "Bauhaus style," Kállai remarked, had become a "catchphrase," and identified with "technology, functionalism, and Americanism," marking trends that many would be eager to shed as passing fashions. In order to counter that perception, Kállai argued, the Bauhaus could not escape to its past, to the "effusive" desire to create a "new total work of art (first period of Weimar)," nor for that matter continue on its path to "Constructivist constriction (second period of the Bauhaus)." In order to guard against "traditionalism as much as modernism," it would instead need to embrace the current forms of new life to the greatest extent.[107] The Bauhaus, moving forward, must become more than a style, and could only do so by internalizing this new directive, to redirect its attention to fulfilling the "needs of the people."

Moholy was particularly sensitive to the accusation that the Bauhaus produced goods exclusively for the rich. His metal workshop made not only forward-looking lighting fixtures but also finely wrought domestic goods, for instance, the geometric silver-plated ashtrays and tea sets for which the Bauhaus had become renowned.[108] These were also precisely what Meyer deplored and what Kállai condemned.

Against these criticisms, Moholy formulated several arguments in a manuscript he never published in his lifetime.[109] The text reads in part like a strategic document meant to be shared with allies within the school. It begins by outlining the successes and achievements of the school over the past few years and redefines the history of the Bauhaus. In the final period in Weimar and the initial time in Dessau, Moholy argues, the Bauhaus arrived at a "truly productive period" that generated "clear, meaningful forms—justified in their materials, made thoughtfully with appropriate technology."[110] This period of intensive research took care to further "human qualities" and demonstrated "the pedagogical value of collaborative work."[111] Even as they oriented their design to industry, Moholy notes, they sought to create objects capable of contributing to a shared sense of social cohesion in their production and eventually in their use. The proposed designs were meant to become the standard for a category of household goods; it was only because of the difficulty of securing industrial partners that the works never entered mass circulation. Without access to mass markets, Bauhaus designs could not transform society directly. In any case, Moholy contends, the preoccupation with productivity as the gauge for success ignores the school's ultimate aim. "[W]ork within the Bauhaus was not purely of a laboratory nature; it was also pedagogical. The Bauhaus as *a new type of school* was of utmost importance."[112]

Moholy's manuscript, in a sense, rewrites history. After all, over the course of summer 1924, at the end of the Weimar period, the speculative, pedagogical mission of the school had been suspended so that orders could be filled. In 1926, Gropius had communicated—emphatically, to students and faculty—the imperative to design and produce efficiently with profitability in mind. The differences Moholy sought to

establish between his own ideas and those of the Bauhaus under Meyer obscures fundamental affinities. In terms consistent with Meyer, Moholy believed that the accessible dissemination of modern design in the form of manufactured paintings, books, and household objects could and would lead to a fundamental transformation of human perception—and with it, community.[113] But Moholy saw Meyer's attack on luxury specifically as a repudiation of his own contributions to the school, so much so that the unpublished manuscript reads curiously as a defense of luxury.[114] In the text, Moholy argues that under existing capitalist conditions, the Bauhaus production of luxury goods constituted a necessary transitional step for the continued development and perfection of forms for future industrial production, even as access to those resources remained out of reach.[115] Put differently, his defense rests on the notion that the cottage production of luxury goods at the school enabled maximal design experimentation with minimal capital exposure.

In his repeated attempts to justify Bauhaus luxury production, Moholy acknowledges irresolvable contradictions at the heart of its enterprise. The Bauhaus aesthetic, which espoused transforming social and economic life through modern design, relied upon anachronistic production models and an elite consumer base to make that vision manifest. Its precarious finances hindered its ability to achieve its stated goals in other ways as well. In his address to the faculty that laid out the reasons for his resignation, Moholy argued that he had been hired as an artist and a teacher.[116] Yet in pursuit of productive design, he had been forced to undertake the impossible task of gaining and maintaining fluency in a number of different technological domains without any expert guidance. This came at a cost to his pedagogy and his artistic vision.[117]

Meyer's purported aim of fulfilling the needs of the people had been the Bauhaus ambition from the start; Gropius himself stated in 1922 that the workshops were not for the "production of luxury goods."[118] But the obstacles to such a project, in Moholy's experience, proved insurmountable under capitalism. For him, the only way to continue working as a teacher and artist who could contribute directly to industry was, paradoxically, to resign from the school. He would continue his pedagogical legacy not by taking another teaching position, but by publishing *From Material to Architecture* as the final volume in the Bauhaus Book series.

As if in rebuke to the charge of luxury, Moholy immediately embarked on a number of projects that sought to reach a broad public. He curated photography exhibitions promoting the power of seeing fundamentally transformed by the modern world. He designed sets integrating the use of new materials and media for the state opera and the experimental proletarian theater of Erwin Piscator alike. He also began work on *Light Prop for an Electric Stage,* a prototype for a kinetic light machine destined not for the bourgeois living room but for a future stage that would dissolve the distinction between actor and audience.

In these projects, Moholy had the aid of assistants to realize his vision. He established a design studio in Berlin that employed several former students from the

Bauhaus as well as architects and other experts who worked on these and other commissions. *Light Prop*, unlike his work at the Bauhaus, enjoyed the direct financial and technical support of AEG (Allgemeine Elektrizitäts-Gesellschaft), one of Germany's largest industrial conglomerates and a leader in light technology. Given these new technological means at his disposal, Moholy abandoned painting altogether to focus on developing new instruments to realize the transformation of light itself into a medium. Moholy's departure from the Bauhaus appeared to unlock the support he had lacked at the school—technological expertise, industrial production, and project financing. The reality, however, proved far more challenging.

3

SORCERER'S APPRENTICE

LIGHT PROP FOR AN ELECTRIC STAGE (*Lichtrequisit einer elektrischen Bühne*) is one of Moholy's most canonical works (fig. 3.1).[1] His initial ideas for this machine emerged in the early twenties, but it was not completed until 1930, when it debuted at the Salon des artistes décorateurs de Paris. It was meant as a prototype for a new form of theater.[2] This work found a particularly enthusiastic reception in the 1960s, concurrent with the burgeoning interest in light and kinetic art among contemporary artists and critics.

In 1967, *Light Prop* graced the cover of *Art in America*, where its chromed, brilliantly polished surfaces reflect the incandescent flash of the photographer's bulb, throwing shadowed contours of the machine against the dark wall behind it.[3] The color photograph of *Light Prop* spiffs it up, the lighting lending it a glitzy newness. The cover accompanied a feature on a growing number of artists "whose major concern is neither light as lighting, nor the representation of light, but the articulation of light itself."[4] Nan Rosenthal, then publishing under her married name, Piene,

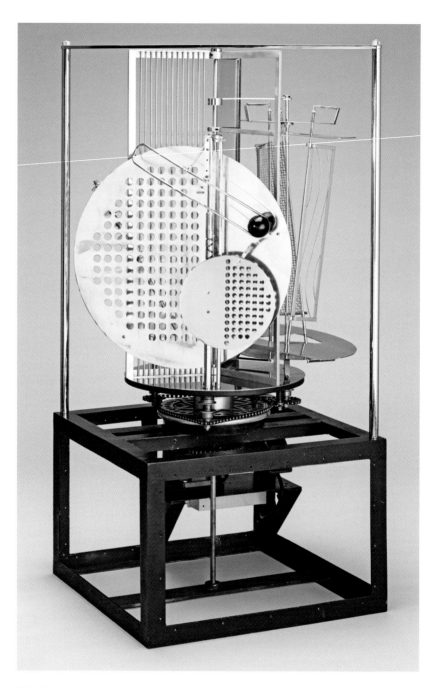

FIGURE 3.1

László Moholy-Nagy, *Light Prop for an Electric Stage* (*Light-Space Modulator*), 1930. Aluminum, steel, nickel-plated brass, other metals, plastic, wood, and electric motor, 151.1 × 69.9 × 69.9 cm. Gift of Sibyl Moholy-Nagy, BR56.5, Harvard Art Museums / Busch-Reisinger Museum. © 2018 Artists Rights Society (ARS), New York / VG Bild-Kunst, Bonn. Photo: Imaging Department © President and Fellows of Harvard College.

highlights the number of shows that featured the work. In 1961, *Light Prop* appeared in Amsterdam and Stockholm for the first major exhibition of kinetic art, *Bewogen Beweging*.[5] Five years later, it traveled to the Stedelijk Van Abbemuseum in Eindhoven, the Netherlands, for *KunstLichtKunst*. There, it was shown with pre- and postwar art, including work by Duchamp, Man Ray, Dan Flavin, Nicholas Schöffer, and others.[6] In the words of Frank Popper, curator of that show, *Light Prop* "has the capacity of remaining young," ageless in its concerns.[7] Rosenthal echoes these remarks in her text. Not only did Moholy's work anticipate contemporary light art by nearly half a century, his work remains startlingly present.[8] For example, ZERO adopted *Motion in Vision—Vision in Motion* as the title of its inaugural exhibition in 1959, a play on Moholy's last, posthumously published book. Many of its members shared the artist's preoccupation with light and shadow and made work that played with the illumination of fire, the metaphorical shadows created by soot and ash or those literally cast by sculptural relief. They also created kinetic machines that brought light to life.[9]

Rosenthal was acutely aware of Moholy's legacy in contemporary art as a critic and editor of *Art in America*. But she was also a graduate student at Harvard, developing an MA thesis on *Light Prop*, which, since 1956, was in the collection of the Busch-Reisinger Museum. Her husband at the time was Otto Piene, founding member of ZERO, whose electrically powered light ballets were perhaps some of the most obvious descendants of Moholy's *Light Prop*. In 1969–71, Piene was one of the first fellows at the newly formed Center for Advanced Visual Studies at MIT, headed by György Kepes, a Hungarian artist who had a long relationship with Moholy and first arrived in the United States in 1937 to teach at the New Bauhaus in Chicago. In a statement announcing the founding of the center in the *Art Journal,* Kepes described the mission in terms resonant with Moholy's enterprise, to explore "the creative use of light, new aspects of environmental art and the role of visual signs in communication."[10]

The cover photograph of *Light Prop* that accompanies Rosenthal's text attests to the machine's brilliance. But the photograph glosses over the material problems that plagued this work—the cracked base, provisionally produced replacement parts, broken welds, spots of rust, and a chronically jamming motor.[11] Two years after the feature in *Art in America, Light Prop* was taken out of traveling exhibitions altogether because of concerns about its condition. The machine had never been particularly sturdy. The Busch-Reisinger Museum's conservation and object file for *Light Prop* is full of descriptions of the machine's problems. When *Light Prop* returned from the *KunstLichtKunst* exhibition, the Busch-Reisinger noted how much the machine had suffered as a result of that overseas loan. For this reason, when the Museum of Modern Art requested *Light Prop* for its seminal exhibition *The Machine as Seen at the End of the Mechanical Age,* the Busch-Reisinger agreed under the condition that it not be activated.[12] To the dismay of the curators and conservators of the Busch-Reisinger, MoMA rewired *Light Prop* and turned it on at the show with the blessing of Moholy's widow,

Sibyl Moholy-Nagy, who felt its operation was necessary to convey the work's intention. The machine was returned to the Busch-Reisinger cracked, warped, and inoperable.[13]

But it was because of these problems, or what conservators would describe as the object's inherent vice, that the work would regain its youth. In 1970, it was reborn twice over as traveling replicas. Sibyl had initially rejected the idea of replication, but given the intense interest in the work and its inoperable state, she conceded that Moholy's legacy might best be preserved by reproducing the machine.[14] Rosenthal helped to supervise this project, which was underwritten by the Wise Gallery, a major force in promoting art of new media. The plans were reviewed and executed at MIT by Woody Flowers, then a PhD candidate in mechanical engineering.[15] One was presented as a part of the 35th Venice Biennale, shown in the central pavilion along with Moholy's *Constructions in Enamel*, sculptures, photography, and paintings on plastic.[16] The second replica starred in an exhibition organized by the Wise Gallery. Rosenthal's gallery text explains that the replicas were necessary owing to the original's dilapidated condition and that producing such copies was wholly compatible with Moholy's theoretical disposition. Both in Rosenthal's text and in the introduction by the curators of the Biennale, *Light Prop* was situated not merely as historical precursor but as an active, living participant in contemporary art unfolding in the sixties and seventies.[17] The freshness of Moholy's ideas was only underscored by the sparkling newness of the replicas' materials.

The extent to which artists, critics, and scholars enlisted Moholy's work to bolster contemporary trends did not go unnoticed. Upon seeing the Wise Gallery exhibition, Hilton Kramer wrote,

> As usual with Moholy-Nagy, what we have here is not a completely successful work of art but a brilliant statement about a new possibility for art. In an age of conceptual art, when ideas need only be stated to be taken for realizations, the distinction I am making may seem a little archaic. But for those of us who remain firm in our belief that what is important in art is not what the artist says he is doing or intends to do or is said to have done, but what he actually achieves in the work itself, the distinction is crucial.[18]

Kramer's multiple reviews from the sixties and seventies of Moholy's paintings and photographs were largely sympathetic.[19] The criticisms in this instance were directed far more at what the critic saw as the refusal on the part of contemporary artists and commentators to historicize Moholy's work and engage with the specificity of its project. Kramer argues that the grand claims made about *Light Prop* could not be sustained by the object itself even as a working replica.

Kramer's remarks called into question artistic practices that had long since gained traction in the art of his time. However, he was not alone in expressing deep reservations about the unbridled enthusiasm for the techno-utopian ambition *Light Prop*

came to represent. *Light Prop* became suspect in another way for those critical of how easily the work might be enlisted in promoting the aims of the military-industrial complex. Over the course of the sixties and seventies, projects that involved collaboration with industry came increasingly under scrutiny as the Vietnam War progressed. Writing of that historical moment, Pamela Lee remarks upon the eagerness with which postwar artists sought to establish equivalencies between the historical avant-garde and contemporary practice in order to "furnish a seamless continuum between prewar kinetic forms and postwar ones . . . Kinetic art seemed to advance without interruption, with virtually no acknowledgement of a world historical disaster of the war to say little of its implications for industrial production, scientific endeavor, and technological progress."[20] Postwar art that sought to bind art with technology, kinetic and light art included, is marked in Lee's analysis by its "implicit faith in machinic forms and the potential of science, in spite of the Bomb and in spite of the Holocaust."[21] In the sixties and seventies, it was precisely on these grounds that many increasingly called such art into question.[22]

The arc of adulation and critique that *Light Prop* garnered in the sixties and seventies curiously tracks positions that Moholy himself would occupy in his own evolving thoughts on this project. As this chapter argues, he would even come to Lee's conclusions by the end of his life. When Moholy presented his *Light Prop* in 1930, he saw it not as a work of art but rather as the culmination of a decade's work in harnessing technology to create immersive environments in which our senses would undergo profound transformation. The machine was meant to be put into industrial production and disseminated widely. As we will see, it was closely linked to his desire to create what he idiosyncratically called a "total work" (*Gesamtwerk*), which would represent a fusion of art with life. But, over the course of the thirties, his faith in the potential of technology to serve these ends was deeply shaken as a result of his experience in exile. By 1944, just two years before his death at the age of fifty-one, his account of *Light Prop* had changed significantly. Writing in English that year, Moholy no longer describes it as a prototype for a machine, but as a "mobile."[23] In his last book, *Vision in Motion*, Moholy explicitly presents *Light Prop* as an example of kinetic sculpture.[24] This shift came in response to economic and political conditions as well as to the machine itself, precisely because of its fragilities and design flaws. The material limits and mechanical failings required him to alter his own comportment toward it. Moholy's ever-changing perception of this work touches on the heart of his aesthetic project and his sense of the responsibility of the artist.

The conceptual genesis of *Light Prop* dates to the early twenties, when Moholy attempted to situate his artistic activities in relation to the catastrophic destruction caused by the First World War. In the war's wake, the autonomy of art, understood as a sphere of individual or subjective creativity, came under attack. John Heartfield and George Grosz summarized some of the stakes of such a position in their

scathing 1920 essay, "The Art Scab."[25] Written in response to an editorial by Oskar Kokoschka in which he pleaded with paramilitary troops and workers to avoid harming "human culture" in violent street fights, their essay offers a critique of art as a bourgeois invention. They assert that Kokoschka's attitude exposes the callousness of those who consider themselves to be cultured. Art aficionados, they claim, are far less concerned with a bullet tearing through the flesh-and-blood body of a worker than with the damage it could inflict on a painting hanging on a gallery wall. For these two Dadaists, art and culture are predicated on rampant class inequality and exist only to serve the interests of the ruling class. For these reasons, they argue that art should be eliminated altogether to prepare for the arrival of a new proletarian culture.

Moholy's own thoughts regarding the place of the artist and his art in relation to the demands of his historical condition were initially informed by, but also critical of, such rhetoric. His intervention in this debate attempts to secure a role for the artist in revolutionary times:

> We, who today have become one with the necessity and the condition of class struggle in all respects, do not think it important that a person should find enjoyment in a picture, in music or in poetry. The primary requirement is that those who have not yet reached the contemporary standard of mankind should be enabled to do so as soon as possible through our work. . . . it is our duty to open all the channels of intuition so that we may influence the maximum number of people.[26]

Moholy published these lines in response to the inaugural issue of *Akasztott Ember* (Hanged Man), a Hungarian journal that featured a translated reprint of Heartfield and Grosz's essay as well as a polemic against art by the journal's founding editor, the poet Sándor Barta. In his essay, Barta demands the boycott of all spheres of bourgeois culture, including art galleries and museums as well as cinemas and schools. He goes on to write that art might be allowed to exist only if it serves as a vehicle for promulgating revolutionary aims, a position he was not alone in espousing.[27]

Moholy's essay "On the Problem of New Content and New Form," published in the second issue of the journal, maintains that artists must help bring about a radical transformation of the world. It acknowledges that the struggle between the arts to determine the primacy of any one medium or the refinement of art as a locus of "enjoyment" was rendered wholly irrelevant by the experience of the war and the revolution that followed. However, he continues, artists have far more to offer than empty vessels for political content or decoration for political slogans. If artists seek to contribute to class struggle, they must address a modern and increasingly international public not bound by national borders, language, or cultural sensibility. To "influence the maximum number of people," artists cannot merely repackage political messages with their art but instead must work to retrain human "channels of intuition," that is, the perceptual paths through which everyone apprehends the

world.[28] For Moholy, the most effective means of reaching the masses is not by providing overtly political didactics but by reconfiguring the senses to enable a new perception of historical and political conditions. According to this logic, human beings must first learn to perceive relationships within a work of art. By becoming attuned to the ways in which subtle shifts in color, form, and space might fundamentally alter the balance of a composition, they might by extension develop a newfound ability to discern the mutability of other kinds of relationships in the world—political, economic, and social.

Many artists working in the aftermath of the First World War, including those involved in the Bauhaus and De Stijl, shared the views expressed in Moholy's essay, especially the belief that any transformation of the world would have to be predicated on the fundamental reconfiguration of sensuous, which is to say, aesthetic perception.[29] In their 1918 manifesto, members of De Stijl stated that the war had created the conditions for a new world by violently purging any values associated with tradition or notions of the individual.[30] Artists too must eliminate remnants of existing conventions in order to achieve "pure plastic expression." Its articulation would transpire through a twofold process. First, a systematic investigation of individual arts would distill each to its irreducible essence. These core elements would then be integrated to constitute a new nonmimetic, universally valid aesthetic vocabulary. By 1922, on the occasion of the International Artist's Congress in Düsseldorf, the members of De Stijl announced that the activity of building (*bauen*) should serve as the locus of unity for the arts, as described in their initial manifesto. Instead of developing in isolation from one another, the arts must find material manifestation in a constructive and inherently integrative architectural project. By subjugating the arbitrariness of any particular individual's subjective impulses to the requirements of architecture, building would become "an objective universal means of creation" through which the arts would converge to find unified expression.[31]

The Bauhaus shared similar commitments well before Moholy's appointment to the faculty in 1923. The founding manifesto of the school, written in 1919, states, "Let us therefore create a new guild of craftsmen without the class distinctions that raise an arrogant barrier between craftsman and artist! Let us desire, conceive and create the new building of the future, which will combine everything—architecture and sculpture and painting—in a single form which will one day rise towards the heavens from the hands of a million workers as a crystalline symbol of a new and coming faith."[32] Lyonel Feininger's woodcut of a sharply faceted cathedral, which was once entitled *Cathedral of Socialism*, illustrates this manifesto (fig. 3.2). The invocation of the cathedral, the guild, and the craftsman underscores how the early Bauhaus turned to an idealized medieval model of collective work as a possible antidote to class conflict. The 1919 manifesto seeks to ameliorate the increasing demand for specialization in modernity by calling for the unification of the activities of the craftsman, architect, and artist alike to create a new community through the shared, practical activity of building. Such an

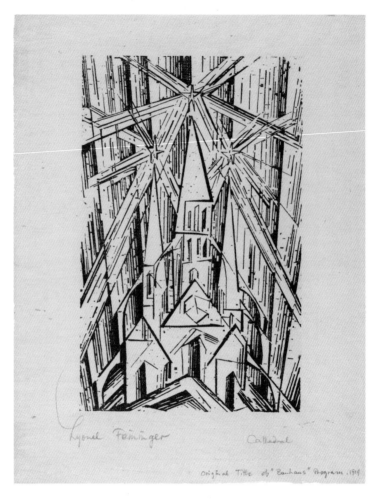

FIGURE 3.2

Lyonel Feininger, *Cathedral* (*Kathedrale*) for *Program of the State Bauhaus in Weimar* (*Programm des Staatlichen Bauhauses in Weimar*), 1919. Woodcut, composition: 30.5 × 19 cm; sheet (irreg.): 41 × 31 cm. Gift of Abby Aldrich Rockefeller, The Museum of Modern Art, New York. © 2018 Artists Rights Society (ARS), New York / VG Bild-Kunst, Bonn. Digital Image © The Museum of Modern Art / Licensed by SCALA / Art Resource, NY.

all-encompassing project of aesthetic integration would result in a total work of art that would serve as the foundation of a socialist utopia.[33]

Moholy was already then in close contact with members of the Bauhaus and De Stijl, and shared this synthetic impulse. He corresponded frequently with Theo van Doesburg, the leading theorist of the Dutch group, before his appointment to the Bauhaus.[34] However, in *Painting, Photography, Film* (1925), Moholy specifically distinguishes his own project of aesthetic integration from the strategies pursued by De Stijl and early

Bauhaus. In a short section entitled "Easel Painting, Architecture, and '*Gesamtkunstwerk*,'" Moholy describes De Stijl and the first period of the Bauhaus as contemporaneous attempts to create a kind of *Gesamtkunstwerk* (total work of art), and further claims that these two movements fail to provide anything more than unity in name only.[35] The unity of their versions of the *Gesamtkunstwerk*, he argues, is predicated on assembling diverse practices and arts together under the sign of architecture, thereby creating an additive rather than an integrative whole: "What we need is not the '*Gesamtkunstwerk*,' next to which life flows separately, but a self-constructing synthesis of all vital moments toward the all-encompassing *Gesamtwerk* (life) that suspends all isolation, in which all *individual* achievements emerge out of a *universal* necessity."[36] The failure to unify the arts and synthesize art with life lies in the persistence of *Kunst* (art) in the *Gesamtkunstwerk*. Unity cannot emerge out of a collection of many parts amassed in one place. Instead, the creative activity pursued by the artist must grow out of what Moholy calls "universal necessity." Only "universal necessity" can lead to the creation of a *Gesamtwerk* (total work), which he parenthetically defines as "life." So long as art persists as a differentiated notion, separate from life, no total integration can emerge. The distinction he makes between the *Gesamtkunstwerk* and *Gesamtwerk* seeks to articulate a creative principle rooted in a universally shared understanding of life, one that incidentally never finds further clarification in this first edition of the text.

In a sense, the distinction Moholy makes in this passage between the *Gesamtkunstwerk* and *Gesamtwerk* willfully misrepresents the stakes for both early Bauhaus and De Stijl, for neither was ever interested in creating a total work of art wholly cleft from life. However, the rhetorical urgency that compelled Moholy to make this polemical case should be understood in light of the particularly fraught moment in which his book was written. He had just arrived at the Bauhaus to replace Johannes Itten, a figure who had asserted a powerful influence over the school and had resigned to protest Gropius's turn to industrial production. Internally, there were still those under the sway of Itten's mystical orientation, but Moholy also had to contend with yet another faction whose loyalties remained with van Doesburg, who taught his own independent seminar in Weimar in 1921–23 and arguably catalyzed the Bauhaus shift toward Constructivism in the first place.[37] In addition, the Bauhaus was under attack from external critics, balking at the extravagance of publicly financing an art school in the midst of an economic crisis. Thus, the chapter "Easel Painting, Architecture, and '*Gesamtkunstwerk*'" has two goals. First, by claiming that early Bauhaus and De Stijl represent flawed, if not anachronistic positions with respect to aesthetic integration, Moholy attempts to disassociate the present task of the Bauhaus from Itten and van Doesburg, who were extremely divisive in the school's early existence. Instead of supporting what might have been seen by the school's critics as the abstract demand for "pure plastic expression" or holding fast to the mystical notion of the Bauhaus as a "crystalline symbol of a new and coming faith," the essay moves away from the lingering metaphysical language pervading both early Bauhaus and De Stijl in order to

ground the need for total aesthetic integration. Second, by insisting that the preoccupation with art must be eliminated to enable activities that could foster and contribute to life, it also tries to answer those critics who saw the Bauhaus as irrelevant, merely concerned with the subjective idiosyncrasies of art.

Moholy revisited this distinction between the *Gesamtkunstwerk* and the *Gesamtwerk* again over the course of the next few years, revising this chapter substantially for the second edition of *Painting, Photography, Film* (1927). The passage in the second edition corresponding to the one previously quoted reads, "What we need is not the '*Gesamtkunstwerk*,' next to which life flows separately, but a self-constructing synthesis of all vital moments toward the all-encompassing *Gesamtwerk* (life) that suspends all isolation, in which all *individual* achievements emerge out of a biological necessity and join in a *universal* necessity."[38] Moholy thus adds biological necessity as that which lends its productive and creative power to *Gesamtwerk*. In doing so, he further distances his aesthetic project from the domain of art, conventionally understood. Ideally, he continues, through the *Gesamtwerk*, "man learns again to react to the slightest stimulus [*Regung*] of his own being as well as to the laws of material."[39] In the account from the second revised edition, *Gesamtwerk* serves to restore and activate biologically grounded senses by attuning them to their surroundings and training them to respond to their material conditions.[40] *Gesamtwerk* would, in this way, lead to a new unified subject: not a metaphysical subject but a biological being made whole again through appropriate stimuli.

In the same essay, Moholy argues that human perceptual faculties cannot successfully be reintegrated without acknowledging the technological advances that modern science affords. In their search for innovative ways to produce effects, artists should experiment with new technologies and devices in addition to continuing their exploration of existing media like painting, photography, and film. The section immediately following "Easel Painting, Architecture, and '*Gesamtkunstwerk*'" highlights a number of future devices that might fuse the acoustic and visual, permit long-range transmission of images, and open up new uses for film. This passage suggests that these new media—and crucially "the field of moving light display"—would liberate the production of effects from the static limits of a material support–bound medium to the dynamic manipulation of colored light in space. A light display machine, along with other technologies, would prevent the audience from reflecting contemplatively upon a work of art, and would transform them into active participants embedded within an environment.[41]

Moholy's expressed intention to activate a passive and contemplative audience through his work resonated with discussions about the theater that were ongoing throughout the twenties and within the Bauhaus itself. Theater was seen at the Bauhaus as an ideal platform to synthesize the activities of the school's workshops.[42] In 1923, the same year that Moholy embarked on the writing of *Painting, Photography, Film*, he also began work on another volume, *The Theater of the Bauhaus*, which was

also completed in 1924 and later published in 1925 as a part of the Bauhaus Book series. It includes illustrations and photographs of recent set and costume designs, as well as the writings of Moholy, Oskar Schlemmer, and Farkas Molnár. Although the book was intended to represent the coherence of theater at the Bauhaus, the contributions by Schlemmer and Moholy reveal certain fundamental philosophical differences on art, rooted in competing models of human agency.[43]

In his essay, entitled "Man and Art Figure," Schlemmer writes,

> The history of theater is the history of the transfiguration of human being: human being as the actor of physical and spiritual events, oscillating between naïveté and reflection, between naturalness and artifice.
>
> The means aiding [*Hilfsmittel*] this transfiguration are form and color, the means of the painter and sculptor. The arena for this transfiguration is found in the constructive fusion of space and architecture, the work of the master builder. In this process, the role of the creative artist, as the synthesizer of these elements, is determined within the domain of the stage.[44]

Schlemmer's essay ascribes agency to artist and audience alike in the transformation of human being by engaging the synthetic space of the theater. For Schlemmer, the stage is an experimental domain for aesthetic education through play, in which individuals might begin to perceive and then achieve the conditions of freedom.

Moholy has a very different understanding of the theater and its history. His contribution, "Theater, Circus, and Variety," claims:

> The historical theater was essentially a disseminator of information or propaganda, or it was an articulated concentration of action derived from events and lessons in their broadest meaning—that is to say, as "dramatized" legend, as religious (cultist) or political promotion, or as compressed action with a more or less transparent purpose behind it.
>
> The theater differed from the eyewitness report, simple storytelling, didactic moralizing, or advertising copy through its own particular synthesis of elements of presentation: SOUND, COLOR (LIGHT), MOTION, SPACE, FORM (OBJECTS AND PERSONS).
>
> With these elements, in their accentuated but often uncontrolled interrelationships, the theater attempted to transmit an articulated experience.[45]

Moholy's account of the theater of the past is dismissive in tone. He describes its achievements as undisciplined attempts at synthesis that were accomplished more or less accidentally. Where Schlemmer's text places an emphasis on the audience member and actor at the center of the development of theater as agents of transformation, Moholy's describes them both as part of theater's different "elements of presentation."[46] Rather than attempting to achieve synthesis through the "uncontrolled" or

arbitrary coordination of these elements, artists must study and regulate the relationships between the theater and its components to produce a necessary and organic unity that Moholy calls the "theater of totality":

> An activity must finally emerge that will no longer let the audience remain silent but rather allows the masses to grasp the activity and to participate in it and to merge with the stage to achieve a redemptive ecstasy [*erlösende Ekstase*] at the highest level.
>
> To see that such a process is not chaotic but that it develops with control and organization will be one of the tasks of the thousand-eyed NEW DIRECTOR, equipped with all the modern means of understanding and communication.[47]

Moholy's model of the audience differs in significant ways from Schlemmer's. We might argue that Schlemmer remains invested in the traditional interlocutor of performance—the humanist subject, an autonomous agent capable of freedom—whereas Moholy envisions a theater that addresses not individuals, but the masses. Where Schlemmer is concerned with the relationship between a staged performance and the responses of a reflective audience, Moholy seeks to transform theater into a sophisticated stimulus generator that works upon bodily reflexes to induce "redemptive ecstasy."[48]

In 1927, just two years after Moholy published his ideas about "the theater of totality," Gropius began working with the leftist playwright and director Erwin Piscator to design and build a *Total Theater* (*Totaltheater*), a project that shared Moholy's ambitions. Although never realized, the theater was envisioned as a machine in which all its parts—stage, walls, and ceiling—would be mechanically movable, creating an infinitely adaptable environment. Films could be projected on any number of surfaces within this grand space to produce a multimedia experience. Thus immersed, the audience member would be transformed from the once passive, detached theatergoer into a member of the activated, revolutionary masses.[49] Some the ideas articulated in *Total Theater* and its mechanisms would return in Moholy's *Light Prop,* years later.

Light Prop for an Electric Stage was built for inclusion in a 1930 show representing the Deutscher Werkbund, organized by Gropius in collaboration with Moholy and Marcel Breuer, at the Salon des artistes décorateurs de Paris.[50] Although the Werkbund sought to promote German design, the style and concerns reflected in this exhibition were recognizably those of the Bauhaus Dessau under the leadership of Gropius despite his resignation from the school in 1928.

Moholy's work on *Light Prop* was funded by the theatrical lighting division of AEG, an industrial conglomerate renowned for its research and production of cutting-edge electrical equipment. Stefan Sebök, a member of Gropius's architectural office who had also worked on his unrealized *Total Theater* project a few years earlier, drafted

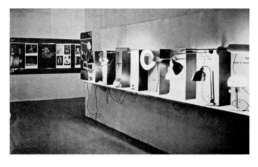

FIGURE 3.3
Installation photograph of the lighting section of
the Deutscher Werkbund's contribution to the
Salon des artistes décorateurs de Paris, 1930.

FIGURE 3.4
Installation photograph of the theater section of
the Deutscher Werkbund's contribution to the
Salon des artistes décorateurs de Paris, 1930.

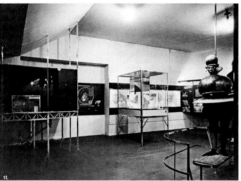

blueprints for the machine's mechanisms and created meticulously rendered color concept art of the machine. Otto Ball, a licensed mechanic, executed the plans for the machine in his workshop in Berlin. Moholy directed the efforts.[51]

Gropius arranged spaces for model modern interiors, outfitting them with Breuer's signature chrome furniture. Moholy was responsible for the theater and lighting sections of the exhibition. He ordered cases manufactured in the newest plastics to set off German light fixtures, some of which were designed by his former Bauhaus students (fig. 3.3). Alongside these sections, Moholy installed a screening room, with a filmstrip documenting the history of German architecture playing in a continuous loop. The walls of the theater section were lined with sketches for and photographs of contemporary set designs, including examples of his own recent set designs for the Kroll Opera. Moholy also prominently featured Schlemmer's already famous abstract costumes from his *Triadic Ballet*, suspended in wire mesh and steel bar cases (fig. 3.4). *Light Prop* was installed in this area of the exhibition.[52]

Moholy made an effort to publicize *Light Prop* and secured a spread in the Werkbund's journal, *Die Form*, to introduce his aims for the machine. His article appeared in a special multilingual edition of the journal that was distributed halfway through the Paris exhibition's two-month run.[53] Moholy's original German text describing *Light Prop* opens with an enthusiastic account of what light technologies have to offer. It recounts how electricity facilitates the production of new light effects for a range of

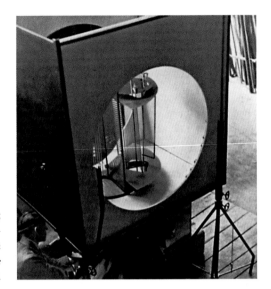

applications. It continues, "In the near future, this technology might be used as adver-
tising, or at public festivals [*Volksfeste*] as entertainment [*Unterhaltung*], or, at the
theater to intensify moments of dramatic tension."[54] The language here is certainly
more restrained than in his essay for *Theater of the Bauhaus*. And yet there is a discern-
ible continuity between the two, especially in Moholy's reference to the uses of *Light
Prop*. Theater, advertising, and festivals describe distinct spaces of public life: the
theater as a space of culture, advertising as a space of commerce, and the festival as a
space of politics. The festival, was, after all, where Jacques-Louis David staged the
triumph of the people over the monarchy, where the martyr of the French Revolution
became enshrined to create a new civic religion. In the Soviet Union, the festival also
offered a space for the performance of victory and allowed its participants to envision
the world to come, founded on the ideals of communism. Moholy suggests the deploy-
ment of *Light Prop* in culture, commerce, and politics, precisely in the contexts where
the masses must intervene to allow for a new world to emerge.[55]

The only existing photograph of *Light Prop* from 1930 appears with Moholy's article
in *Die Form*—it was completed too late to be pictured in installation press photographs
of the Paris show (fig. 3.5). The characteristics of *Light Prop* are difficult to glean in this
picture, taken by an anonymous photographer. It looks like a work in progress. Shot
awkwardly from above, the machine is shown elevated on a rough wooden
platform in a workshop with two unidentified men stooped underneath, perhaps
examining the gears and motor powering the machine. The joint of the exposed
corner looks uneven, waiting to be filed down to match the walls it connects. About
a third is visible through one of the two circular openings of the box that shelters it.
Nearly invisible in this photograph are the colored light bulbs lining the interior cir-

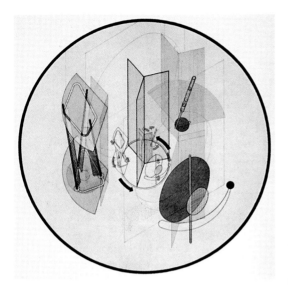

FIGURE 3.6
Graphic representation of *Light Prop,*
published in Moholy-Nagy, "*Lichtrequisit einer
elektrischen Bühne,*" *Die Form: Zeitschrift für
gestaltende Arbeit* 5, nos. 11/12 (1930): 298.

cumference of two circular openings. In addition to this photograph, the article offers a schematic drawing intended to clarify the internal mechanisms of the machine (fig. 3.6).[56] It shows a central compact view of *Light Prop* as a whole, overlaid with enlarged details corresponding to *Light Prop*'s three center sections arranged in axonometric projection. On the final page of the article, two abstract diagrams serve as graphic scores, describing the timed on/off sequence for the individual light bulbs as well as their arrangement lining the box in relation to the revolutions of the machine (fig. 3.7).[57] From these illustrations, it is difficult to fathom how this machine could serve the expansive ambitions laid out in Moholy's opening paragraph. As if anticipating this potential failing, he goes on to state that the exhibition of *Light Prop* in Paris represents only a modest initial attempt to introduce the possibilities of light technology to the public. This step must be made tentatively, the text argues, not because of technological limitations but because human beings are not yet familiar with electrically produced kinetic light effects. If light machines are to help train the viewer to respond appropriately to the phenomena produced, their future development must take into account the audience's lack of familiarity.[58]

Critics, as it turns out, did find this project puzzling. For the non-German reader of *Die Form,* Moholy's project was rendered more obscure because his explanatory text was dramatically abridged in the French and English translations included in the issue. Among the sections excised were his optimistic description of possible future uses of this machine, his caveat about the experimental nature of this prototype, and the final paragraph arguing that *Light Prop* suggests how light and movement design (*Licht- und Bewegungsgestaltung*) should develop into fields in their own right.[59] The translations focus only on Moholy's technical description of the machine's mechanisms, which do

Beleuchtungsplan für eine Umdrehung der Schalttrommel des
Lichtrequisits. Dauer zwei Minuten in 31 Beleuchtungsphasen
Plan d'éclairage pour un tour de rotation, des tambours de
lancement du poste d'illumination. Durée: 2 minutes pour
31 phases différentes d'illumination
Plan of illumination for one rotation of the switchboard of
the lighting requisite. Duration two minutes, 31 phases of
illumination

Lage der Glühbirnen, Rückansicht der vorderen Platte
Position des ampoules à incandescence, revers de la plaque
de devant
Position of the electric bulbs, rear view of the front plate

Lage der Glühbirnen, Rückansicht der hinteren Platte
Position des ampoules à incandescence, revers de la plaque
du derrière
Position of the electric bulbs, rear view of the back plate

FIGURE 3.7
Diagrams pertaining to *Light Prop*, published in Moholy-Nagy,
"*Lichtrequisit einer elektrischen Bühne*," *Die Form: Zeitschrift für
gestaltende Arbeit* 5, nos. 11/12 (1930): 299.

more to dissect the machine than convey its potential applications.[60] If Moholy's ambition for this work in 1930 was synthetic, directed toward the production of a total, immersive environment for the viewer through the manipulation of light by means of this machine, the essay, diagrams, photograph, and physical construction of *Light Prop* failed to convey that aim to his audience.

This distance between what the machine was supposed to do and how it appeared to his public found expression in contemporary reviews. Although the Deutscher Werkbund section of the exhibition was generally well received, few knew what to make of Moholy's *Light Prop*. One of his friends, Swiss architect Sigfried Giedion, simply lists the prop as one of the works shown in the theater section.[61] One French reviewer refers to it as "a curious demonstration of the play of colored light."[62] German critic Wilhelm Lotz, a member of the Werkbund and an expert on lighting design, writes especially critically of what he sees as Moholy's, and implicitly the Bauhaus's, tendency to make a fetish of technology. Lotz reprimands Moholy for his disregard of the purpose technology should serve.[63] He directs this criticism not specifically at *Light Prop* but at the whole of Moholy's various contributions to the show—from the display cases for various light fixtures to his use of filmstrip. These unsympathetic comments appear in the same special issue of *Die Form* that focused on the Paris show, the very one that included Moholy's article. For this reason, perhaps not surprisingly, Lotz's most scathing comments in his essay were redacted from the English translation.

This was not the first time Moholy's work met with harsh criticism. Lotz's irritation with Moholy's fascination with technology recalls some of the reviews of the latter's set designs for the Kroll Opera in Berlin in 1929, examples of which were also on view in Paris in 1930. His set for Jacques Offenbach's *Tales of Hoffmann* featured highly polished surfaces, metal grating, and hinged, convertible panels that served different purposes in each scene (fig. 3.8). It incorporated some of the dynamic modular ideas Gropius had explored with Piscator. The industrial and austere look of the sets struck several writers as cold. Oskar Bie, art historian and critic for the *Berliner Börsen-Courier*, offers one of the more eloquent and considered critiques of Moholy's design: "The pure conception of the space of the stage, composed of exposed scaffolding, planes, and building parts, which never became popular in Russia, appears to represent rather the last offshoot of a formalist position, a new l'art pour l'art, an appetite for domination, indeed, even a tyranny, than anything resembling immanent necessity."[64] This critique appeared in 1929, at a moment when the radical, properly Constructivist project in the Soviet Union had long since become in the West one style among many in contemporary art.[65] For Bie, Moholy's designs bore no obvious relationship to the Offenbach opera and appeared to represent a willful imposition of style. These reviews characterize Moholy's set as a new l'art pour l'art, even if adopted with an anti-art attitude. His interest in new technologies and investment in abstract visual language appeared to these critics like the empty moves of an artist playing within the codified confines of particular art-world isms.

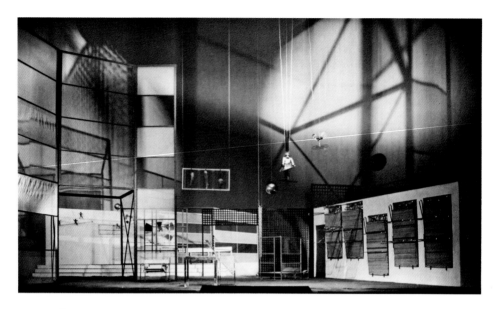

FIGURE 3.8

Lucia Moholy, photograph of László Moholy-Nagy's stage set for scene 3 of Jacques Offenbach's *Tales of Hoffmann* at the Kroll Opera House, Berlin, 1929. Estate of László Moholy-Nagy. © 2018 Artists Rights Society (ARS), New York / VG Bild-Kunst, Bonn.

Some of Lotz's and Bie's critiques sound strikingly similar to the kinds of criticism Moholy himself had once made against the proponents of a more traditional conception of art in the early and mid-twenties. Yet far from espousing art for art's sake, he had called for the development of a new kind of creative activity that might escape art's boundaries and codes, if not art itself. Moholy sought to break down the tautology of art for art's sake, to eliminate the traditional conception of art, and to move from the *Gesamtkunstwerk* to the *Gesamtwerk*. *Light Prop,* like his stage set designs, was directed at those aims. But for Lotz and Bie, Moholy's desire to create a new definition of art and overcome a history determined by the project was unrecognizable from what he produced. Instead, they saw him as an artist rehashing styles of the past—for Lotz, the name of that style was Bauhaus; for Bie, it was Constructivism.[66]

Moholy read many of his reviews, a task facilitated by the international press clipping services Gropius subscribed to during their Bauhaus years and afterward.[67] Moholy's keen interest in his work's reception was not simply vanity, but was intimately linked to the stakes of his own aesthetic project. The reviews offered Moholy an indication of the efficacy of his efforts. During the thirties, Moholy reflected on the criticism he received and became acutely aware of how limiting his associations with Bauhaus and Constructivism had become. *Light Prop,* introduced as the prototype of a new revolutionary tool to transform human perception, was seen by his critics as an elaborate toy; an orphaned, oversized gadget with no real application.

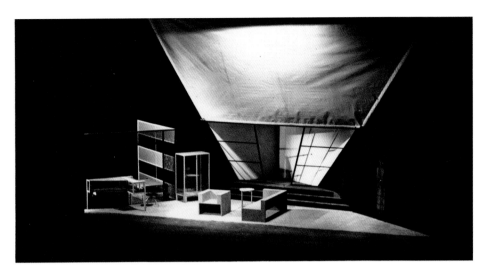

For all his enthusiasm, Moholy's embrace of new technologies was often fraught. From the start, *Light Prop* was fragile and prone to jamming and other mechanical problems. But it was only one of many projects Moholy pursued that encountered technical difficulty. Already in 1929, he planned to incorporate film and photographic slides to be projected onstage on a scrim for Piscator's production of *The Merchant of Berlin,* an anticapitalist play (fig. 3.9). The intention was to create a projected overlay above the stage that would confront the viewer with the devastation and social stratification wrought by capitalism. In theory, the use of technology was supposed to agitate the audience to fulfill its revolutionary potential.[68] However, according to Alex Strasser, the cameraman for the cinematic aspect of the play, the film was massively underfunded, beset by constant changes to the scenes, and it had no script. Not that this would matter: the flickering images could barely be seen on a scrim that was not appropriately stretched to serve as a projection screen for this avant-garde production.[69]

Despite these setbacks, Moholy remained committed to developing new film projects. He completed a short reportage he shot in 1929, entitled *Impressions of Old Marseilles.* In winter 1931, he completed *Lightplay: Black White Gray,* which featured *Light Prop* as its subject. Both films premiered in March 1932 and were billed as a part of an evening of "Constructivist Film" at Kamera Cinema in Berlin, a major theater on Unter den Linden a few blocks from the Kroll Opera House. Moholy delivered a lecture introducing the films. The fact that they were shown at all in a commercial context is significant, and it was no doubt because of their prominent setting that they came to be reviewed in major newspapers by the likes of Lotte Eisner and Siegfried Kracauer.[70]

Regarding the evening at Kamera Cinema, one critic recounted that Moholy intended to unify "deliberately formed moving light and shadow to transform our sense of space through the two-dimensionality of film." The reviewer was left unimpressed by what he saw. The review remarks that Moholy's *Lightplay* produced "interesting lights and shadows, interesting combinations of movement, interesting fantasies of space," yet failed to convince the viewer of anything, offering little more than newfangled effects.[71] Kracauer's review expresses a bit more sympathy. He opens with his admiration of Moholy's photographs, and lauds *Lightplay* for its "wondrous plays of form." Nonetheless, both films lack "purpose and meaning."[72] Kracauer was sensitive to the avant-garde fascination with the possibilities of film. However, he observes, such investigations run the risk of being little more than "abstract artistic exercises," revealing a desire to "flee from the engagement with the matters and fundamental problems that face us."[73] As much as Moholy must certainly have been aware of these risks, Kracauer maintains that the artist's treatment of social problems in *Old Marseilles* overemphasized the "painterly effect" of his imagery at the expense of palpably rendering the suffering of the impoverished inhabitants of the city.[74]

Kracauer recognized the latent political ambitions of Moholy's work but critiqued his formal experiments for veering too close to hermetic, art-world aestheticism disconnected from the actual social and economic conditions his work was supposed to engage. For Kracauer and others, flashing lights and unexpected arrangement of lines and shapes, however rigorous and even if executed in the new medium of film, could not alone serve as a vehicle for political change. Moholy's *Light Prop for an Electric Stage*, set designs, and films represented his most concerted attempt to integrate new aesthetic effects he had developed over the course of the twenties to create new instruments with which to transform the masses. Yet when all of these projects were finally brought to fruition and shown, they were met, even by the most sophisticated viewers, with little more than amusement.

The 1932 screening at Kamera Cinema in Berlin was the only instance in Moholy's lifetime when his films showed in a commercial theater. Even on that occasion, his work was not the main focus; the early Hollywood western *Hell's Heroes* headlined the evening. Moholy's *Old Marseilles* and *Lightplay* ran for a single week. Nonetheless, he worked doggedly to promote his films, hoping to pique the interest of a commercial studio to allow for broader distribution and garner support for future projects. In the process, he met his second wife, Sibyl, who was working as a script reader for the Tobias Studio. Almost immediately after their first encounter at the end of 1931, she began to assist him in promoting his films. She also took on the task of finding ways to integrate sound in his films, but this project was abandoned when the necessary technical expertise and resources outstripped their ability to secure them.[75] In 1932, in the hopes of selling either or both *Lightplay* and *Old Marseilles*, Moholy approached Julien Levy, whose gallery in New York had just opened and was attempting to show and sell photography. Although Levy expressed a deep interest in both, he declined

Moholy's offer because it was unclear how a gallery should handle films as saleable artwork.[76]

Moholy had resigned from the Bauhaus in part because the lack of resources at the school prohibited him from pursuing the kind of ambitious technological experiments he hoped to achieve in his work. Industrial partnerships appeared so tantalizingly close when he began work on *Light Prop* with AEG at his side. But as the twenties drew to a close, funding opportunities disappeared amid the growing global economic depression. The dream of enlisting technology to tap his public remained well beyond his reach. Even films were difficult to make and distribute, held hostage by censors, governments, and industries that were hardly sympathetic to his experimental aims.

Sometime in 1930, Moholy began to paint again, after having abandoned the practice for nearly two years. His paintings from this period investigate effects he once tried to achieve by other technologically mediated means. Their formal vocabulary shifts entirely away from the rigorous geometry that had become identified with Constructivism in the West. He continued the experimental exploration of surface qualities begun in his paintings on metal and plastic in Dessau and introduced new compositional strategies, some featuring dispersed leaves of color, or relief-like facture on a variety of supports. *Light Prop,* in its constant rotation, could produce dynamic plays of light and shadow through the illumination of its many polished surfaces, and his new pictures attempt to produce similar effects on canvas, plastic, or metal (plates 12, 15). These new paintings would have seemed foreign to a viewer familiar with Moholy's earlier Constructivist paintings, photographs, films, or *Light Prop.* He was well aware of how difficult it might be for viewers to discern the relationship between this new work and his stated artistic project.

In an attempt to address such questions, Moholy wrote an introduction to a retrospective monograph of his works published on the occasion of a major solo exhibition in Brno, Czechoslovakia, held in 1935.[77] In it, Moholy laid out the limits of *Light Prop.* In order to develop a machine capable of reshaping the senses—the ambition he held for his light technology—he required capital outlays and technical knowledge far exceeding those he had cobbled together over the course of a decade.[78] These remarks were made in the middle of the thirties while Moholy was in exile, working precariously from one contract to the next with few opportunities to pursue the experiments he felt offered the way forward. Moholy explained that he returned to painting, not because he had given up exploring the production of new visual effects but because he began to see that the minimal material and technical requirements of painting allowed it to serve as a provisional space for experimentation. Painting became an imperfect surrogate for fostering future ideas. Moholy's justification for returning to painting echoes the defense he mounted for the continued production of luxury goods at the Bauhaus, where the aim to incubate new industrial standards for all was thwarted by the difficulty of establishing manufacturing partnerships.

FIGURE 3.10

Heinrich Hoffmann, Nuremberg Rally, featuring view of Albert Speer's *Light Cathedral,* 1936. Photograph. Der Bayerische Staatsbibliothek / Hoffmann Archiv, Munich.

However, Moholy's growing ambivalence toward technology was also rooted in his heightened awareness of the various ways in which technologically sophisticated mass spectacles were being realized to serve ends wholly incompatible with his own. One stunning example took place in September 1936. Wilhelm Lotz, who had once so roundly criticized Moholy in 1930, offers the following description of that event.[79]

> A hundred thousand people stand here, ordered on the large field. . . . Music begins to murmur, the excitement grows. The air crackles with energy. The searchlights, whose beams play across the field, suddenly converge at a single point. Jubilation breaks out; minutes of enthusiasm follow, minutes that are indescribable. The people scream, they cheer, they are happy.
>
> And then the picture freezes. The people are silenced. Brilliant beams cleave through the masses. . . . Circumscribing the field are the searchlights, cutting vertically and drawn sharply into the heights. The field in the Lorenzerwald is no longer a piece of the earth, it is a space in a gigantic light cathedral, whose cupola is suspended in the night sky. The people are separated from all the weight of the earth; they are all part of a larger community, part of an experience larger than them. At the central point of this gigantic theater of light [*Lichtspielhaus*], there stands the man. . . . The Führer speaks.[80]

This account of Albert Speer's monumental *Light Cathedral,* created for the National Socialist Party's Nuremberg rally, details a highly orchestrated public festival. Lotz describes a synthetic, totalizing aesthetic experience in which individuals are transformed and integrated into orderly, regimented masses (fig. 3.10). The National Socialist *Light Cathedral,* in its luminous nighttime presence, cannot help but recall the Bauhaus evocation of cathedrals as a "crystalline symbol of a new and coming faith."[81] The mood certainly resonates with Moholy's description of what a "theater of totality" could achieve—a shared experience of "redemptive ecstasy." But *Light Cathedral* is not the Bauhaus *Cathedral of Socialism.* Where the Bauhaus imagined a cathedral built from the ground up through the collective, communal work of craftsmen, *Light Cathedral* was generated by over a hundred of the most advanced antiaircraft searchlights, which Speer had requisitioned directly from the Luftwaffe's reserves.[82] Where Lotz portrayed those assembled in the Nuremburg audience as ultimately *silenced* by the production of a theater of light, Moholy dreamt of a "theater of totality" that could *give voice* to its mass audience.

In 1936, Moholy looked on anxiously from London at the events unfolding in Germany. According to his second wife, Sibyl, he had briefly returned to Berlin in August that year, hired by a British agency to film the Olympics, where, on the first day of his arrival, a former Bauhaus student of his greeted him in full SS uniform. He stayed only two days, leaving again without having shot anything and in considerable distress.[83] He returned to London, and a year later would leave Europe permanently for Chicago.

Moholy belonged to a generation of leftist thinkers who shared the belief that the masses could be transformed in the service of the revolution by using the correct technology to produce the proper stimulus. This techno-utopianism, which links progressive politics with technological advancement, is amply clear in Moholy's writings and work throughout the twenties. By the mid-thirties, he had to contend with the troubling reality that technologies and artistic strategies can and will be deployed for any number of ends. The problem is not, as some have claimed, that Moholy's ideas might have held an unacknowledged fascistic or proto-fascistic seed, but that instruments, spaces, and ideas proved appropriable for ends other than those he intended.[84] The Kroll Opera House, for which Moholy once designed theater sets, became the seat of the Reichstag after the fire in 1933, its stage the backdrop for Hitler's speeches.[85] The manipulation of light technology need not lead to a progressive transformation of the masses; such technology served the ideological purposes of the Nuremburg rally equally well. And a Bauhaus student—even one of his own—could, and in this case did, end up in the Nazi party.

Moholy was highly sensitive to this problem of appropriation, as well as to the ways in which the material requirements for the production of technologically sophisticated work might require compromises that impinged both politically and ethically on his original vision. His description of *Light Prop* at the end of his life, when he recast it

as a sculpture, represents an attempt to articulate a space of creativity that might somehow resist appropriation.

A passage from Moholy's 1944 autobiographical essay, "Abstract of an Artist," describes the genesis of *Light Prop*:

> I started . . . to work on a light display machine, a space kaleidoscope which occupied me for many years. It was a mobile structure driven by an electrical motor. In this experiment I tried to synthesize simple elements by a constant superimposition of their movements. For this reason most of the moving shapes were made transparent, through the use of plastics, glass, wire-mesh, lattice-work and perforated metal sheets. By coordination of such elements of motion I obtained results that were visually rich. For almost ten years I planned and battled for the realization of this mobile, and I thought I had familiarized myself with all of its possibilities. "I knew by heart" what all the effects would be. But when the "light-prop" was set in motion for the first time in a small mechanic's shop in 1930, I felt like the sorcerer's apprentice. The mobile was so startling in its coordinated motions and space articulations of light and shadow sequences that I almost believed in magic.[86]

Over the course of a few sentences, the status of this object shifts from machine to mobile. The fact that the essay uses the term "mobile" to describe *Light Prop* situates it in an entirely different context than that of the electric stage. Considering this work as a mobile positions it within the history of a new kind of sculpture that had come to be identified with an artist such as Alexander Calder, whose work Moholy knew. And, significantly, a sculpture is a discrete work of art—quite the opposite of the *Gesamtwerk*.

But something else is at work in this statement. Where his language in 1930 emphasized the expansive potential of *Light Prop* through the use of the future tense, this text adopted the limited register of the past. While his ambition at the end of the twenties was directed outwardly to address universal needs, this later account centers on Moholy's intimate feeling, on his own experience of the machine, heightened by the first-person perspective. In the passage here from "Abstract of an Artist," Moholy presents himself as the lonely figure on whom the machine appears to have had a profound effect.

Moholy's turn of phrase "I felt like the sorcerer's apprentice" captures his own effort to describe the response that *Light Prop* elicited within him. The sorcerer's apprentice, after all, is clearly not the sorcerer. It is perhaps surprising that he would cast himself in the role not of the creator or artist but rather of the apprentice or student. The figure of the sorcerer's apprentice has its roots in Goethe's *Zauberlehrling*, a poem with which any German speaker of Moholy's era would have been familiar. But, writing in 1944 in English and living in Chicago, Moholy would likely have

had another apprentice in mind, since he had seen Walt Disney's *Fantasia*. Released in 1940, the film featured Mickey Mouse in that role. Moholy also wrote about the Disney film in his last, posthumously published book, *Vision in Motion*.

We know the scene. Dressed in a robe several sizes too big, Mickey struggles up the stairs with a heavy pair of filled pails, the water sloshing about with every step he takes. He stops and looks with wonder at the sorcerer, who pulls luminous colored forms out of the dark, which undergo a series of metamorphoses: first into a fluttering bat and then into a glowing butterfly. These delicate shapes shatter in a brilliant flash of light. The sorcerer tires of his painting in light and shadow. He departs, leaving Mickey alone, looking covetously at the master's cap left behind. Exhausted from his chores, Mickey tries on the cap and mimics the gestures of his master, trying to use magic to do his bidding. He animates the broom, endows it with limbs, and obliges it to carry the water buckets. The broom gets out of hand, and Mickey tries to smash it but ends up replicating it endlessly. Only when the true master returns is order restored.

In *Experiment in Totality,* Sibyl Moholy's biography of her late husband, she describes his deep devotion to *Light Prop* even as the couple negotiated the trials and travails of exile. Moholy insisted on bringing *Light Prop* with him wherever they moved, despite the costs of shipping and risk of damage. Sibyl's description of her struggle with *Light Prop* recalls Mickey's with his anthropomorphic broom. She calls *Light Prop* a "problem child" that caused her grief, because it seemed to have a will of its own. It "refused," for example, "to pass custom authorities in the normal way." It is as if it insisted on playing all sorts of different roles—"a mixing machine, a fountain, a display rack . . . and a robot"—except the one Moholy had intended it to play.[87]

One of the few texts to address the anthropomorphism of *Light Prop* and the significance of this quality is Rosalind Krauss's "Mechanical Ballets: Light, Motion, Theater," from *Passages in Modern Sculpture*. Writing in 1977, she argues that "no matter how abstract its forms and its function, *Light Prop* is a kind of robot; the place it was meant to take on stage is that of a mechanical actor."[88] Krauss sees the anthropomorphism of this work as its defining feature. Because its place in the theater, she assumes, would have been as a "mechanical actor," this work ultimately conserves the traditional relationships between the audience and stage. "The conventional drama locates the spectator outside the staged event, looking on, ignored by the actors. This removal from the physical flow of action on stage affords the viewer a kind of external perspective, which promotes his independent analytic stance." *Light Prop* supports that removal; the business it attends to is its own.[89]

In her view, *Light Prop* preserves—or worse, "promotes"—the structure of traditional theater. Its presence on the stage substitutes for the human actor, but it plays the role of the actor all the same, thus maintaining the distance between audience and stage, and allowing for the contemplative comportment of "conventional drama" to hold. Her account of Moholy's project, which emerges out of her meticulously detailed and persuasive description of *Light Prop*, wholly contradicts what I have argued to be

his ambition for a new kind of theater, which would produce an environment that would transform the senses and revolutionize the world.

Writing in the 2009 MoMA Bauhaus exhibition catalogue on *Light Prop* in the MoMA exhibition catalogue *Workshops for Modernity*, Alex Potts remarks:

> there is a tension between the projected vision of a radically new world of open, mobile forms and the somewhat old-fashioned materiality and inertia of the apparatus itself, which are at odds with the more seamless look of technological perfection that Moholy-Nagy cultivated in his paintings. Witnessing the *Lichtrequisit* in action, one becomes aware of clanking sounds and slightly jerky movements, and even when viewing the film, the strong sense one has of moving parts underlying and offering resistance to the fluid play of light and shade is integral to the effect.[90]

"Old-fashioned materiality and inertia" are generous ways to describe the lumbering, halting movements of the machine and the creaking of gears that have consistently brought it to moments of unintended halt. For Potts, writing in 2009, just as much as for Moholy's critics in 1930, Kramer in 1970, and Krauss in 1977, the artist's stated claims cannot be substantiated by looking at what was actually made, not because of some fundamental misunderstanding of his aims, but rather because the material object itself could never deliver on those ambitions.

The manifest form of the object absolutely impinges on the aspirations Moholy once invested in it—what Potts describes here as the "projected vision of a radically new world of open, mobile forms." *Light Prop* barely functioned under the best of circumstances, but over the years when it traveled with Moholy in exile, the machine suffered further damage. By the time the machine entered the collection of the Busch-Reisinger in 1956, it was nearly inoperable.[91] When the museum attempted to restore it in 1965, the expert hired to fix the mechanism absconded with the original engine. A 1969 memo from a conservator at the Busch-Reisinger states, in no uncertain terms, "The mechanical engineering employed in the creation of the 'Light Space Modulator' is at best experimental in nature ... I can predict with some confidence that, if this work is again run excessively without constant conservation and maintenance, it will self-destruct."[92] Even the two replicas from 1970, manufactured specifically to overcome the design flaws of the original, were eventually pulled from the exhibition circuit. A third machine was built for the Tate Modern *Albers and Moholy-Nagy* exhibition of 2006. That object was produced explicitly as a "traveling exhibition copy."[93] Even this newest addition requires constant care and attention.

What we find here is an unruly thing that refuses to behave as it should. Precisely because of the instabilities of the original design, of its inherent vice, it is also an object that requires continual repair and replication for it to be shown in movement. Rather than producing a dynamic and immersive environment through light effects, this contraption comes to life and breaks down unpredictably as if according to its own whims.

Moholy came to acknowledge this aspect of *Light Prop* at the end of his life, and did so, in part, through his invocation of the "Sorcerer's Apprentice," the *Fantasia* segment about an animated, anthropomorphic, endlessly self-replicating object.

Moholy knew *Fantasia* well. "Abstract of an Artist," in which he described himself as a "sorcerer's apprentice," was written in 1944, the same year that he was in the process of writing his last book, *Vision in Motion*. In that book, he criticized Disney for cutting the most abstract animated sequences out of the film. The excised segments were executed by Oskar Fischinger, whom Moholy knew from their days in the Weimar Republic.[94] Referring to Disney's cuts, Moholy writes that "the public here, as in so many other cases, is used as a scapegoat for the producer's own incapacity to sustain a genuinely artistic concept."[95]

However critical Moholy might have been of Disney, the animation company nonetheless pursued a strategy that bears a striking similarity to the one he promoted in theory two decades earlier. In a sense, Disney had moved away from the *Gesamtkunstwerk* and toward the *Gesamtwerk,* at least in its stated desire to escape from the confines of high art. Disney was able to secure, even if with difficulty, the means to develop advanced cinematic technologies to produce the most immersive experience imaginable. Disney even considered introducing smell as an integral part of the film.[96] Although *Fantasia* failed to embrace the universal language of abstraction in its vocabulary, a task Moholy felt was urgently needed, it went much farther than he ever could have dreamed in creating a total theater of pure effects. Art (*Kunst*), that central mediating term of the *Gesamtkunstwerk,* never entered into the equation for Disney, who was quoted in a 1940 article for *Time* magazine: "We don't even let the word 'art' be used around the studio. If anyone gets arty, we knock them down. What we strive for is entertainment."[97]

Gropius hired Moholy to play the role of the Constructivist radical, the artist-engineer perhaps best epitomized by the iconic portrait Lucia Moholy shot of him in Dessau, included in the introduction to this book (fig. 0.1). The artist as engineer was a common enough figure in the twenties. John Heartfield and Alexander Rodchenko both famously understood themselves to be engineers of sorts, each committed to the idea that the world could be shaped through the mastery of technology. Art, for the avant-garde of the twenties, seemed to be a concept that needed to be either radically revised or eliminated altogether. By the end of Moholy's life, however, his understanding of the place of art and the artist in the world had changed. He writes in *Vision in Motion* that "no society can exist without expressing its ideas, and no culture and no ethics can survive without the participation of the artist who cannot be bribed."[98] For Moholy, the autonomy of the artist and his work must be a prerequisite for an ethical community.

"I felt like the sorcerer's apprentice. The mobile was so startling in its coordinated motions and space articulations of light and shadow sequences that I almost believed in magic."[99] What compelled Moholy's belief in magic was what the object did, independent of his own preconceptions about and intentions for it. In this final text by

Moholy, *Light Prop* is cast not as the animated broom that is brought to life to execute a specific task but ends up wreaking havoc. Instead, Moholy cast *Light Prop* as a teacher of sorts, as the sorcerer himself. In the next sentence, he writes: "I learned much from this mobile." In 1944, Moholy characterizes himself as the humbled student. And in that way, he resists the temptation to put *Light Prop* to use, to deform its magic into yet another technological tool to bend the will of the masses. Rather, *Light Prop* becomes a sculpture, a work of art.

4

PAINTING AFTER PHOTOGRAPHY

THROUGHOUT THE TWENTIES, as we have seen, Moholy advertised his readiness to dispense with the traditional categories of art. At the Bauhaus, he openly questioned the relevance of wall painting and sculpture workshops at the school, provocative statements reinforced in print in *Painting, Photography, Film*. After seeing the book in 1925, his colleague Oskar Schlemmer exclaimed that "[Moholy] wipes the slate clean of anything that might be called painting . . . [he] is so aggressive on this score that he sees, like a soldier, only the enemy (painting) and his victory (photography)."[1] It was precisely because of his reputation as a champion of photography that, in 1927, Moholy became the editor of film and photography for *i10*, an avant-garde journal based in Amsterdam that featured writings by J. J. P. Oud, Walter Benjamin, Ernst Bloch, Adolf Behne, and Ilya Ehrenburg, among others.[2] In its pages, Moholy asserted that photography should not merely be elevated to the status of art, but should also be taught as a part of elementary education, like reading or arithmetic. "The illiteracy of the future," he declared in 1927, "will be an

illiteracy of photography."[3] The line would reappear a few years later as an unattributed quote in Walter Benjamin's "Little History of Photography."[4] In 1929, following his resignation from the Bauhaus, Moholy curated the introductory room at the groundbreaking *Film und Foto* exhibition in Stuttgart.[5] Emblazoned in sans-serif script on the wall of the exhibition space was the question "Where does photographic development lead?" His response came in the photographs he showed, artistic images juxtaposed with those drawn from commercial, scientific, and artistic contexts—a range of images that underscored the expansive potential of photography in both practical and aesthetic terms. A year later, he presented *Light Prop for an Electric Stage* at the Deutscher Werkbund in Paris, adding to his portfolio a work that harnessed cutting-edge technology to make light itself as the basis for a new medium.[6]

As the previous chapter argued, further development of *Light Prop* could not be pursued due to economic and political reasons. Plans initiated by Alexander Dorner to exhibit the machine as part of what Moholy called the *Room of the Present* (*Raum der Gegenwart*) in Hannover failed to garner support.[7] But it accrued an afterlife, its renown based upon his published descriptions of its potential and upon *Lightplay,* his film of the machine. *Lightplay* might have run just once at a commercial house in his lifetime, but began showing internationally in art-house cinemas almost immediately.[8] It presents the machine in a series of tightly framed sequences, each highlighting a different section of its structure and its rotational movement (fig. 4.1). It interjects manipulated frames of film—in negatives, double-exposed prints, and angled projected distortions—integrating views of the *Light Prop* as if shot by X-ray or produced as a photogram. *Lightplay* is short, suggestive, and showcases Moholy's ability to conjure new effects in moving pictures. It served as his calling card—on the strength of that film, he would be hired to develop special effects for a big-budget science fiction film in London in 1936.[9]

Reputations are hard-earned, but perhaps harder to shake. After the challenges he faced with *Light Prop* as the economic crisis worsened, painting grew ever more important to his art and thought in exile. His eloquent advocacy for technological media and photography, in both word and practice, however, made this return to painting baffling to his audience. This became especially apparent after he visited his own exhibition in Utrecht in 1934. To his wife, he wrote, "There are so few people who really can grasp [my paintings] in their reality, and because they don't know anything about the effort put into their making and nothing about the overarching problems [*Gesamtproblematik*] with which these paintings engage . . . a gallerist in Utrecht told me that because of my photograms, the newspaper there sent a photography expert to the exhibition who didn't have the slightest idea as to how to begin dealing with the paintings."[10]

This problem would continue in his lifetime and long after. In a review of his solo show in London in 1936, one critic writes, "All the implications of the paintings or 'Constructions' as most of them are called, are of a communal art which is fundamentally architectural, yet they are framed and hung as pictures."[11] This reviewer suggests that the communal ambition identified with Moholy's work is undermined by his

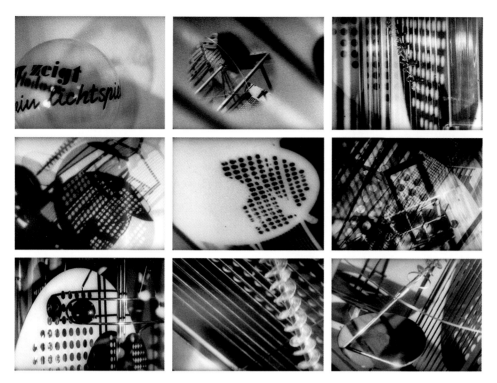

FIGURE 4.1
Film stills from *Lightplay: Black White Gray* (*Ein Lichtspiel: Schwarz weiss grau*) 1931. Estate of László Moholy-Nagy.
© 2018 Estate of László Moholy-Nagy / Artists Rights Society (ARS), New York.

insistence on showing easel pictures in a commercial gallery. The article goes almost as far as to suggest that Moholy betrayed the Constructivist enterprise, or at the very least, given the artist's renowned work in film as well as his contributions to modern architecture, that "in these paintings he is working out of his context."[12] Decades later, on the occasion of his traveling retrospective, Whitney Halstead, writing in *Artforum*, remarks that Moholy's most important achievement "was the actual use of light, in the light and shadow play from his *Light-Space Modulator* (*Lichtrequisit*), the machine constructed especially for that purpose." He quotes Moholy directly, describing proposals for "painting with light by technological means on clouds, reflecting and warped surfaces." Such projects, Halstead concludes, "illustrate his ideas in actual practice and at their most imaginative." By contrast, he characterizes Moholy's commitment to painting as "at first incongruous and inconsistent with his espousal of modern means for the artist."[13] After all, why would an artist retreat from his most visionary projects and return instead to the confines of an easel? Halstead turns to Moholy's own words to explain this seeming contradiction: "Since it is impossible at present to realize our dreams of the fullest development of optical techniques [light architecture] we are forced to retain the medium of easel painting."[14]

Halstead drew both Moholy's tantalizing reference to cloud painting and his explanation of painting's provisional necessity from *Telehor,* the first and, as it turned out, only issue of an international avant-garde journal founded and edited by Czech architect František Kalivoda. It was originally planned to coincide with Moholy's retrospective exhibition in Brno in 1935 organized by Kalivoda, but was later published in 1936. Kalivoda created *Telehor* as a forum to disseminate the most advanced art of his time. The journal was not meant to be monographic, but Kalivoda justified the exclusive focus on Moholy in the first issue by pointing to his pioneering work on light, which the architect calls the "decisive artistic problem of the next few decades, if not centuries."[15] In language that echoes Moholy's own stated aims for *Light Prop* in the 1930 Werkbund journal *Die Form,* Kalivoda argues that electric lighting has already transformed the urban landscape and introduced new, powerful tools for advertisers to reach their consumer base. Moholy's work goes further and shows how light can be developed to help cultivate a politically progressive vision in the near future.[16]

Telehor offers a highly curated selection of Moholy's writings from different periods, each of which testifies to his enduring fascination with technology and light. Not surprisingly, *Light Prop* features prominently throughout—as sketch, photographic documentation, and filmstrip. However, the first text by Moholy to appear in its pages is an open letter, penned to Kalivoda in response to the question "Why paint?" Moholy's reply seems to cast painting as a proxy, an inadequate substitute he was "forced" to employ. But his visual argument for painting is far less melancholy: paintings appear throughout the publication in vibrant color. Stunningly, on the cover of *Telehor* is a color reproduction of the painting *Z VII* (1926; plate 13).

Moholy's selection of *Z VII* is remarkable in many respects, not just for the fact that it was a *painting* that he chose to serve as the representative image for his work. *Z VII* is an anomaly in Moholy's oeuvre. Its composition bears structural affinities to other works from the mid-twenties, but its bright palette and highly worked surface contrast sharply with paintings from the same period. As we saw earlier, the paintings from his time in Weimar and the first year in Dessau sought to demonstrate painting's potential to inform industrial design, if not to become actual products for manufacture. By contrast, *Z VII* announces the presence of Moholy's hand in several areas of the canvas, as evidence not of virtuoso performance but, at times, of labored, manual effort (plate 8). Moreover, as this chapter will show, what appears on the cover of *Telehor* is a heavily damaged work, one that Moholy repaired and extensively repainted prior to its exhibition in Brno in 1935 and its color photographic reproduction in 1936.

The unification of art, technology, and industry meant to fulfill human needs proved illusory in his experience, not only at the Bauhaus but also in his efforts with *Light Prop.* The integration of science and rationality into modern life advocated by the avant-garde in the twenties as a means to revolutionize the world took perverse forms in the thirties and forties, when advances in physics and chemistry and the application of management ideas enabled new techniques of mass extermination. Moholy's return

to painting took place in a damaged world, coinciding with the Great Depression and the Second World War. To paint under such conditions might seem absurd, recalling the question he himself posed as a young man: "May I claim for myself the privilege of art when all men are needed to solve the problems of sheer survival?"[17]

Moholy knew it would be easy to see his return to painting as a move to take refuge from the world, its continued practice anachronistic if not outright retrograde, especially after his advocacy of photography and new technology. Yet, *Telehor* and his exhibition in Brno allowed him to mount his defense of painting by demonstrating the interrelatedness of his work across media, to sketch out the contours of his *Gesamtproblematik* textually and visually. His selection of *Z VII* for the cover of the publication is significant on that count. In fact, *Z VII* and its reproduction on the cover of *Telehor* illuminate a number of transformations in Moholy's thinking and practice that occurred from the late twenties into the mid-thirties. The work was repainted several times—in its final form, it becomes emblematic of how the seemingly anachronistic medium could advance the as yet unfulfilled potential of new technologies. In its repair and color photographic reproduction, Moholy also began to forge what I would describe as mutually recuperative sets of practices between his painting and photography. This becomes most visible in a body of work he called *Space Modulators,* which he developed while in exile in London. These painting-sculpture hybrids integrate industrial materials with traditional art techniques and attempt to envision how art might repair, even if in minimal ways, the damage inflicted by the existing world.

Z VII is at once representative of Moholy's work from the twenties and wholly atypical. Between 1922 and 1926, Moholy made a number of paintings whose titles consist of the letter Z followed by Roman numerals; most measure roughly 95 × 75 cm, a size and format shared by several canvases from the period.[18] The numbering of these works does not follow a strict chronology, but they share structural features with individual paintings that he produced in the corresponding years. For instance, *Z I* (1922), likely the first of these pictures, is anchored by a strong, dominant black strip, a compositional device found in other pictures from that year, such as *K VII* (1922; fig. 4.2). Composed only of primary yellow, red, white, and black, *Construction Z I* explores dynamics of projection through the distorted repetition of the structural unit at left foreground in the upper right quadrant. Pigment has been applied in thin, delicate layers to avoid obvious brushwork. *Z VIII* (1924) is executed on unprimed canvas in tempera and shares its palette and dimensions with pictures such as *A II* of the same year (plates 9, 10). In these works, Moholy exploits the chalkiness of tempera to hide his hand. The color juxtapositions, wedded to the rigorous geometry of the structures he lays upon the canvas, work together to create the illusion of luminous, crystalline forms. The following year Moholy made *Z VI* (1925), a picture featuring yet another wholly distinct set of pictorial strategies (plate 11). It too incorporates a number of compositional elements developed in years prior, but the precisely wrought lattice of black lines

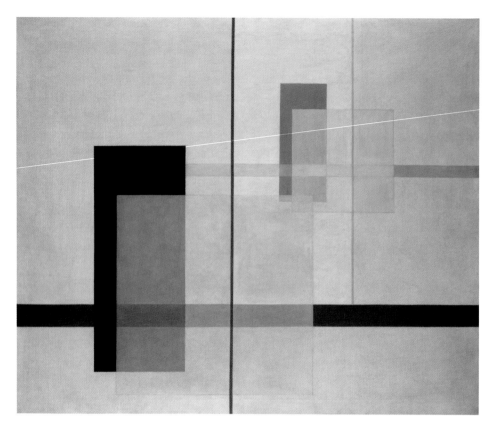

FIGURE 4.2

László Moholy-Nagy, *K VII*, 1922. Oil paint and graphite on canvas, 115.3 × 135.9 cm. The Tate Gallery, London.
© 2018 Estate of László Moholy-Nagy / Artists Rights Society (ARS), New York. Photo Credit: Tate, London /
Art Resource, NY.

projecting at the left might also offer a clue as to the meaning suggested by the title of
the series. It recalls the scaffolding of modern structures, the skeletal interior of an
airplane hangar or perhaps part of a dirigible under construction, images that appear
prominently in several publications throughout Moholy's career. Perhaps the *Z* in the
title offers quiet homage to the zeppelin as a symbol of modernity.

That the compositions in the *Z* series iterate other works from the same period is
not surprising. Executed around the time he made and showed *Constructions in Enamel*,
the paintings' sheer repetition of forms was meant to offer evidence of his methodical
approach. Their even, self-effacing handling attempts to erase the artist's presence, and
invites the viewer to imagine paintings made all at once by machine. And their archi-
tecture, palette, and color juxtapositions also endeavor to create the illusion of lumi-
nosity and transparency—they envision a world freed from the limits of brute matter.
In these same years, Moholy also argues that painting in pigment prepares the ground
for eventual painting in light, a trajectory he laid out in *Painting, Photography, Film*.[19]

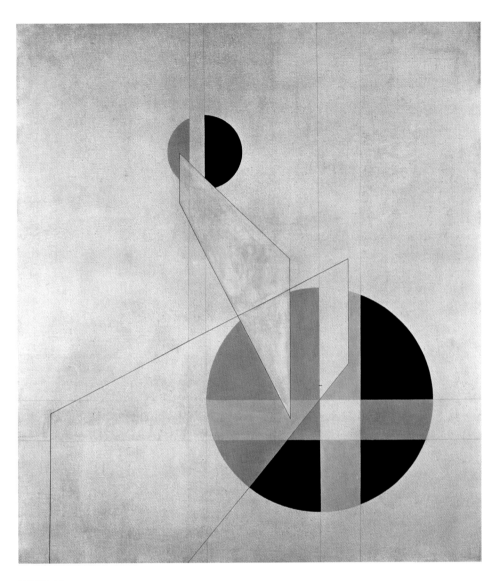

From X-ray and infrared imaging, we know that *Z VII*'s composition was not altered.[20] It has direct compositional corollaries from that period, its structure strikingly similar to *A.XX* (1924), also reproduced in *Telehor* (fig. 4.3). Both paintings are organized around the presence of a prominent circle underpinning a complex of suspended planes. However, where *A.XX* offers a remarkable study of white on white, its pristine surface seemingly untouched by human hands, *Z VII* is a jumble of textures and

FIGURE 4.4
László Moholy-Nagy, *Z VII*, 1926, reverse.

colors, announcing the laboriousness of manual work at every turn. Its surface treatment moves jarringly from the impasto of the gray disc to the thin expanse of brilliant red that constitutes the plane jutting below the circle and running down the center of the picture (plate 8). Instead of creating an open, dynamic structure engineered as if with translucent, luminous substance, Moholy presents obdurate shapes, heavy and opaque, ratcheted together to constitute a compact, almost sculptural figure.

Some of the irregularities present on the surface of *Z VII* are due to its condition. *Z VII* was one of many paintings from Moholy's estate that his widow sold in the decade after his death. These paintings ranged broadly in terms of their quality and condition.[21] They suffered from years of being transported, accompanying the artist from one station of exile to the next. Over the course of the thirties, as the political situation in Germany grew increasingly untenable, Moholy was unable to retrieve a number of his works still stored in Berlin. His former housekeeper, to whom he had entrusted much of his early work, destroyed a cache of paintings.[22] Those remaining were sent out on frequent loans, and Moholy himself treated whatever damage his works suffered in transit.[23]

But in the case of *Z VII*, the damage was extensive, as was the repair. It suffered a trauma to the canvas. A tear, several centimeters long, was roughly patched (fig. 4.4). The swell in the circle marks an area where the application of thick, viscous paint was meant to conceal the rip, with paint distributed across the circle in broad, unbroken strokes applied with a stiff brush (plate 8). If this were simply a matter of patching up a tear, we would expect to see a more localized treatment and not the vigorous, if not obsessive,

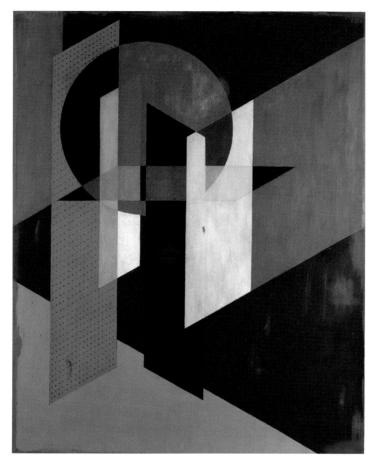

FIGURE 4.5
László Moholy-Nagy, *Z VII*, 1926, UV photograph. National Gallery of Art,
Washington, D.C.

repainting evident in the whole of that sector. The dramatic nature of the intervention
suggests that this was repaired by Moholy's hand. This is further indicated by the fact
that the paint and technique used differ from those in documented, posthumous cam-
paigns of restoration. Under ultraviolet light, the difference between the original and
restoration paints is even more evident (fig. 4.5).[24] The restoration paints fluoresce a
yellow haze along the perimeter of the canvas, which also intrudes in isolated, cloudy
patches in the lower right quadrant, and emanates from the lower outer circumference
of the gray-circle sector. By contrast, the tear and its surrounding area within the circle
fluoresce a striated lilac web, stretched across the gray sector like a sheath of protective
fascia. Unlike other areas of subsequent conservation treatment, where conservative
repairs and restoration attempts are identifiable as discrete patches, this entire section
of the circle was treated with a continuous, highly impastoed coat of paint.

This intervention was neither conservative nor restorative but radical—Moholy did not attempt to smooth over the slit quietly, nor did he attempt to return the painting to its original state. The gray circle was repainted; it appears that other portions of the canvas were as well. Under magnification, the paint over the repaired tear covers a black ground; the dotted, enamel-like gray vertical plane masks an expanse of red, revealed in areas of abrasion and along its outer edge; bright blue peeks through the drying cracks in the black-circle sector. We cannot know for sure when these changes were made to *Z VII*. But the compositional structure and colors under the surface, the primaries of blue, red, and black, are far more common in Moholy's work of the mid-twenties than are the contrasting grays and yellows that dominate the picture as it stands.

The difference between the visible, patchwork surface of *Z VII* and what it blankets is significant, for it registers changes in the roles Moholy assigned the medium and practice. The 1926 painting underneath adopts the axonometric spatial logic of architectural drawing; its palette generates the convincing illusion of light effects in order to allow the viewer to imagine the contents of a "Domestic Pinacoteca" and a future of painting in pure light.[25] The repainted version of *Z VII* appears to undermine these two earlier aims.

Moholy's relationship to painting in the twenties and, for that matter, during much of his career was fraught for both theoretical and practical reasons. He justified the continued viability of paintings—particularly during the volatile Bauhaus transition from Weimar to Dessau—explicitly as incubators for industrial design, as spaces for the exploration of luminous color and, more broadly, as potential manufactured instruments for the training of the senses. As chapter 2 argued, in Dessau, especially as he began working more extensively with newly developed plastic and metal supports, his argument shifts away from direct utility or durability of these new materials and toward their specific capacity to materialize unprecedented phenomena. In *From Material to Architecture*, he argues that the capacity of metal and plastic to "mirror and reflect" the "environment to permeate the pictorial ground" liberates painting from its role as an illusionistic window to the world. Paintings on polished plastic and metallic substrates become a part of and transform the actual space they occupy.[26] Moholy presents these experiments as important innovations in the history of painting, but they could only serve as way stations that prepare us to harness technological resources in the service of transforming light itself as a medium, fixed or enlivened by movement. Writing in *From Material to Architecture*, published in 1929, he states, "the use of manual techniques fulfills individual or pedagogical tasks. They remain, however, less relevant to contemporary needs than the available mechanical methods."[27]

Moholy underscored this point in several essays he published in *i10*, beginning with "Directness of Spirit, Detours of Technique" (Geradelinigkeit des Geistes, Umwege der Technik).[28] It opens with a discussion on the condition of thought, in which thinking (*Denken*) is described as "the functional result of relationships among bodies and the cosmos" and as "characterized by the continual generation of new phenomena,"

whereas "*Geist* is the immanent emanation of being [*Dasein*]."[29] *Geist* is often translated as mind or spirit, but in this text Moholy uses it to describe something akin to world-historical consciousness in the Hegelian sense. The language of *Geist* and *Dasein* in this text offers an account of how ideas emerge in thought not as subjective, idiosyncratic obsessions but as manifestations of ever-evolving, epochal longing. Although *Geist* seeks to articulate thought directly, it must rely upon the contingent mediation of materials and techniques. Ideas must be translated into language, and language into action, and for the artist, action into material form. The broader problem is that "the mind [*Gehirn*] works more quickly than the speed at which the hand can execute."[30] The expression of the will of *Geist* requires what Moholy calls "detours of technique."[31]

Even if these detours are necessary, they nonetheless threaten to distort what *Geist* seeks to express. Moholy provides a concrete example of how these problems are present in his own practice. His artistic ambition is to capture and manipulate light itself as a medium.[32] Painting offers an indirect way to achieve his goal, but it is imperfect because it can only serve as a "repository for light" (*Lichtlagerungsstätte*). Merely storing light in painting threatens to obscure other, more appropriate means to achieve light's potential. For hundreds of years, since the introduction of the first "magic lantern, or the camera obscura," artists have had the technology on hand to create "projective, reflective plays with fluted colored lights; fluid, immaterial, floating, translucent sheaves of color; [and] the vibration of space with iridescent light emulsion." Such fruitful means, in Moholy's view, must be explored more readily—and outdated diversions, like painting, avoided. The essay concludes with the pronouncement: "*Geist* and eye feverishly work out new dimensions of vision, for which photography and film offer both plan and reality. Details for tomorrow. Today, the practice of seeing."[33]

Film and photography are presented in this essay as the most appropriate technologies to direct us to "new dimensions of vision." This position would sharpen over the course of the following year. In the final issue of *i10*, in "Photogram and the Frontier," Moholy would argue that, "until yesterday, 'painting' represented the pinnacle of optical form creation."[34] However, at the time he was writing, in 1928, he contends, "The photogram appears to be a bridge leading to new visual creation for which canvas, paintbrush and pigment cannot serve, but only through reflecting plays of light, with 'light frescoes' [can we arrive at our aim]."[35] The existence of the photogram and the development of new technologies of electric light thus displaced painting's privileged means for optical form creation (*Gestaltung*). By the summer of 1929, Moholy redirected the focus of his own artistic practice to mirror the commitments he expressed in these theoretical writings. He abandoned painting altogether to focus on *Light Prop*, curating photography shows, and pursuing new film projects.

The arguments Moholy made throughout the twenties appeared to both his most avid supporters and his most vehement critics to set photography against painting. However, only two years after he made these categorical statements, he would begin

to dismantle this polarity. He delivered a lecture on painting and photography in Cologne, and, although no notes for it survive, the argument he presented appeared in print a few months later in the April 1932 issue of *a bis z* (a to z), the journal of the Cologne Progressives. The essay sought to overcome the dichotomies that divided avant-garde artists into irreconcilable camps: photographers against painters, abstract against figurative artists, those for versus those against the mobilization of art in the service of politics. He describes the current state of affairs as follows: "painting and photography are frequently pitted against one another . . . however, upon closer examination, it becomes clear that both domains are part and parcel of an investigation of optical *Gestaltung*."[36] Objecting to art with a dogmatic political message, what he calls "propaganda art" encouraged by "active politicians," Moholy argues that the aims of a "future society" can only be achieved when artists address "the subconsciously hidden capacities" of human beings at work in seeing.[37] The instruments deployed in this enterprise should encompass every means available to the artist—painting as much as photography.

To present such ideas in Cologne and to publish them in *a bis z*, which was edited by the painter Franz Wilhelm Seiwert, was in some respects to preach to the converted. The Cologne Progressives, as Lynette Roth has shown, countered the pervasive expectation during the Weimar Republic that the most effective political art relied on photography as its main weapon. Instead, they argued that painting itself, as artifacts that preserve and transmit the work of the hand, could convey political values. The formal qualities of their paintings—in their antihierarchical compositions, heightened facture, and simple palette—were meant to instill the sensibilities needed to build a harmonious, egalitarian future order.[38] One might be tempted to read the case Moholy made in his essay, with its emphasis on the continued relevance of painting, as simply a canny instance of appealing to one's audience. However, the essay came in the wake of criticisms, often in political terms, concerning the relevance of *Light Prop*, his films, and theater sets. As we have seen in previous chapters, several critics argued that his adoption of abstract forms and machine aesthetics were simply hallmarks of the Bauhaus, representing little more than Constructivism shorn of political meaning. Far from achieving the revolutionary aims of dismantling the divide between art and life, Moholy's work was seen by some as the mannerist recapitulation of a fashionable style among the elites. His essay sought to justify his artistic enterprise as one that remained politically engaged while also working to prepare the public for his return to painting as part of that commitment.

His presentation in Cologne and the published remarks that followed in *a bis z* were just the start of his attempt to rehabilitate painting as part of what he called his *Gesamtproblematik*. However, as he notes in a letter to his wife, a show of only his paintings might strike the viewer as "monotonous" (*eintönig*), and fail to demonstrate how crucial they were to his broader aesthetic and political aims.[39] Kalivoda's invitation to show his work in Brno and publish his writings in *Telehor* was thus all the more

welcome in 1934 because it provided him with just the opportunity to demonstrate the interrelatedness of his practices and to justify his return to painting.

Kalivoda was the first person Moholy had to persuade of the importance of painting to contemporary political concerns, as Kalivoda's primary interest in Moholy's work centered on his films. In March 1934, Kalivoda gave a lecture entitled "Outsider Photofilms," featuring four of Moholy's works, including *Lightplay*.[40] Later that year, he published one of Moholy's essays in the first and only issue of *Ekran* (Screen), another avant-garde journal Kalivoda founded devoted to modern film, photography, and cinematography with a decidedly revolutionary bent. Along with Fritz Rosenfeld's "Film and the Proletariat" and Vsevolod Pudovkin's "Notes on the Art of Film," Kalivoda included Moholy's "Open Letter to the Film Industry and to All with an Interest in the Development of Good Films," which decries the studio system's unwillingness to support experimental avant-garde projects.[41] In that essay, Moholy argues that the lack of "independent producers" has endangered the future of film generally. "Art can only be developed by artists, and they demand sovereign access to the means they require."[42] Under the present conditions, he claimed, the equipment, expertise, and distribution network needed to make and show film was nearly impossible for the independent, avant-garde artist to access. Urgent reforms on the part of governments, studios, and film training programs needed to take place in order to permit the medium's continued development. Kalivoda's interest in Moholy's work had to do with his unrelenting drive to bring new media, a modernized vision, and new conditions for art into being. *Telehor* itself was meant to celebrate Moholy's achievements, to promote his contributions to revolutionary thinking concerning light and its potential. Advertisements announcing its publication, it should be noted, featured Moholy's photograms and not his paintings.[43]

There is a tension at play in *Telehor,* manifest in Kalivoda's desire to promote Moholy's prophetic vision of a luminous future, and in the artist's own wish to lay bare the difficulty of such a task. Kalivoda's question—"Why paint?"—expressed surprised not only at Moholy's return to painting but also at his renewed reliance on traditional art exhibitions for the presentation of his work. Moholy responds that he had abandoned the two activities because they felt "out of date and insufficient for the new requirements of art at a time when new technical media were still waiting to be explored."[44] He continues, "You have every right to ask, why I gave in [*warum ich die waffen streckte*], why I am painting and exhibiting pictures, after . . . having recognized what were the real tasks confronting the 'painter' [*maler*] of today."[45]

The language of Moholy's letter to Kalivoda is striking, for it avoids the direct, confrontational force of even recent writings, including his "Open Letter to the Film Industry," which was republished in slightly modified form in *Telehor* as well. The word *painter* appears in quotation marks, setting it apart as a problematic term but also marking it as a notion to be recuperated: the quotation marks serve to protect and embrace rather than to bracket off and disavow. The phrase *warum ich die waffen*

streckte simply means "why I gave in," but it translates more literally as "why I laid down my weapon." This turn of phrase vividly recalls the militant language pervasive in debates about painting and photography in the twenties, about photography's potential as a weapon and painting's apparent inability to induce revolutionary change. Moholy returns to this question time and again throughout his life. "Youth has every right to know why our claims have failed, why our promises have remained unfulfilled."[46]

In this text, he attributes his struggle to develop and finance his ambitious technological projects to the broader systemic failures he partially laid out in "Open Letter to the Film Industry." The technical, material, and infrastructural requirements needed to realize the full potential of *Light Prop* or cloud painting remained out of reach for the lone artist. But even if such projects could come to fruition, in Moholy's view, few industries would be prepared to make use of the artist's discoveries in the service of enriching our perceptual faculties. The problem is not confined to style or medium: there is "above all the basic discord between man and his technical achievements, the retention of antiquated forms of economic organization in spite of changed conditions of production, the spread of an outlook inimical to biological necessity."[47] Moholy maintains that the fundamental hostility to embracing technology as a means to liberate man from his toils and to support rather than undermine his biological needs stems from "the rapid spread of industrialism and the fact that it has been forced into the wrong channels by our capitalist production."[48] Every attempt to alleviate this situation through coordinated action and planning "necessarily encounters the conscious or instinctive resistance of the ruling caste of society. And for the same reason every creative achievement, every work of art prognosticating a new social order and striving to restore the balance between human existence and industrial technique, is categorically condemned."[49]

Moholy contends that technological progress under capitalism has been directed toward perverse ends, to the production of sensational materials—news, images, and commodities—that do little to contribute to healthy human existence. Urban life, "press, photography, films and the rapid and uncontrolled spread of civilization have leveled our color sense to a scale of grays from which most of us will have greatest difficulty in escaping." Thus, he believes that one of the most pressing tasks at hand for the artist is to help people "regain the receptivity for color that we until recently possessed. We must escape from the exuberance of uncontrolled emotion in our handling of color and learn to raise the struggle for a mastery of optical technique to a constructive level."[50] Modernity, Moholy argues, has sapped the world of the pleasure of color—against the ubiquity of black, white, and gray, the task of the artist is to restitute our sensitivity to color with rigor.

Moholy remarks to Kalivoda that what he achieved with *Light Prop* represents "only a very modest beginning, an almost negligible step forward."[51] In a world where the logic of industrial capitalism remains inescapable, Moholy's projects would find no place. Where his "Open Letter to the Film Industry" in *Ekran* demanded that industry extend

the "artist sovereign access to the means he requires," the letter to Kalivoda recognizes the impossibility of such systemic change. He argues that sovereignty of means is available only to the painter, whereas "the designer of light displays is only too often the slave of technical and other material factors, a mere pawn in the hands of chance patrons." His justification for his return to painting is riven with a sense of loss and regret. Moholy might have caught sight of the future that could be attained through existing technologies, but as long as industries and governments prevented his access, painting would have to continue to enable the speculative, experimental work of *Gestaltung*. For the same reasons, art exhibitions too would need to continue to function as the imperfect means through which the results of his experiments could be communicated.

Moholy felt the pressure of "chance patrons" in the thirties. His access to the technologies that he felt held the most promise was regulated by interests wholly different from his own. *Light Prop* had been built with the expertise and resources of AEG, but without its continued support, the machine became stillborn technology, a memorial to an unfulfilled dream. Moholy's film ideas—abstract, experimental, and devoid of narrative or plot—found little interest among studio heads. As funding opportunities for film and theater projects disappeared, Moholy and the Berlin studio he ran grew ever more dependent on commercial design projects to sustain them.

Moholy still bristled at suggestions that the Bauhaus had become shorthand for a style of luxurious modern design. But it was the strength of that association that enabled him to secure a series of relatively stable positions—as creative director to several publications, and as marketing designer for retail stores. He and several other former Bauhaus students and faculty contributed to *die neue linie*, a fashion magazine targeted at self-described modern women with disposable incomes.[52] Bauhaus was a part of its brand identity—the magazine devoted an extensive, lavishly illustrated feature to the Werkbund exhibition in Paris to celebrate the achievements of Bayer, Breuer, and Moholy, touting their roles as members of *die neue linie*'s creative staff.[53] There were subtle attempts to continue encouraging some of the more socially progressive aims of the Bauhaus, such as a feature by Gropius on the future of high-rise living and the egalitarian ambition of such projects.[54] However, the magazine itself was undeniably a luxury, well out of reach for the average worker, with its regular features on travel, fashion, and interior decorating directed to the upper classes. Moholy's cover designs speak to its target audience. For example, a cover from 1931 shows a glamorous woman collaged into a vibrant modern interior furnished with Marcel Breuer's iconic tubular steel furniture and a rug of abstract design (fig. 4.6).[55]

The same month that issue appeared, Moholy's marketing campaign for the men's clothing chain S.S. Kettenläden, which specialized in mass-produced menswear with suits available at four different price levels, garnered interest from the advertising industry. The bilingual trade magazine *Gebrauchsgraphik: International Advertising Art* drew attention to Moholy's designs as powerful tools with which retailers could attract

a weary consumer base back to the store. In one ad, instead of simply cataloging suits
for sale, Moholy publicized the arrival of a new line of herringbone with a visual pun
on *herringbone* achieved through the use of a striking X-ray image of a fish skeleton (fig.
4.7).[56] In another, he shows a close-up of a happy couple looking forward to an upcom-
ing sale marketed with the slogan "Half the Price, Double the Joy" (fig. 4.8). For H. K.
Frenzel, editor of the magazine and author of the feature "Where Is Advertising
Going?," effective ads were necessary to help resolve the dire global economic crisis—
and to "break" the scourge of what he describes as "the consumers' strike."[57]

FIGURE 4.7
László Moholy-Nagy, advertisement for herringbone suits at S.S. Kettenläden, published in *Gebrauchsgraphik: International Advertising Art* 8, no. 5 (May 1931): 31. © 2018 Estate of László Moholy-Nagy / Artists Rights Society (ARS), New York.

FIGURE 4.8
László Moholy-Nagy, advertisement with the slogan "Half the Price, Double the Joy" for S.S. Kettenläden, published in *Gebrauchsgraphik: International Advertising Art* 8, no. 5 (May 1931): 31. © 2018 Estate of László Moholy-Nagy / Artists Rights Society (ARS), New York.

"Joy" was hard to buy in 1931 and the "consumers' strike" even harder to break. Unemployment reached over 20 percent in Germany that year and the economy suffered massive deflation, a situation made all the more worrisome by regular reports of bank failures.[58] Moholy's designs for *die neue linie* peddled Italian cars and holidays in Switzerland that few could afford, while the suits he promoted cost about a third of what an average worker made in a month during the best of times.[59] Still, fashion and advertising commissions sustained Moholy's Berlin studio, and his income was bolstered by his appointment in 1931 as creative director of the trade magazine *Der*

Konfektionär (Ready-to-Wear). In 1933, the magazine was Aryanized, and the publisher fled to Amsterdam to establish *International Textiles*. Moholy followed, initially out of a sense of economic rather than political urgency. His second wife, Sibyl, remained in Berlin, helping to oversee the operation of the studio while he worked in the Netherlands as creative director to that publication.[60]

His position at *International Textiles* gave him the resources to research color photography and its commercial application in print media. Just days before he started work at the magazine, he traveled to London, where his ex-wife, the photographer Lucia Moholy, lived. He spent time in the darkroom learning different processes of color photography from her. In a letter to Sibyl, he exclaimed that it was an "endlessly fascinating" but "demanding craft," expensive and difficult to master.[61] In 1934, he returned to London to learn more, but he admitted to Sibyl that he doubted he could convince the magazine to put what he learned to use because of the costs associated with color reproduction.[62] And indeed his superiors resisted his suggestions. Although a few layouts were produced in color, Moholy's use of the medium to serve the demands of commercial design can hardly be described as particularly innovative.

Moholy's letter to Kalivoda, published in *Telehor* in 1936—a defense of his return to painting—also catalogs the disappointments he experienced over the course of these years. It is dated June 1934, but he continued to revise it until September 1935, after he had dissolved his Berlin studio and left the Netherlands for London. In light of this detail, his revisions unexpectedly temper the pessimism of earlier drafts. Although he concludes that his return to easel painting is provisional and that it compensates for the impossibility of fulfilling the "fullest development of optical technique (light architecture)," the final version includes new references to his continued experimentation with "synthetic substances such as galalith, trolit, aluminium, zellon, etc.," retained "as media for [his] work, because the use of these materials in art will help to demonstrate their applicability in a wider sphere."[63] Moholy was continuing to seek viable paths forward for the fulfillment of his aims.

Despite the letter's gloomy tone, the images reproduced throughout *Telehor* illustrate the breadth of Moholy's exploration of light and color across media. A number of photographs and photograms are published as positive and negative pairs, the simple reversal sometimes rendering familiar objects wholly alien and at other times revealing the rich range of effects possible even within the limits of grayscale reproduction (fig. 4.9). *Light Prop* appears repeatedly, not as a failed experiment, but as a brilliant yellow and red schematic drawing, documented through photographs and in filmstrips (fig. 4.10).[64] Eight of his paintings are reproduced in vibrant color, with thirteen more published in black and white. Several of the paintings included are executed on the new material supports to which Moholy refers. In each case, he takes pains to reveal the specificity of their effects as much as possible even in reproduction. New works on transparent plastic supports are lit to reveal shadows cast by painted and inscribed areas.[65] Several paintings are photographed in raking light in order to highlight the varied textures produced on their

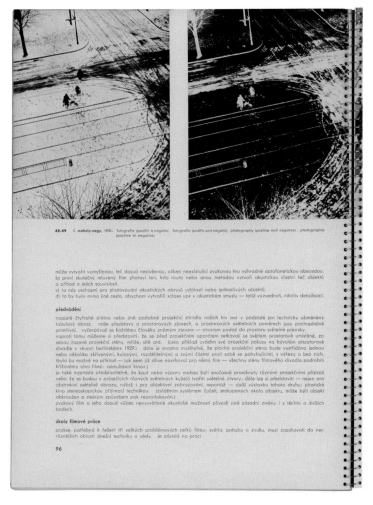

FIGURE 4.9

László Moholy-Nagy, *Photograph (Positive and Negative)*, 1930, published in *Telehor* 1–2 (1936): 96. David K.E. Bruce Fund National Gallery of Art Library, Washington, D.C. © 2018 Estate of László Moholy-Nagy / Artists Rights Society (ARS), New York.

surfaces. *Sil 1* (1933), executed on Silberit, a newly developed aluminum alloy used in aircraft manufacture, is photographed from an oblique angle to capture the light and shadows cast from overhead atelier windows.[66] Moholy's desire to convey that reflective effect leads to the publication of a photograph skewed so that the rectangular shape of the painting appears as a parallelogram (fig. 4.11).

Moholy wrote with much pleasure about his new paintings on Silberit to colleagues and friends, including Franz Roh, art historian and theorist of photography. In March 1934, Moholy noted how these paintings create "an interesting effect: the colored planes float in an abstract space that is constituted only through reflections and mir-

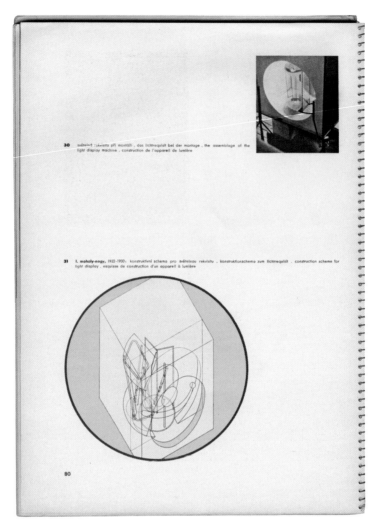

FIGURE 4.10

László Moholy-Nagy, *Light Prop* schematic and photograph, published in *Telehor* 1–2
(1936): 80. David K.E. Bruce Fund National Gallery of Art Library, Washington, D.C.
© 2018 Estate of László Moholy-Nagy / Artists Rights Society (ARS), New York.

roring."[67] In *Sil 1*, Moholy moves away from the strict architectonic compositions of
the twenties and instead opts for free-floating planes levitating above the ripple of
clouds. His approach does not mask the presence of pigment but uses it as a way to
introduce a range of textures meant to create haptic effects and subtle plays of shadow.
Straight, engraved lines barely tethering the colored planes together go in and out of
view as the beholder changes position. With every shift, the space mirrored within the
surface and reflected outward transforms anew. The movement of the viewer galva-
nizes the painting, bringing a range of effects to life.

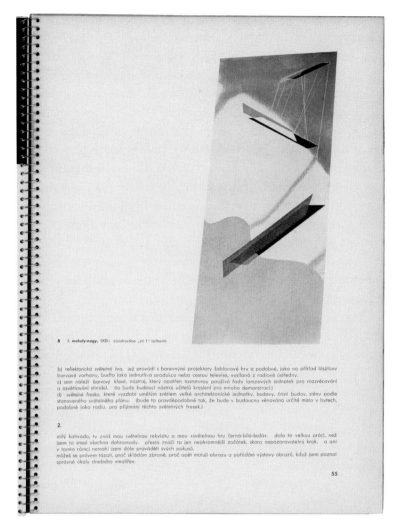

FIGURE 4.11
László Moholy-Nagy, *Construction "Sil 1,"* published in *Telehor* 1–2 (1936): 55. David K. E.
Bruce Fund National Gallery of Art Library, Washington, D.C. © 2018 Estate of László
Moholy-Nagy / Artists Rights Society (ARS), New York.

Paintings are not kinetic objects, and, traditionally, any movement that they might suggest is the product of illusion. However, the use of reflective, translucent, or transparent materials enables phenomena that reveal the dynamics of light and shadow in action, generating effects Moholy hoped *Light Prop* would achieve. In this respect, we should recall that *Light Prop* has no internal light source—and so plays of light and shadow it could produce were created by the ways its materials reflect, refract, and obstruct light. *Telehor,* even within its printed form, attempts to demonstrate how Moholy's most technologically ambitious projects persist in different forms.

Telehor's illustrations are organized roughly by medium: painting, sculpture, *Light Prop,* photography, theater, and film. But the volume's spiral binding—a relatively new innovation in the history of the book—invites the reader to flip back and forth between the illustrations.[68] Thus, formal affinities across images begin to appear. *Light Prop's* distinctive features—its mesh flags, vertical grates, and translucent reflective planes—reappear as specters in photograms. The perforations that pierce the most prominent circular disc in *Light Prop* reveal themselves in altered form along the physical spine of the volume, in several paintings, and as dancing rounds scattered across the colorful surface of *AL 6* (plate 12).[69] *AL 6* is composed of an aluminum plate pierced through with five identical die-cut holes and mounted with brackets in front of a painted wooden plank. The holes in the painting provide areas where real shadows are cast, where light qualities shift with the changes in the surrounding environment. The perforations appear again with painted circles and cutouts found on *Cel 4* (1935), a painting executed on celluloid, a material synonymous with cinema (fig. 4.12).[70] The painting is lit and photographed to maximize sharp shadows, revealing the interplay between the painting and its environment even in black-and-white reproduction.

In these examples, it becomes readily apparent that Moholy painted with *Light Prop* in mind. This is true not only of his experiments on new supports but also of his paintings on canvas. The one painting in which the features of *Light Prop* appear most prominently is *Z VII* in its repaired, repainted form. The similitudes are apparent when the painting is viewed in portrait orientation with a circle at the top (plate 8). In a photograph of the painting's verso, it turns out that this orientation was indicated by "OBEN" and "HAUT," which correspond linguistically to the German and French venues where Moholy showed his works until the mid-thirties (fig. 4.4). The blue dots spread across the parallelogram bear a likeness to *Light Prop's* perforated plate. *Z VII's* circle, which was so obsessively repainted with layers of thick gray paint, takes on the features of a textured metal disc. It is rendered as if in movement, partially enshrouded in shadow and partially caught behind material planes. In this orientation, the painting's sculptural features cohere into a portrait of a levitating light machine of the future (plate 8).

Both *Light Prop* and *Z VII* embrace the failures of their original conceptions to launch other opportunities for the objects. *Light Prop* never operated with particular finesse, and its lofty ambitions were cut short by economic, technical, and material realities. But it nonetheless became a procreant object for subsequent work, translated into different forms. *Z VII* was first executed in a period in which Moholy's canvases envision a future for painting free of the labor of the hand, either as manufactured pictures or as luminous, dematerialized creations. The tear on the canvas cripples its capacity to sustain such fantasies, but the accident and repair occasioned a shift in Moholy's thinking and practice—leading to attempts to recuperate both an otherwise ruined painting and an inoperable machine.

The salvaged painting, *Z VII,* is the result of rushed effort. Moholy employed what recent scientific analysis suggests to be opaque commercial enamel paints in an

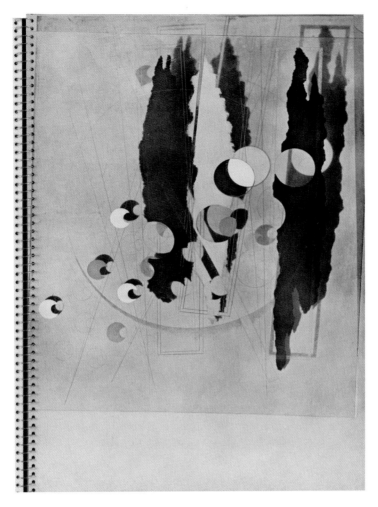

attempt to cover large areas quickly.[71] The tear itself was plastered over roughly, a process visible on historical photographs of the painting's reverse. Thickly applied gray paint buries the trench, with the grain of the brushwork serving as additional camouflage. The central red square puckers from the impatient application of layers of paint applied atop one another without each being allowed to dry thoroughly. That expanse of blue dots is applied with care, but in haste nonetheless. The dots are unevenly daubed with inconsistent coverage. Yet these imperfections are not readily apparent in the color reproduction of the painting on the cover of *Telehor* (plate 13). If anything, the limitations of color reproduction enhance the painting. Evidence of damage, of

wrinkled skins of paint and inelegant brushwork, is absorbed into the halftone matrix of the offset color print. Turned on its side, the planes expand laterally, and the sculptural quality so palpable in its vertical orientation disperses.

Kalivoda writes in his postscript for *Telehor* that the issue is devoted to Moholy's work because it shows the future potential of "light as an artistic medium" through the exploration of new "technical possibilities."[72] Painting, for Kalivoda and Moholy alike, can be seen as "no more than a transitional phase, leading to new and higher forms of expression."[73] Nonetheless, I want to suggest that the presence of *Z VII* on the cover does not contradict these claims; instead, it testifies to how painting advances color photography and its photomechanical reproduction.[74]

Moholy was deeply invested in how the publication would be produced and how the color images would appear.[75] Before *Telehor* went to press in 1936, Moholy examined the color proofs of his paintings, meticulously annotating areas that needed color correction.[76] Significantly, among the color reproductions of his work in *Telehor,* none featured his recently inaugurated experiments in color photography. With the single exception of his yellow and red schematic rendering of *Light Prop*, all the color illustrations in the volume were of his paintings.

The color reproduction of *Z VII*, oriented horizontally on the cover of *Telehor,* doesn't convey the failure of painting or of *Light Prop*. It becomes an annunciation of sorts. The use of gray throughout the painting attempts to prepare the eye—adapted to the black and white of industrial life—to enter a world in color. In part because the print is tinged with yellow throughout, the thick, opaque whites of the original take on an airier quality on the cover. The reproduction warms the entire image, opening the spatial relations within the picture. The plane jutting out toward the lower right, which registers in the painting as a jaundiced extension, reads in the reproduction as a luminous plane of pure, golden light emitting from the complex of shapes. By rotating the painting, embracing its limitation, and exploiting a burgeoning technology, Moholy found a way to articulate a vision that could not have otherwise existed. It is through this process of experimentation that Moholy began once again to paint in pursuit of color photography.

Painting might be provisional, but it is clear that Moholy used it to pioneer technological media. The same year *Telehor* was published, Moholy remarks in a letter to his friend Paul Citroën, "I've incidentally recently been on a very good painting streak. I've been painting for a few months now with real courage and excitement. Mainly I've been working out paintings on rhodoid, a kind of celluloid. I tone them to achieve shadows and color effects . . . I think one more step, and I've figured out a new way to put color film on a new path."[77] Moholy had long been enthusiastic about the possibilities of new materials, but these latest paintings also held out the promise of enabling a "new path" for color film and photography. Moholy had already begun working

with Dufaycolor processes as early as 1933 and later with Vivex while in London (plate 14, fig. 4.13).[78]

In his 1936 essay "Paths to the Unleashed Color Camera," Moholy enumerates the many limitations of color photography, including the impediments posed not only by the complexity of its chemistry and costs but also by the viewer's expectation that it be used only to reproduce the objects and colors of nature.[79] In a move that recalls the strategy he laid out in "Production-Reproduction" (1922), "Paths to the Unleashed Color Camera" argues that the technology of color photography must go beyond

"recording," which simply reinforces existing visual relations.[80] Instead, it must "divorce" itself from "naturalistic-illusionistic meaning" in order to explore "colored form in light."[81] The path to color photography, he continued, must be achieved through a thoroughgoing investigation of painting, because the latter had provided the most rigorous interrogation of color "as expressive medium."[82]

Moholy also describes how his most recent paintings could transform color photography and film. In one piece in particular, he had worked

> the front and back of a transparent material. Adjacent to the colored surfaces there is a perforation. This admits unfiltered light, so that in addition to the pigmentary effect of the painted spaces we have a direct material effect derived from the light striking through upon the background. Thus a kind of spatial kinetics also begins to play its part. When the picture is secured at a certain distance from its background we have effects of light and shade which appear to move as the spectator walks past the picture.[83]

The description could well refer to *Space Modulator Experiment, AL 5*, completed in 1935 and made of three parts: a wooden base, a perforated aluminum plate, and a disc made of Rhodoid, a brand of clear celluloid acetate plastic (plate 15). Overlaid with delicate black rays, the disc is secured with three metal pins attached to a polished aluminum panel, itself covered with a web of red rays emanating from unseen sources. Three die-cut circles corresponding to textured painted rounds on the metal surface offer glimpses of the wooden support beneath. The hole near the center of the picture reveals a roughly painted matrix of red, yellow, and blue. In two places, the red rays on the aluminum extend onto the painted wooden ground. Like *AL 6*, this work also features lines engraved upon the plastic and metal surfaces, elements best seen when the viewer shifts position. Our changed perspective allows us to observe how light filters through the plastic disc, and how cast shadows change the way painted passages register. As Moholy's own account suggests, the work was meant to stimulate our kinetic perception of space by encouraging our movement in relation to it, anticipating the effects of a future abstract color film.

The title *Space Modulator* has a decidedly cosmic ring to it. We might imagine its function as an interplanetary device used to transmit views of the outer cosmos in motion, with planets coming in and out of eclipses, seen against a field streaming with shooting stars. Its orientation toward the future is announced not only by its imagery and title, but also by its material substrate. Aluminum and Rhodoid were both closely identified with the airplane, a most modern invention, ready to launch man into flight. This work and others like it were made in London, around the time Moholy was invited to collaborate with a major film studio to produce special effects for the science fiction film *Things to Come*.[84]

Things to Come was loosely based on a book by H.G. Wells. For a film that opened in 1936, its plot had eerily prophetic elements. The world it imagined would be consumed

FIGURE 4.14
László Moholy-Nagy, *Kinetic Gyros*, ca. 1936,
destroyed, photograph. Estate of László
Moholy-Nagy. © 2018 Estate of László Moholy-
Nagy / Artists Rights Society (ARS), New York.

by a global conflict with civilization, and its technological achievements decimated in
the process. Mankind enters a new dark age, yet a cluster of scientists, engineers, and
aviators survive. They set up a base in Basra, Iraq, reintroduce the airplane, and bring
about a harmonious age through the judicious use of a sedative "Peace Gas," bombing
belligerents into somnolent submission with no loss of life. Scientific progress returns
as the guiding force for civilization. Human beings come to live under wholly artificial
conditions, without need for sunlight, in interiors furnished with clear, plastic furni-
ture, everything functioning as smoothly as the walls of that world's architecture.
Constant scientific discoveries free the human race of want and disease, but the unre-
lenting drive for technological progress is called into question by a sculptor. In this
science fiction scenario, the artist leads an armed rebellion against the development
of a space program, which emblematizes the pursuit of progress for its own sake,
unmoored from the needs of earthbound man. The film concludes with the revolt
foiled and the successful launch of a couple into the stars, their path narrated by a wise
technocrat announcing the promise of a future in space with the line "All the universe
or nothing."

Among Moholy's special effects was a kinetic contraption comprising mercury-
filled tubes that whirled against a mirrored backing (fig. 4.14). We have the photo-
graphic stills of the future Moholy imagined with mock-ups of cities of tilting cones
and crystalline forms. There are brief segments of film that show his experiments with
plastics, metallic, and fluid materials. He was deeply disappointed that few of these
effects were ever used, nor was he credited in the film for his contributions. He chalked
it up to the persistent unpreparedness of viewers to grasp and respond appropriately
to his abstract effects. But perhaps more fundamentally, there might have been a mis-
match between Moholy and the filmmakers' understanding of futuristic materials. For
the filmmakers, plastics signified a technological future in which tensions and con-
flicts had come to resolution, smoothed over like the edges of the streamlined cine-
matic habitat. In contrast, Moholy's work in film was never mere set dressing; instead,

FIGURE 4.15

Prospectus and application form for the New Bauhaus American School of Design, Chicago, "Designed by Moholy-Nagy, printed at the Lakeside Press, R.R. Donnelley & Sons Co., Chicago," 1937. David K. E. Bruce Fund, National Gallery of Art Library, Washington, D.C. © 2018 Estate of László Moholy-Nagy / Artists Rights Society (ARS), New York.

he sought to use the stimulation and agitation made possible by advanced materials to induce in the cinemagoer a modern sensibility, or a new vision.

While Moholy worked in London on *Things to Come,* he also held the post of creative director at Simpson's of Piccadilly, a modern department store, which offered him a degree of stability in exile. The store opened in 1936 as the flagship store for the DAKS line of suits, which advertised its use of factory production to modernize dress and at the same time achieve standards of quality unprecedented in ready-to-wear garments. Moholy was hired precisely because of his Bauhaus credentials and his work on other fashion and retail projects. The merchandise on view might have been machine-made, but it was hardly inexpensive. A single pair of DAKS trousers cost more than half the price of an expertly hand-tailored suit set.[85]

Moholy would never overcome the economic system in which he participated and therefore perpetuated—he would remain beholden to "chance patrons." Yet these same patrons also enabled his experiments with film, gave him access to color photography, and provided him the use of new materials even if unwittingly. Much of his work for *Things to Come* was left on the cutting-room floor, but he walked away with photographic documentation that would serve as the basis of future designs (fig. 4.15).

The metal and plastic sheets broken down from the film's sets were transformed into substrates for Moholy's paintings. Rhodoid, ordered ostensibly for use in his Simpson's displays, was diverted to serve as a part of *Space Modulator Experiment, AL 5,* becoming the clear, scratched, painted portal mounted upon that work (plate 15).[86]

It was in London that Moholy began calling his experimental works on industrial materials *Space Modulators*. The name is evocative and futuristic. But it also offers an apt description of the works' function and origin. To *modulate* is not to revolutionize, but instead to "adjust or to keep in proper measure or proportion."[87] Modulators do not create something out of nothing but instead must change the properties of something that already exists. In electronics and telecommunication, *modulation* describes the alteration of a waveform to allow it to serve as a medium for the transmission of a message. How modulation worked in theory and in practice was also key to understanding the wireless transmission of images. Light modulation and the modulation of signals were discussed in a book published in 1936 to introduce the British amateur to this topic. Wireless image transmission is now commonly known as "tele-vision," or seeing at a distance. The name derives from the Greek *telehor,* which was how its Hungarian inventor Dénes Mihály described this technology in 1919.[88]

Moholy would write critically throughout his career about how capitalism undermines the development and use of technology to support the health and well-being of mankind and how existing infrastructures prevent artists from fulfilling their duty to engender new optical forms with the most advanced technical means. Systemic transformation would be required to resolve these pervasive problems. But by the mid-thirties, Moholy could not wait for conditions to miraculously improve. He intervened in the system in his own small way, by stealing bits of the time, materials, and technical resources from his patrons, and by gathering the detritus and refuse of his commercial projects for use in his painted *Space Modulators*. In these works, he could reign sovereign over domains where capitalism, or for that matter, fascism saw no use.

Space Modulator Experiment, AL 5 integrates every aspect of Moholy's practice, drawing upon his experience as a printmaker, painter, sculptor, photographer, and filmmaker. It is painted and hung on the wall, but its tiered, sculptural relief, as well as its reflective and transparent materials, invites an engagement with the work that differs from the still contemplation associated with easel painting. The viewer is brought into motion, and thus the object awakens. It reflects constantly changing effects, contingent on the lighting conditions in the space around it. The painted expanses of color, suspended on transparent plastic, serve as pathfinders for future possibilities in color film and photography. This object shifts the sensibilities of an individual, however minimally. In that tiny shift, *Space Modulator* endeavors to transmit a vision of how technology might foster the needs of human beings even within this compromised, damaged world.

CONCLUSION

Homecoming

———————

LÁSZLÓ MOHOLY-NAGY'S VOICE was captured in a recording of a lecture he delivered sometime in 1943.[1] Moholy speaks in slow, deliberate, and heavily accented English. Just a scant few minutes recounting his youthful entrée into art remain more or less audible. Even through the thicket of his accent, beneath the skips, jumps, and distortions of the disintegrating recording, one particular detail related to his early thoughts on art survives. He remarks, "My approach was more that of 'hearing' the very significant literary base elements and not the position and relation of line, color, form. I was not conscious then of those elements nor the technique of education." In this address to the general public on the occasion of his retrospective exhibition at the Cleveland Museum of Art, Moholy sketches a picture of himself as a young artist with few inborn talents.[2] He began as so many of us do, attending far more to the narrative, symbolic anchors that aid us in the interpretation of a picture than to the built surface of painting or the structural logic at work in composition. He presents himself as an everyman whose senses were yet untrained.

This lecture became the foundation for an autobiographical text that he drafted in 1944, later published in the third revised edition of *The New Vision* as "Abstract of an Artist." There, he confesses that he did not start out with any ambition of becoming an abstract artist, and was initially "[i]ntimidated by the apparent chaos of contemporary painting, then represented by the Fauves, Cubists, Expressionists, and Futurists," and was attracted instead to the work of the old masters, especially the drawings of Rembrandt, which he emulated in his own sketches.[3] From there, he moved on to study Van Gogh's drawings. That led him to articulate the first artistic "problem" that would guide his efforts in coming years. He observed through his engagement with Van Gogh that "line drawings ought not to be mixed with half tones; that one should try to express three-dimensional plastic quality through the unadulterated means of line; that the quality of a picture is not so much defined by the illusionistic rendering of nature as by the faithful use of the medium in new visual relations."[4]

In "Abstract of an Artist," Moholy reproduced a self-portrait and landscape—both works on paper executed shortly after his medical discharge from the Austro-Hungarian military in 1917—to exemplify this early work.[5] In his self-portrait, a tangle of lines tether dark scribbled hollows of the eyes to the sharp nose, the undulating curve of the cheek to the chin (fig. 1.3). That same jagged, jumpy line is used to describe the pockmarked surface of the battlefield, bound with barbed wire (fig. 5.1). Much of the work Moholy produced prior to his arrival in Berlin in 1920 took this approach, enveloping faces, objects, and scenic views alike with a web of skittering marks.

His essay continues, "The young painter passes beyond dilettantism, mere subconscious doodling and somnambulistic repetition of examples when he begins to discover problems for himself and then tries to solve them."[6] Looking at what might otherwise be dismissed as juvenilia, Moholy identified the value of these sketches in his early development. They "went beyond the analytical intention. The drawings became a rhythmically articulated network of lines, showing not so much objects as my excitement about them."[7] Those tightly wound lines ricochet and peak sharply, producing pictures abuzz with energy. Lines, he discovered, need not subordinate themselves to depiction.

Moholy's early work, from 1917 to 1920, bears very little formal resemblance to the elegant Constructivist compositions of the twenties. However, in works like *Vertical Black, Red, Blue* (1945), executed on Plexiglas during his years in Chicago, the energetic graphic marks of his early drawings and paintings return once more (plate 16). Commercially introduced in 1936, Plexiglas is renowned for its unparalleled optical clarity, but its glassy surface resists easy paint application. Moholy overcame this problem by exploiting another feature of the material—it is easily scuffed.[8] In a work like *Vertical Black, Red, Blue,* each of the colorful, playful forms is applied to areas where the plastic beneath has been prepared with scratches and deeper engraved lines made with a range of tools, some borrowed from the printmaker's workshop.[9] Initially used to

address the practical problem of paint adhesion, the marks Moholy incised onto the plastic also became part of the design—in *Vertical Black, Red, Blue*, the seismic scratching characteristics of his early drawings and paintings frame the lucid center in diaphanous clouds, imparting an effect Moholy likened to the "iridescence which I had admired so much in thin glass vessels buried thousands of years."[10] Not only is Plexiglas transparent, it is also malleable when heated. Moholy activated this quality in these late works. After painting and engraving both sides of a clear Plexiglas work, he would warm it, making it pliable and receptive to its final shape.[11]

The works on Plexiglas that Moholy produced in his late career, exemplified by *Vertical Black, Red, Blue*, were also often called *Space Modulators*. The link between the early drawings and these late plastic paintings is made explicit in "Abstract of an Artist," which opens with a full-page illustration of *Space Modulator with Highlights* from 1942, followed by his two drawings from 1917 (fig. 5.2). This object stands upright, set upon a custom-made wood base, carefully sanded and stained to reveal its fine grain. The candy-colored, ebullient forms dance upon the topography of rolling hills created by the warped plastic sheet. A single, painted white disc floats within an ovoid clearing. From certain perspectives and lighting conditions, the transparent Plexiglas support becomes nearly invisible, and the colorful shapes, suspended in midair, become animated as if in a Technicolor space-age production (plate 17).

Moholy's late corpus is brilliantly, even garishly colorful, executed in a palette most closely identified with print advertising or products destined for the modern home: vibrant juicy orange, gaudy lemon yellow, and richly saturated blue. His experiments with Plexiglas yielded biomorphic shapes, which also populated his late work on flat surfaces, including paper, canvas, and man-made materials that often had domestic connotations. He adopted a pair of red and yellow Formica sheets, ubiquitous in the mid-century home, to serve as the ground for two paintings he made in Chicago, a detail captured in the titles he gave these works—*CH for R1 Space Modulator* and *CH for Y Space Modulator* (both 1942). In these paintings, the forms seem to levitate, but the balance and calm of his Constructivist paintings are nowhere to be found. Instead,

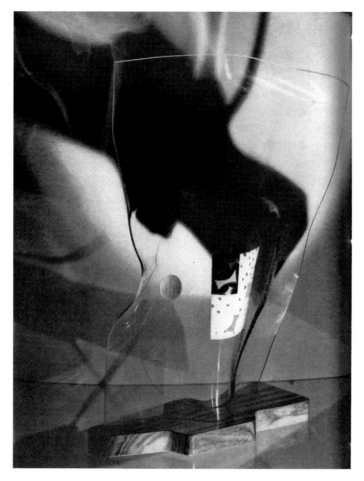

László Moholy-Nagy, *Space Modulator with Highlights* (1942), published in *The New Vision; and, Abstract of an Artist*, 4th revised edition (New York: Wittenborn, Schultz, 1947), 66. © 2018 Estate of László Moholy-Nagy / Artists Rights Society (ARS), New York.

the jumbled elements are captured as if in playful intergalactic free fall (plates 18, 19). Of these works especially on plastic, Moholy himself admits they run into the "danger of pretty effects," acknowledging how closely they skirt the edge of kitsch.[12]

To some scholars and critics, this late work can, as Hal Foster remarks, "look like so much 'experimentalism' . . . or, even worse, like so much research-and-development—research into new substances, development of new products." In an assessment shared by many, Foster continues, "After his arrival in the United States, his critique of capitalism became muted, and more than once Moholy suggested that the logical beneficiary of the modernist evolution in abstract styles was commercial design, and close connections do exist between some of his artworks and his advertisements." In the

same essay, he writes, "Indeed, pared of its residual socialism, 'the new vision' could be adapted to the social, economic and political conditions of corporate America."[13] Foster's account is characteristically precise in identifying the central contradictions in Moholy's artistic enterprise—he did not "fully acknowledge how his technophilia and his humanism might be at odds, and further, how this techno-humanist idealism might be turned to ideological ends."[14]

Foster has little interest in characterizing the avant-garde as a failed enterprise, but this assessment of Moholy's time in America tracks a familiar narrative of his rise and fall that has everything to do with the artist's willingness, if not eagerness, to forge instruments to serve American capitalism out of his utopian ideas. And in some respects, my own account follows the same telos. This chapter will attend to Moholy's American years and the myriad ways in which artistic, philosophical, and pedagogical enterprises were compromised; tools, strategies, and technologies deployed as instruments in projects antithetical to the utopian spirit in which they were once invented. However, as I've already suggested in previous chapters, my conclusion will address how painting becomes the fragile refuge where the trace of the human being might survive. I end with neither triumph nor certainty, which is where the story of American modernism at mid-century often begins. Instead, this account of an avant-garde artist concludes with Moholy's modest attempt at homemaking.

It is hard not to see Moholy's work in the United States as evidence of his willingness to compromise the radical orientation of his early art and thought to conform to American business. After all, Moholy's perceived ability to make design profitable helped enable his escape from Europe. In 1936, he was appointed director of the New Bauhaus, an enterprise funded by the Association of Arts and Industry in Chicago to train students to apply modern design ideas to jump-start stalled consumption in the Great Depression. As we have seen in the previous chapter, such ideas were certainly not unprecedented, nor were they particularly American. But Chicago was especially well disposed to embrace the union of art, industry, and commerce. Already by the start of the twentieth century, Barbara Jaffe notes, Chicago educators and industry leaders agreed that teaching the principles of design permitted students both to appreciate and eventually to produce marketable objects of enduring beauty and function.[15] Moholy's art and theory had already begun to circulate in the United States before his arrival in 1937. As early as 1932, his book *Von Material zu Architektur* (*From Material to Architecture*, 1929) appeared in English translation as *The New Vision*. The book gained attention in progressive education circles almost immediately after its publication, and became an important reference for teachers interested in modern, industrial design.[16] Moholy's reputation as a teacher and leader in design made him an attractive candidate to lead the New Bauhaus. After failing to secure a teaching position in London, and with political and economic uncertainties continuing in Europe, Moholy welcomed the opportunity to shape a new pedagogical program in America

based on his vision of the Bauhaus project. More importantly, the position offered him and his family a path toward stability and safety in a dangerous world.

It is no small feat to garner support for and run an institution in its infancy. In order to make the case for the New Bauhaus, to advertise its methods, mission, and ambition, Moholy edited and rewrote parts of *The New Vision* in 1937. It was to be published expressly to launch the New Bauhaus Book series.[17] Borrowing language Gropius used to justify the practicality of the Bauhaus program in the mid-twenties, Moholy writes in this edition that the New Bauhaus does not "aim at the education of geniuses, or even of 'free artists' in the old sense."[18] He continues, "there are too many 'free artists' with minor talents and minor problems who have no possibility of making a living." Students of the New Bauhaus "must see themselves as designers and craftsmen who will make a living by furnishing the community with new ideas and products. This is the realistic basis of workshop training."[19] This no-nonsense language speaks to the industrialist, the potential donor, and to a public wary of the eccentricities of the artist, impatient for returns on dollars invested in design education after years of economic hardship. Moholy adopted this rhetoric in part because conditions in the United States appeared to mirror the contentious final months of the Bauhaus in Weimar when the school fought to justify its continued existence. While the setting for the New Bauhaus may have been American, Moholy anticipated the recurring challenge of justifying art's role in training workers for an industrial economy. Yet instead of having to depend on fickle public funding, Moholy was grateful for the prospect of private support through the Association of Arts and Industry.[20]

However, the New Bauhaus was short-lived. Private sponsorship of the school, it turned out, was unreliable. The association suffered enormous losses in the stock market in fall 1937, throwing its finances in disarray just as the school opened. Aware of the school's uncertain future, Moholy embarked on a grueling fundraising trip over the summer of 1938 that yielded no additional investments. He was informed that the New Bauhaus would not reopen for that fall after less than a year in existence.[21]

It was an unfortunate turn of events. The closure of the school coincided with the publication of the revised edition of *The New Vision* as well as with the Museum of Modern Art exhibition *Bauhaus 1919–1928* later that same year. For some, the school's failure was a general indictment of the Bauhaus enterprise. In her letter to the *New York Times,* affirming Edward Alden Jewell's dismissive review of the MoMA exhibition, former Bauhaus student Nathalie Swan argued, "I do not believe that this culture which, even at that time, was without roots in the economic and social structure of Germany, can or should be transplanted here." Her conclusion is damning: "The Bauhaus having moved from Weimar to Dessau to Berlin to Chicago, and having failed through its own weakness to acclimatize itself, has shown its ghostlike nature. This exhibition in the caverns of Radio City is a final danse macabre."[22] The fact of the school's itinerancy and its inability or unwillingness to assimilate itself to its environment proved, to her, the weakness of the endeavor. These criticisms, delivered in the

pages of the *Times* in 1938, were directed at the Bauhaus and its failures, but Swan's language and logic would have been felt with particular force by émigré artists and intellectuals. America might have taken Moholy in, but in the thirties the nation hardly held positive views of European refugees—eighty percent of those surveyed by *Fortune* magazine in 1939 opposed their admittance.[23] For Moholy, itinerancy had become a fact of his existence, adaptation a challenge he had to confront in order to survive, and becoming a ghost was quickly turning into a very real possibility for those who could not leave or could not stay where they arrived.

Following the debacle that unfolded in the pages of the *New York Times*, Alfred Barr and Moholy, among others, mounted a defense of the school and its contributions to American design and progressive education.[24] This controversy was not all negative— it piqued curiosity about the Bauhaus in America. By Christmas of 1938, the second revised edition of *The New Vision* sold out in many stores. Even without funding from the Association of Arts and Industry, Moholy convinced some former faculty of the New Bauhaus to form the core of the School of Design early in 1939. Because the association's closure of the New Bauhaus violated multiyear contracts with faculty, it tacitly agreed to allow teachers to take furniture and equipment in lieu of back pay. These items, requisitioned from the old institution, furnished the minimal new facility.[25] Its first students were those who had started at the New Bauhaus. But these arduous beginnings would improve, especially after Walter Paepcke, head of the Container Corporation of America, became a passionate and engaged patron. He worked tirelessly to promote the school as a valuable resource to the business community—a resource capable of training an effective and efficient corps of technically adept and technologically savvy designers.[26] Once the United States entered the Second World War, Moholy transformed Bauhaus ideas to accommodate the needs of his adopted home.[27]

The war posed an existential threat to Moholy's fledgling institution—rationing of materials and the draft of students and faculty alike made continued operation difficult. To rally support for the program and attract new student populations, the School of Design developed several courses directly related to war efforts, including mechanical and architectural drafting for the war industry, blueprint reading, photography for war services, visual propaganda, and model-airplane building. Offered at night, these courses allowed students to continue working and contributing to American wartime production needs while also furthering their education. In 1942, the school sent faculty to the Office of Civilian Defense for training and certification in camouflage, which became an important and heavily attended department within the School of Design.[28] In the first semester the program was introduced, over half of the school's students enrolled in the camouflage course.[29] Ideas that Moholy had once proposed for painting with lights on clouds were translated in this context into proposals for veiling cities with smoke upon which lights would be projected to disorient enemy aircraft. In the realm of product design, he and his students developed objects for both domestic and military contexts, making creative use of limited materials. They designed a wood-

spring mattress that generated royalties from a commercial manufacturer and worked on flat-pack plywood furniture.[30] They proposed helmets, portable landing strips, emergency flotation devices, and other items for use in battle.[31] Moholy created a department focused on work with plastics, materials used extensively in the theater of war. They developed friction-welding methods to repair Plexiglas windshields in combat, techniques that were subsequently tested and endorsed by DuPont, the American manufacturer of the material. Moholy worked doggedly to share his findings with the National Defense Research Committee and later the Air Force.[32]

In each of these examples, Moholy demonstrated his ability to marry art with practical commercial and military applications. Some of his most influential ideas about teaching found use in the service of war aims as well. Recall that in his book *The New Vision*, Moholy inveighed against specialization in modern life, arguing that it often stunts the emotional and biological development of modern man and leads to an experience of life that is fundamentally fragmented, fractured, and alienated. The task of art, its practice, and pedagogy is to aid integration, to engender seeing and being that might make whole what modernity has wrested apart, not through a return to the primitive but instead with technology calibrated to human needs. In wartime, he returned to these ideas and applied them with particular force to a program in which he proposed to use art to help rehabilitate returning veterans, wounded both physically and psychically from battle. An integrative approach would hasten their return to productive society.[33]

His ideas held sway far beyond his own school, finding application in a number of contexts. In 1943, Moholy's work was embraced by the influential Progressive Education Association, which published *Art and Materials for the Schools: Activities to Aid the War and the Peace,* a guide meant for K–12 instructors. In one chapter, the authors argue that teachers must recognize "the tremendous importance of air power for both destructive and constructive purposes. The nations which control the airways will probably govern the peace." For this reason, "aviation education" becomes of crucial importance. "This does not mean that every boy and girl must become a flyer or an expert mechanic, but it implies a need for their awareness and active familiarity with the underlying factors and problems of the oncoming air age."[34] The authors include references to Moholy's work—in particular, how engaging experiments in abstract art would help children learn to interpret the dynamics of speed in flight.[35] Salvation from this violent age, the authors suggest, would be predicated upon training our children to see like aviators—with eyes accustomed to the view from above—unmoored from earth, soaring at speeds only machines can achieve.

This book began with Moholy on the battlefields of the First World War—an artillery reconnaissance officer in the Austro-Hungarian military learning to see, fighting for an empire that would cease to exist by the close of that conflict. We witnessed how he transformed his training in that context into values and resources he would draw upon

in his art and thought. Where human beings served the requirements of the machine in combat, Moholy sought to devise strategies and techniques to transform technology into instruments that could enhance the health and development of humans as biological, psychological, and social beings. Technological perception, precision, and exactitude became signal virtues for him when their deployment was redirected toward life, not death. In this respect, *Constructions in Enamel,* I would argue, is an exercise in speculative cartography and imagined telephony, adopted in the service of sensorial training for peace, not war.

The relationship between man and machine, however, always stands in precarious balance. Even in Moholy's thought, the fantasy of creative liberation through technology often appeared to promote the unquestioning embrace of its use at the expense of basic human needs, biological and social. At the Bauhaus in Weimar and Dessau, the desire to prove the productive potential of unifying art with technology led to creating an aesthetic in his own art and in his students' designs that conveyed a world of perfectly polished serial objects and luminous harmonious structures. That vision of modernity belied the extravagant labor and resources expended in the manufacture of these products—rendering them affordable only to the very few. Over the course of the twenties and thirties, Moholy had to contend with the reality that what he postulated as possibilities for the near future—seemingly so close at hand and achievable with what he thought were existing means—would be nearly impossible to attain under the conditions in which he lived and worked. Moholy consequently would need to apply his ideas and talents to domains that appeared to run counter to the idealistic aims he espoused. His positions in advertising and publishing leveraged his reputation to promote luxury goods and lifestyles. His association with the Bauhaus as a vocational and industrial design school prepared his escape from London to Chicago. We might argue that his accommodation to American capitalism was extensive, if not total, evident even at the level of his sartorial decisions. Moholy exchanged his engineer's jumpsuit from his time in the Weimar Republic (fig. 0.1) for the businessman's suit in Chicago (fig 5.3).

It's a far cry from how we picture him in his youth. The contrast is perhaps most dramatic when we juxtapose the portrait of Moholy in Chicago with a photo taken in the fall of 1922 at the Dadaist-Constructivist Congress in Weimar (fig. 5.4). The Weimar group is friendly and uproarious. Newlyweds Lucia and László Moholy-Nagy look on with El Lissitzky at the scene unfolding before them with an amused expression— Werner Gräff has Hans Richter pinned down with his cane, Tristan Tzara plays gentleman with Nelly van Doesburg, and her husband, Theo, wears *De Stijl* as fashion accessory, strapped to his hatband like a paper stovepipe. The photo captures the sense of possibility at play in these early years. Unexpected artistic alliances were forged in order to transform the world with a concept of art wholly redefined. The horrors of the war stiffened their collective resolve to set aside, if not actively destroy, the conventions and values that made such conflict possible. On the battlefield and home front

alike, each artist witnessed the transformative power of total war, in which technology, economy, and culture were mobilized in an integrated manner in the service of international conflict. Around them, existing values, conventions, institutions, and even nations would be leveled in the wake of the Great War. Tabula rasa, a slate blasted clean, was not simply a metaphor for their point of departure; it was, in some respects, an accurate description of their reality. Given the urgency of the needs revealed in the aftermath of destruction, the artist could no longer remain above the fray but had to become pathfinder and agent of the new. Even the most nihilistic Dadaists shared a belief that by freeing artistic activity from the atelier, allowing it to spill out onto the unruly streets, new worlds of possibilities could be unlocked. Constructivists envisioned the use of publications, exhibitions, and industrial design to bring a modern future into present being.

Manifest in that playful photograph and in the pages of avant-garde publications of the Weimar years is a faith in the heroic capacity of the artist to serve as the vehicle of modernization. Modern design practices in architecture, advertising, and print would permeate everyday life and establish the foundations for a transformed social sphere. Benjamin Buchloh aptly describes this as the "delusion in the 1920s on the part of the

FIGURE 5.4
Dadaist Constructivist Congress, Weimar, 1922.

historical avant-garde." They believed that "they could cooperate with, if not coopt and optimize, the dynamic conquest of public visual experience upon advertising's first triumph."[36]

The avant-garde—as would become amply clear in the thirties—had little, if any, ability to dictate the terms in which their designs would be deployed. Nor would the modernization of the visual realm lead to the progressive and revolutionary ends to which they aspired. If anything, the economic and political crises between the wars only revealed how dependent the avant-garde was upon the industries they hoped to coopt and transform.

The depth of what Buchloh couches as avant-garde delusion, we might argue, is proven by how much thinkers and artists would contort themselves to accommodate new conditions radically different from the modern world they once envisioned. Moholy was hardly alone on that count. Examples abound, including early attempts to align modernist projects with newly powerful fascist powers in the thirties. Already in June of 1933, the executive council of the Deutscher Werkbund—renowned for fostering modern, industrial design and partially responsible for the success of the Bauhaus during the Weimar Republic—voted overwhelmingly, with the exception of Gropius, Wagenfeld, and Martin Wagner, in favor of voluntary coordination (*Gleichschaltung*) with the Third Reich.[37] In 1934, even Gropius, along with Herbert Bayer and Mies van der Rohe, would contribute to the design and development of *German People—German Work* (Deutsches Volk—Deutsche Arbeit), an exhibition organized by the Reich Propaganda Ministry to promote the ideas of racial hygiene and its role in productive labor.[38]

Wagenfeld, despite his public criticism of the Nazis, was able to continue exhibiting and working in Germany throughout the thirties and forties, and was even appointed to help design the German Pavilion at the 1937 Paris World's Fair.[39] Another Bauhaus figure, Xanti Schawinsky, would spend much of the thirties creating iconic posters for Illy coffee and for Mussolini. Schawinsky's escape from Europe was made possible through a teaching appointment at Black Mountain College; later he would join Moholy's faculty in Chicago.[40]

These were not isolated incidents. Many artists and intellectuals who might have denounced the Nazis in public or private—before, during, and/or after they went into exile—nonetheless attempted in the initial months and years of the Third Reich to find a place within the new order. Some did so out of a sense of loyalty to the German nation, others out of economic necessity, out of a desire to stay in familiar surroundings, or out of sheer disbelief at the permanence of the changed environment. As Karen Koehler has shown, even after Gropius came to the United States to lead the Graduate School of Design at Harvard in 1937, he still held out hope that he would one day return to Germany. For this reason, he assiduously avoided public condemnations of National Socialism—all the while working privately to assist others to flee from Nazi persecution. These parallel tactics were strategic. Becoming an enemy of the state would lead to the confiscation of his German assets and eliminate the possibility of his return, but the motivation was not simply monetary. He and others feared that criticism could endanger friends, family, and colleagues still in Germany.[41]

Once the United States joined the war, many in the émigré community, like Moholy, committed themselves to the cause of national defense. Konrad Wachsmann, who worked with Gropius to develop low-cost prefabricated housing at Harvard, and legendary modernist architect Erich Mendelsohn became consultants to Standard Oil and the American military's Chemical Warfare Service. In 1943, their expertise in housing was used to replicate German working-class apartment blocks on the Dugway Proving Grounds in the Utah desert. Completely furnished down to the bedding, curtains, and toys found in a typical proletarian home, these buildings were constructed, destroyed, and reconstructed repeatedly to fine-tune incendiary bombs later used on German cities. Their work contributed to the refinement and development of napalm as a weapon.[42]

In light of these episodes, it would indeed appear delusional to believe that the avant-garde had any chance at bringing their vision of the future into being by coopting advertising or any other arm of industry. Max Horkheimer and Theodor Adorno's *Dialectic of Enlightenment* (1944), after all, has taught us that all enterprises can be ideologically hijacked, commandeered, and compromised both externally and internally.[43] Published as the war continued and as news of fresh atrocities emerged with regularity, the authors sought "to explain why humanity, instead of entering a truly human state, is sinking into a new kind of barbarism."[44] The answer they proffer is fragmented, but it might be summarized as a tale of survival gone hideously awry. Primordial man made use of reason in

order to endure the sheer brutality of nature—thus cunning is enlisted as the instrument with which human beings transform the chaotic contingency of experience into materials they are able to exploit to their ends. Civilization is forged out of the instrumental deployment of reason, but that impulse to dominate becomes the source of its barbarism as well. Faith in reason's total capacity to know and to master only grows with enlightenment and its consequence, evident in the horrors of war. Neither concentration camp nor culture industry was anomalous or irrational, they would argue. We might say that they were both the fruits of the enlightenment's inherent vice.

In scholarship, we might turn to critical theory to supply us with a theoretical or interpretive framework. We teach it as part of our methods. But in the analysis of the avant-garde, and crucially of its seeming failures, we should view the conclusions of *Dialectic of Enlightenment* with particular alertness to the fact that material, economic, and political pressures are lived, and any thought or expression cannot help but bear their force. This work grew out of the experience of exile. The narrative of survival in which cunning enables not only continued existence but also unexpectedly gruesome consequences distills the experience of so many artists and intellectuals between the wars, both those who went into exile and those who remained. They each turned their talents into instruments with which they could justify their employment, secure papers, and continue to fulfill their most basic needs, while often serving ends that were out of their control. But of course, no absolution is granted in Adorno and Horkheimer's account, nor is it ever on offer in this monstrous world.

Moholy was hardly delusional even in the twenties; he was alert to the constraints under which he had to work and the contradictions he would have to sustain throughout his career. To each impediment he encountered, he attempted to develop new tactics, at times by making use of proxies. For example, in some of his earliest writings detailing his most ambitious technological projects, he admits the difficulty of their pursuit under capitalist conditions. He recognized as early as 1924 that his film idea, *Dynamic of the Metropolis*, could not be made within the existing studio system. Yet the film could still be presented provisionally as an example of typophoto—print made visceral through dynamic juxtapositions of word and image. The Bauhaus's inability to access investment capital and large-scale manufacturing capacity led Moholy to conclude that the small-batch production of luxury goods was justified as the only viable path to fulfill the school's self-declared mission: to serve as a laboratory for developing standards for future industrial manufacture. Protesting what he saw as an increasing emphasis on immediate results—a consequence of the appointment of Hannes Meyer—Moholy resigned from the Bauhaus in 1928, not to leave teaching, but, in a seeming paradox, to continue teaching. He turned to print once more as a proxy, publishing *From Material to Architecture* in 1929 as a way to sustain what he saw as the ideal balance in an educational program, dedicated to integrative perceptual training rather than achieving short-term results.

Throughout these years, there exists in Moholy an undeniable optimism. He had faith in progress and believed that true transformation was around the corner once new resources, instruments, and technologies could be secured. However, by the thirties, he came to understand how difficult it would be to pursue the technologically advanced projects he once imagined were readily achievable on his terms—the costs were too great, and not limited only by economic formulations. The lone avant-garde artist would, after all, never have access to what Albert Speer had at his disposal, both in terms of resources and political support. Moholy's desire to remain in contact with the latest developments in film, photography, and material science led him to work in advertising, promoting luxuries that appealed to those who could still afford to spend in the midst of a global depression. It was in the context of exile, faced with the precariousness of that existence in which survival was often predicated on compromise and the largesse of "chance patrons," that the autonomy of the work of art, however circumscribed, became a pressing question for Moholy and for other intellectuals as well.

In "Avant-Garde and Kitsch" (1939), Clement Greenberg remarks: "No culture can develop without a social basis, without a source of stable income. And in the case of the avant-garde, this was provided by an elite among the ruling class of that society from which it assumed itself to be cut off, but to which it has always remained attached by an umbilical cord of gold."[45] A stable source of income was highly coveted in a world racked by the Great Depression, all the more so for the millions displaced through forced exile. Moholy's pursuit of financial support led him to recast his mission for different audiences, to translate his aesthetic into forms usable for a range of contexts, commercial and otherwise—a process that he knew could jeopardize the reception of his art as little more than "'modernistic' kitsch."[46] He felt the pull of that cord in its constant threat to break or weaken, but, just as powerfully, he became keenly aware that whatever nourishment the cord provided could just as likely deform or abort his artistic enterprise.

Out of that experience, Moholy concluded that his vision could be articulated with anything resembling "sovereignty" only in painting, made with his hands, with paint and brush, on materials reclaimed out of the scraps of a damaged life. In that respect, it is perhaps no accident that Moholy would confide in Gropius in 1938 that he considered himself first and foremost a painter, a claim he would restate with urgency to Sigfried Giedion and Carola Giedion-Welcker shortly before he died in 1946.[47]

Moholy began his career as an artist who, like so many other avant-garde artists of his generation, explicitly embraced the transformation of art into an instrument of modernization. Instrumentalizing art would allow the masses to take hold of it as a tool of perceptual refinement and as a disruptive mechanism capable of transforming technology from that which enslaves human beings into the means for their liberation. However, over the course of the thirties and forties, what emerges in Moholy's work is an attempt to reassert the autonomy of art that he and the avant-garde once derided, to preserve it as a refuge for what might still be described as freedom in what Adorno

would characterize as an administered world. Art's autonomy, however, is never total—and is fundamentally weak. Any freedom that could be glimpsed by art would stand in proportion to its uselessness to the existing world.[48]

Moholy understood how suspect the pursuit of art, unrestrained by the pressure of direct utility, appeared to a nation intent on immediate results in times of economic hardship and, later, in a time of war. But even as he advertised the School of Design's emphasis on training students for a "world of machines," even as he eagerly pointed to innovative solutions for the material shortages of war and promoted the idea that new efficiencies could be wrought through modern design, Moholy worked privately to secure spaces in which "free art" could continue to be pursued.[49] In a letter to architectural historian Nikolaus Pevsner in 1943, he admits that the school's program

> is set up for designers and architects with the integration of art, science and technology in mind. I am convinced that a balanced education in intellectual and emotional matters is the main requirement, which means that all our students have time to work on free art problems besides on scientific and technological matters. For practical reasons, however, we officially emphasize at present more the scientific and technological approach, as with our meager budget situation we constantly have to prove with practical products that we are worthy of support.[50]

Moholy's pursuit of his own "free art problems" took place in his late paintings, his sculptures, and, crucially, his *Space Modulators*. They were made using materials recycled from the school's practical experiments, executed at night and on weekends and in the snatches of time he had away from his official duties as teacher, administrator, fundraiser, and designer. Even as he outwardly extolled the efficiencies that new materials like plastics could afford for mass production, his own use of the material in his *Space Modulators* is evidence of manual effort and lavish attention. In 1943, he argues that his painted plastics and aluminum works are experiments to lead the way to new industrial uses—yet his approach, if anything, seeks to undermine their utility in the conventional sense.[51]

Moholy's *Space Modulators* cannot be reproduced at a factory; they even resist photographic reproduction. They are not durable objects, but instead are extremely delicate and unpredictable. Within his own lifetime, a number of his plastic pictures, despite his careful packing and detailed instructions, cracked at exhibition or in transit.[52] Unlike damage to painting on canvas or to sculpture in more traditional materials like stone or metal, cracks that develop in these works in plastic cannot be restored by filling losses or nicks. Put simply, artworks executed in traditional materials live longer than those in plastic. Plastic can be extremely unstable. Its malleability, its very plasticity, relies upon the use of acids that are neutralized at the end of production. Differing levels of residual acid in individual batches even of the same

brand or formulation of plastic can lead to radically different life spans. As acids evaporate, hairline fractures appear. In the vocabulary of conservation science, plastics craze—they buckle or shatter of their own accord, their durability undermined by inborn material characteristics, what conservators call inherent vice.[53]

We should also note that despite the associations Moholy courted with plastics in public—those of science and technology, laboratory experimentation and factory production—Moholy made his *Space Modulators* in the privacy of his own home. His daughter, Hattula, recalls him at work in the kitchen on weekends with his scratched, painted Plexiglas sheets. As a young girl, she watched him heat the plastic in the oven. Once sufficiently warmed, these works were shaped with his bare hands. Her childhood memory is confirmed in a letter Moholy wrote advising a colleague on the properties of new plastic materials and their handling.[54] In a number of ways, the picture of him at work alongside wife and children in his Chicago kitchen offers a slightly absurd tableau of the avant-garde quite literally domesticated in America, so different from the image we usually have of the heroic interwar European avant-garde, say, that of El Lissitzky the constructor or Rodchenko researching form in his studio-laboratory (figs. 5.5, 5.6). But seen against the backdrop of the thirties and forties, when heroes were few and crimes were many, when the techno-utopianism of youth was confronted by the techno-determinism of fascism, totalitarianism, and capitalism, the domestication of past ideals might not be so terrible. After all, the word *domesticate* means to bring something "in intimate association with and to the advantage of human beings."[55] This would seem to represent one of the few ethical positions one might take under those circumstances, resonant with a dominant preoccupation in Moholy's thought. The possibility of domestic life, that is to say of homecoming, was also an abiding concern in his American years.

It is difficult to approach the years between the wars without viewing it from our retrospective vantage point, with full knowledge of what is to come. The luxury to assess a situation at a distance, that is to say with perspective, proves difficult, if not utterly impossible, when living in quotidian time. Moholy's correspondences with his wife from those years are telling in that respect. They are affectionate, but dominated by everyday concerns about expenses and contracts, as well as opportunities won and lost. Politics figure less overtly, mostly written in asides. In 1935, after they had moved to London, Sibyl asked Moholy not to return to Berlin that summer during his travels on the continent, simply because she had "a bad feeling" about the idea.[56] Yet she felt safe enough to travel to Dresden and leave her children there with their grandparents while she prepared their move from London to Chicago in the summer of 1937. On August 6, she reports to Moholy, already in Chicago, about her annoyance at having to deal with the German embassy and British home office to allow her nanny to bring the children back to England after their visit with the grandparents in Dresden. There is no sense of danger in her recounting, just irritation at the bureaucratic details. On

FIGURE 5.5

El Lissitzky, *Self-Portrait: Constructor,* 1924. Gelatin silver print, 10.7 × 11.8 cm. Victoria and Albert Museum. © 2018 Artists Rights Society (ARS), New York / VG Bild-Kunst, Bonn. Photo Credit: V&A Images, London / Art Resource, NY.

August 10, she conveys her growing sense that war hysteria is beginning to sweep across Europe, evident in the shift in British politics to the right. But she concludes that she simply does not believe that Germany will go to war—"the blockade has weakened them and has weakened their ability to rest enormously. The people are malnourished and overtaxed."[57] She was well informed and distressed by what she witnessed in Germany, but it is clear from these letters that she did not view the events unfolding as posing a direct threat to her or her family. When she sailed with her children to America in 1937, she still believed that she would return to Europe and that her parents would see their grandchildren again. Her attachment to Germany was to her family and to a place she still could call home.

By 1945, Sibyl's world had changed. An agonizing private diary entry that year reflecting on the declaration of victory in Europe discloses that she felt no joy in the occasion. In English, she writes:

> This is Sunday, May 13th 1945. It is a lovely Sunday. Following one of the very few routines we have been able to establish—and which gives our family life a semblance of uniformity with other middle-class families—Laci [László] has been taking the children for a walk in the park while I made the beds and cooked Sunday dinner . . . So

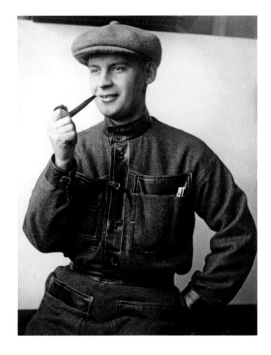

FIGURE 5.6
Alexander Rodchenko, 1923. Moscow Photo
Museum (House of Photography). © 2018 Artists
Rights Society (ARS), New York / VG Bild-Kunst,
Bonn. Photo Credit: HIP / Art Resource, NY.

this is a Sunday like all the other Sundays we have tried to establish after a middle-class dream pattern—hoping against probability to give our children the security and unobtrusiveness prescribed by psychologists as so wholesome to individual and society. But something is different. This is May 13th and May 8th, last Tuesday—was V-E Day: last Tuesday was

> the end of the European part of World War II
> the end of National-Socialism in Germany
> the end of Adolf Hitler, of Goebbels, Goering, Papen, Himmler.[58]

This diary entry expresses something of the everyday experience of the family in exile—of the self-conscious struggle on the part of parents—to create stability and offer children a sense of routine and normalcy that does not come naturally or easily, but is hard-won. She continues:

> There is an unwritten code among emigrants—even when you are married. . . . Every reference to Europe or to the past is guarded, casual, uttered only after the emotion behind it has been secured safely with an enforced dosis [*sic*] of self-control. There is an emigrant etiquette, and Laci [László] adhered to it the same as I. So the European victory, the defeat and death of the greatest objective enemy we had known in our life-time, the end of twelve incredibly strenuous years, was mentioned between us only in passing.

Nothing escapes the experience of exile, not even the most intimate conversations and interactions shared between spouses. Even there, feelings are suppressed, sentences redacted.

Hannah Arendt made public what Sibyl expressed in private in her essay "We Refugees" (1943), written two years after she arrived in America, well before the certainty of victory was secure. She describes the sense of profound dislocation—the loss of home, occupation, language, and family—and simultaneously of the expectation that, once in the safety of their new country, the depth of that loss will have to be forgotten:

> We were told to forget; and we forgot quicker than anybody ever could imagine. In a friendly way we were reminded that the new country would become a new home; and after four weeks in France or six weeks in America, we pretended to be Frenchmen or Americans ... In order to forget more efficiently we rather avoid any allusion to concentration or internment camps we experienced in nearly all European countries—it might be interpreted as pessimism or lack of confidence in the new homeland.[59]

Arendt's essay is written from the specific perspective of the Jewish refugee, but her description of exile applies in some respects to the experience of someone like Sibyl as well. Sibyl's own diary entry attests to exile's deforming effects, to the ways in which silence and active forgetting were employed in an attempt to adapt to one's new surroundings. Arendt was pointed in her assessment of the imperative to remain silent about one's immediate experiences. She writes, "how often have we been told that nobody likes to listen to all that; hell is no longer a religious belief or a fantasy, but something as real as houses and stones and trees. Apparently nobody wants to know that contemporary history has created a new kind of human being—the kind that are put in concentration camps by their foes and in internment camps by friends."[60]

Sibyl's diary entry from V-E Day testifies to the disconnect between attempting to create the semblance of domestic stability in America and full knowledge of how changed the world had become. On that day, she wrote with particular agony about the relatives she still had in Germany. She notes with bitterness that her father's practice as a prominent architect in the fatherland continued without travail in the war. Her brother died in battle, fighting as a son of the Reich. Her mother and sister, despite their impeccable pedigrees and education, refused to acknowledge the crimes they knew were being committed in their name. Implicated in the atrocities of war, the warmth she once felt for her own parents and siblings went cold.[61] Germany had ceased to be her home, but in America, even on a day that should represent victory, the act of home-making remained fraught.

Longing for home was pervasive between the wars. In *Minima Moralia: Reflections from a Damaged Life*, begun during his exile in California, Theodor Adorno describes the

difficulty—pragmatic, political, philosophical, and otherwise—of making oneself at home, of establishing something like a private, domestic sphere in a masochistically administered world. In a section entitled "Asylum for the Homeless," he concludes with the line "Wrong life cannot be lived rightly" (*Es gibt kein richtiges Leben im Falschen*). There is no good life to be lived in a world as false, as perverse, as monstrous as this. This statement does not permit abdication of responsibility. But it does capture the central dilemmas of the refugee. The desire to preserve one's private sphere constitutes an attempt, however weak and tainted by an attachment to property, to resist a world constantly governing the movement of bodies, identities, and relationships— and by which one's fate will be determined.

Moholy, as a Hungarian, was an alien in Germany as much as in the United Kingdom, subject to the scrutiny such a status entails. In America his foreignness impeded his citizenship process until just months before he died in 1946. His situation was in some ways more precarious than his German wife's, and he sensed the changing situation differently. His work's inclusion in the *Degenerate Art Exhibition* held in Munich in the summer of 1937 represented tacit censure, and his association with the Bauhaus was by then a liability in Germany, to say the least. Acutely aware of the plight of his compatriots, he attempted to use the New Bauhaus and its later iterations to help those trying to flee political persecution in a continent that had become a war zone.[62] Moholy also extended the shelter of the school to students under threat within the United States. In 1942, the School of Design was one of the few institutions to accept Japanese American students who would otherwise have been trapped in internment camps.[63] In addition, from its beginnings, the school accepted African American students at a time when segregation was the norm.[64] None of this is to suggest that Moholy's school operated as a particularly effective charity or rescue service. But the attempt to remain open in the darkest of times and to include those multiply displaced speaks to his impulse.

Moholy's hopes for Chicago went beyond abstract ideas of home. In one of his first letters to his wife from the city in 1937, he describes the strangeness of living in a hotel and expresses the frustrations of being apart, of the complexities of negotiations, and of the foreignness of this new world. Despite these difficulties, he exclaims, "But wait! Family life will come, if this all works out!"[65] For Moholy, beyond the professional opportunities, beyond the respite it would offer from the uncertainty engulfing Europe, the city held out the most intimate promise of home.

There is a world of difference between 1937, when he exclaims with such excitement at the possibility of creating a home in Chicago, and 1945, when the war ends. Compromises were made, atrocities committed, and no one escaped the war unscathed. However, in practice, Moholy attempted to create an institution that was more than a means of escape, more than a potentially lucrative business opportunity built on outdated ideas. His school sheltered people and ideas driven out by an

inhospitable world. And in his own home, he made what are at once his most modest and ambitious works on clear, painted, warped Plexiglas. His *Space Modulators* are not melancholy but are insistently colorful, playful, and cheerful (plate 17). Their billowing forms are made possible with the warmth supplied by the kitchen oven, the same appliance used to heat his family's Sunday supper. There, Moholy created a place where orphaned avant-garde ideals might have room to grow.

POSTSCRIPT

Utopia into Action

Perspectives must be fashioned that displace and estrange the world, reveal it to be, with its rifts and crevices, as indignant and distorted as it will appear one day in the messianic light. To gain such perspectives without velleity and violence, entirely from the felt contact with objects—this alone is the task of thought. It is the simplest of all things, because the situation calls imperatively for such knowledge, indeed because consummate negativity, once squarely faced, delineates the mirror-image of its opposite. But it is also the utterly impossible thing, because it presupposes a standpoint removed, even though by a hair's breadth, from the scope of existence, whereas we well know that any possible knowledge must not only be first wrest from what is, if it shall hold good, but is also marked, for this very reason, by the same distortion and indignance which it seeks to escape.

—THEODOR ADORNO, *MINIMA MORALIA: REFLECTIONS ON A DAMAGED LIFE*

IN THE YEARS MOHOLY CREATED his *Space Modulators,* in which the frenzied marks of his early paintings and drawings return with such prominence in his practice, he was completing his last book, *Vision in Motion*—where his portrayal of the task of the artist resonates profoundly with the artworks he was producing. He opens with a discussion of the "formative ideological function" that the artist must play. As the Second World War has shown, the artist must "take sides and proclaim his stand." However, what Moholy promotes is not an art of propaganda but an alertness to how "the work of the artist corresponds to the creative problems in other fields, complementing them in the

structure of civilization of that particular period."[1] He continues: "Through his sensitivity the artist becomes the seismograph of events and movements pertaining to the future. He interprets the yet hazy path of coming developments by grasping the dynamics of the present and by freeing himself from the momentary motivations and transitory influences but without evaluating their trends. He is interested only in the recording and communicating of his vision. This is what materializes in his art."[2] From such a description, we imagine the artist as a particularly refined instrument attuned to the currents that reverberate through a particular epoch, the needle through which the felt and heard rumblings of an era come to be transmitted in graphic form, zigzagging over time across a page. To conceive of the artist as seismograph is to claim the necessity of his being grounded in the world, in contact with its material conditions. It is only through the intimacy of that contact that the artist might register the seismic shifts, major and minor, that unfold over time. What becomes visible, takes shape, and finds form are the rumblings he captures in his medium. And it is only retrospectively that the meaning of those marks might be gleaned. What characterizes Moholy's art and thought, especially at the end of his career, is a rejection of the classic avant-garde call for a clean slate as the first step toward creating a new future. In his last book, he remarks, "Man cannot turn away either from past knowledge or from present reality."[3]

Vision in Motion was drafted over the course of several years, much of it written as the war was drawing to a close and the challenge of peace approached. It was completed while Moholy underwent treatment for leukemia, written with full knowledge of his own mortality. It was this sense of urgency that led him to advocate strategies that might foster the well-being of human communities through attending all the more to their material, intellectual, and biological needs. The necessity of such an endeavor was unequivocal after all the resources invested or squandered in the service of war, where training emphasized fitness to work and fight, demanding the fragmentation of human experience in the service of specialization.

Moholy recognized in the current state of affairs that no piecemeal solution would suffice. *Vision in Motion* opened and closed with a proposal for the creation of a "parliament of social design." Its mission would be to synthesize the latest research in a number of different fields in the interest of restoring "the basic unity of all human experiences":

> As a first step for such a task, an international cultural working assembly could be established, composed of outstanding scientists, sociologists, artists, writers, musicians, technicians and craftsmen. They would work either for a long or a limited period together, in daily contact, in their studios and laboratories. They would investigate the roots of our intellectual and emotional heritage. They could deal with such problems as the individual and the group; town and country planning; production and dwelling; prefabrication and standards; nutrition with its old and new theories; recreation and leisure; opto-phonetics; psychological and physiological color values; functions of museums; music; theater; cinema;

television; the eternal problem of general and higher education; industry and agriculture; village colleges; sociography of towns, cities, countries and continents; the social phenomena of working processes; folklore; crime and rehabilitation, economies and government, etc.[4]

This assembly would promote its findings in meetings and publications: "Together with its possible branches the assembly could represent a center of the highest aspirations. As the nucleus of a world-government, it could prepare new, collective forms of cultural and social life for a coming generation." At stake in this proposal is nothing less than what Moholy called the transformation of "Utopia into action."[5]

It is with utopia that Moholy concludes his final book. He envisions an international body capable of articulating a "new unity of purpose" and of devising a new language, if not legal framework, that would culminate in "the right and the capacity of self-expression (the best bond for social coherence) without censorship or economic pressure."[6] His demands might seem absurdly ambitious from our perspective. His implicit trust in technocratic expertise lends the passage a period patina, recalling the mania for scientific planning in all domains of life—economic, educational, and political—that swept across the mid-twentieth century. The language of utopia and of world government in Moholy's proposal lends credence to his reputation as the visionary optimist, perhaps too modern for his own time and too idealistic to be of much use in our own age.

Nonetheless, I want to suggest that Moholy endeavors to reformulate utopia in relation to the existing world. We sometimes think of the historical avant-garde as fundamentally anti-institutional, determined to demolish the structures of the past, to reduce tradition to rubble in order to pave the way for the possibility of the new. Here, however, Moholy assigns an importance, even a responsibility, to institutions for coordinating the work of experts in a variety of domains. His proposal recalls the mission he cast for the school he hoped to build and the kind of community he attempted to foster. Perhaps more remarkably, what he describes already existed then and continues to exist today in institutions of higher learning, but viewed from a different perspective.

Moholy is celebrated as a visionary artist, oriented unabashedly toward the future. But one of his most remarkable strengths as an artist and thinker is his insistence on contending with the demands of the present. The possibilities of the future are not unlocked by some unimaginable tool, but might be activated by altering our perspective or intervening in minimal ways on existing means. The utopianism that is present at the end of Moholy's career requires us to perceive this world from another vantage point, even if a hair's breadth away, to borrow Adorno's language.

"Getting perspective" on a situation is something that has become commonplace in our own everyday parlance—it's part of the language of pop psychology, dispensed as practical advice in times of change or crisis. But for artists and intellectuals at mid-century, especially those driven into exile and forced to take root in unfamiliar ground,

perspective was difficult, or, as Adorno would suggest, impossible to achieve. Adorno began drafting *Minima Moralia* in 1944, soon after becoming an American citizen in 1943, with the war ongoing and an increasing uncertainty about the future of his Germany.[7] It is aphoristic, its observations fractured and conclusions fragmented. Its form and its language testifies to the remark in its pages that "Every intellectual in emigration is, without exception, mutilated." The impossibility of perspective, the deforming effects of exile, are not merely theoretical or philosophical claims, but experienced in everyday dilemmas of when to stay or when to leave. When the book was finally published in 1951, it bore the subtitle "Reflections on a Damaged Life." The subtitle might appear at first glance astoundingly bleak, but it also asserts the possibility of living and reflecting in the aftermath of catastrophe.

Moholy's late work expresses a utopianism spurred not only by the recognition of his own mortality, of his finitude, but also by a faith in the possibility of a new beginning. That too he shares with other exiled thinkers of his generation. In 1958, seven years after Hannah Arendt became an American citizen, she introduced the concept of natality in her book *The Human Condition*.[8] Writing, in a sense, against the seeming pessimism of Adorno and Horkheimer, Arendt argued that human beings are shaped fundamentally by the fact of being born into the world. Birth is the product of union and offers testimony to *armor mundi,* the love of the world. Being born is contingent, but at birth we already enter into relationships, into communities that cannot help but be transformed by our arrival.[9] In the fecund forms of the *Space Modulators*, Moholy also visualizes how his art might incubate new possibilities.

Perhaps more than any other works in his oeuvre, the *Space Modulators* attempt to make that perspective possible, but they also return us to the claims he made at the start of his career. In "Production-Reproduction" (1922), he argued for the need to move away from merely reduplicating existing relationships, either mimetically in art or by recording them through new technologies. Paintings, sculpture, and new technologies of reproduction like the camera or sound-recording devices should be used to generate unprecedented effects that would stimulate the senses, helping to prepare human beings to inhabit the new conditions of an industrial, urban world in responsive, creative ways. Moholy does not propose the invention of entirely new categories of machines. Instead, one of his examples of how new productive relationships might be engendered involved nothing more than a scratch on a gramophone disc. A single scratch, introduced by hand, makes the needle skip and generates a sound that previously did not exist. That little scratch made by the human hand reveals at once how a technology operates, what it was developed for, and how it could come to achieve new, future aims.

In the case of the Plexiglas *Space Modulators*, the scratch introduces rifts and crevices that permit the plastic support to become receptive to oil paint (plate 20). These objects attempt to fuse art with industry, not in the service of research and development, but to disrupt the expected uses for a clear sheet of plastic, rendering it useless

as gunner cockpit, windshield, or shop vitrine. *Space Modulators* are vividly painted and delicately inscribed. Describing them concisely as "Plastic shaped by hand," Moholy delineates the proper relationship between science, technology, and human being.[10] The undulating curves of these painted, sculpted plastics offer a home for the action of living hands. They allow us to view, even if fleetingly and without certainty, this world made human, warm, and vibrant.

ARCHIVE ABBREVIATIONS

AAA Archives of American Art, Smithsonian
 Institution, Washington, DC
BHA Bauhaus Archiv, Berlin
BR Busch-Reisinger Museum, Harvard Art
 Museums, Cambridge, MA

NOTES

INTRODUCTION

1. On the profound impact of Lucia Moholy's photographs in shaping the reputation of the Bauhaus, see Robin Schuldenfrei, "Moholy's Bauhaus Negatives and the Bauhaus Legacy," *History of Photography* 37.2 (May 2013): 182–203.

2. Christopher Phillips, ed., *Photography in the Modern Era* (New York: Aperture, 1989). There is growing recognition of the role Lucia Moholy played not only in introducing László Moholy-Nagy to photography, but also in helping develop and draft some of his most important theoretical texts. See Rolf Sachsse, *Lucia Moholy* (Düsseldorf: Marzona, 1985); Mercedes Valdivieso, "Eine 'symbiotische Arbeitsgemeinschaft' und die Folgen—Lucia und László Moholy-Nagy," in *Liebe Macht Kunst: Künstlerpaare im 20. Jahrhundert,* ed. Renate Berger, (Cologne/Weimar/Vienna: Böhlau Verlag, 2000), 65–85; Anja Baumhoff, "Zwischen Kunst und Technik: Lucia Moholy und die Entwicklung der modernen Produktfotografie," in *Klassik und Avantgarde: Das Bauhaus in Weimar, 1919–1925,* ed. Hellmut Th. Seemann and Thorsten Valk (Göttingen: Wallstein Verlag, 2009), 169–84.

3. Maria Morris Hambourg and Christopher Phillips, *The New Vision: Photography between the World Wars—The Ford Motor Company Collection at the Metropolitan Museum of Art* (New York: Metropolitan Museum of Art, 1989).

4. Renate Heyne and Floris Michael Neusüss with Hattula Moholy-Nagy, *Moholy-Nagy: The Photograms; Catalogue Raisonné* (Ostfildern: Hatje Cantz Verlag, 2009), 155.

5. This book will refer to László Moholy-Nagy simply as Moholy, which was his own practice among peers and colleagues.

6. László Moholy-Nagy, *Malerei, Fotografie, Film,* 1st ed. (Munich: Albert Langen Verlag, 1925), 5. All translations are mine unless otherwise noted.

7. El Lissitzky, "Proun," *De Stijl* 5.6 (June 1922): 82.

8. Ibid., 85.

9. Maria Gough, "The Language of Revolution," in *Inventing Abstraction, 1910–1925: How a Radical Idea Changed Modern Art,* ed. Leah Dickerman (New York: Museum of Modern Art, 2012), 262–64.

10. Benjamin Buchloh, "From Faktura to Factography," *October* 30 (Autumn 1984): 82–119.

11. L. Moholy-Nagy, "Dear Kalivoda," trans. F. D. Kingender, *Telehor* 1–2 (1936): 32.

12. Ibid., 31.

1. NEW VISION

Epigraph: László Moholy-Nagy, "Abstract of an Artist," in László Moholy-Nagy, *The New Vision, 1928; and, Abstract of an Artist,* trans. Daphne Hoffmann, 4th rev. ed. (New York: Wittenborn, Schultz, 1947), 79–80. "Abstract of an Artist" was written by Moholy-Nagy in 1944 in English. This chapter elaborates upon ideas partially developed and previously published in Joyce Tsai, "Lines of Sight: László Moholy-Nagy and the Optics of Military Surveillance," *Artforum* 54.3 (November 2015): 272–77; and Joyce Tsai, "Reconfiguration of the Eye: László Moholy-Nagy," in *Nothing but the Clouds Unchanged: Artists and the First World War,* ed. Gordon Hughes and Philipp Blom (Los Angeles: Getty Research Institute, 2014), 156–63.

1. Whitney Halstead, "Chicago," *Artforum* 8.1 (September 1969): 68.

2. Jan van der Marck, "Art by Telephone," LP recording sleeve (Chicago: Museum of Contemporary Art, 1969).

3. Ibid.

4. For a concise account of postwar practices in the use of industrial fabricators in art, see Michelle Kuo, "Industrial Revolution: The History of Fabrication," *Artforum* 46.2 (October 2007): 306–15.

5. Lucia Moholy, his first wife, was one of the first to call this claim into question. Lucia Moholy, *Marginalien zu Moholy-Nagy / Moholy-Nagy, Marginal Notes* (Krefeld: Scherpe Verlag, 1972), 34, 76.

6. The first instance of the use of the title *Telephone Pictures* appears in Sibyl Moholy-Nagy's biography of her late husband, published in 1950. Sibyl Moholy-Nagy, *Experiment in Totality,* 1st ed. (New York: Harper and Brothers, 1950), 31. That same year, the Fogg Art Museum

held an exhibition of Moholy's work. *Telephone Picture III* is listed in that catalog under "Painting" as item 9 and *Telephone Picture I* under "Industrial Design" as item 63. Fogg Art Museum, *Works of Art by Moholy-Nagy* (Cambridge, MA: Fogg Art Museum, 1950), n.p.

7. László Moholy-Nagy, "Emaille im Februar 1924," *Der Sturm* 15 (February 1924): 1. Translation from Brigid Doherty, "László Moholy-Nagy: Constructions in Enamel. 1923," in *Bauhaus 1919–1933: Workshops for Modernity,* ed. Barry Bergdoll and Leah Dickerman (New York: Museum of Modern Art, 2009), 130.

8. Doherty, "László Moholy-Nagy: Constructions in Enamel," 133. Doherty engages with the intellectual history—developed in Lorraine Daston and Peter Galison, *Objectivity* (New York: Zone Books, 2007)—of the emergence of scientific objectivity as it coalesced in the late nineteenth and early twentieth centuries.

9. Key accounts of artists' pursuits of abstraction in attempts to overcome subjective, arbitrary composition include Yve-Alain Bois, *Painting as Model* (Cambridge, MA: MIT Press, 1990); and Maria Gough, *The Artist as Producer* (Berkeley: University of California Press, 2005).

10. The narrative of Moholy's early career in terms of stylistic development is found in Passuth's pioneering and influential work on his work. Krisztina Passuth, *Moholy-Nagy,* trans. Kenneth McRobbie and Ilona Jánosi (London: Thames and Hudson, 1985), 18–31.

11. Oliver A.I. Botar, *Technical Detours: The Early Moholy-Nagy Reconsidered* (New York: Salgo Trust for Education, 2006), 21.

12. Krisztina Passuth, "The Postcards and Figurative Drawings of László Moholy-Nagy in an International Context," in *László Moholy-Nagy: From Budapest to Berlin, 1914–1923,* ed. Belinda Chapp (Newark: University of Delaware, 1995), 60.

13. Krisztina Passuth, "László Moholy-Nagy, the Painter: The Formative Years," in *Moholy-Nagy: Laboratory of Vision,* ed. Iguchi Toshino (Hayama: Museum of Modern Art, 2011), 254–55.

14. László Moholy-Nagy to Antal Németh, July 18, 1924, trans. Júlia Szabó, in Chapp, *From Budapest to Berlin,* 103.

15. László Moholy-Nagy, "Personalblatt," September 29, 1918, Sibyl Moholy-Nagy Papers, AAA.

16. Lajos Kassák, "Program," *A Tett* (1916), trans. John Bátki, repr. in *Between Worlds: A Sourcebook of Central European Avant-Gardes, 1910–1930,* ed. Timothy O. Benson and Éva Forgács (Cambridge, MA: MIT Press, 2002), 160–61. Éva Forgács, "The Activists in Budapest," in Benson and Forgács, *Between Worlds,* 149.

17. Edit Tóth, "From Activism to Kinetism: Modernist Spaces in Hungarian Art, 1918–1930: Budapest—Vienna—Berlin" (PhD diss., Pennsylvania State University, 2010), 4.

18. *Forradalmárok!,* poster, March 25, 1919.

19. Botar, *Technical Detours,* 55.

20. Ibid.

21. Oliver Botar, "An Activist-Expressionist in Exile: László Moholy-Nagy, 1919–1920," in Chapp, *From Budapest to Berlin,* 111n8. Daniel-Henry [Kahnweiler], "Merzmalerei," *Das Kunstblatt* 3.11 (1919): 351.

22. Moholy-Nagy to Iván Hevesy, April 5, 1920, in Passuth, *Moholy-Nagy*, 388.

23. George Grosz's work is illustrated in *Ma* 6.7 (June 1, 1921): cover, 5, 9, 13.

24. Lloyd C. Engelbrecht, *Mentor to Modernism* (Cincinnati: Flying Trapeze Press, 2009), 128.

25. Eleanor M. Hight, *Picturing Modernism: Moholy-Nagy and Photography in Weimar Germany* (Cambridge, MA: MIT Press, 1995), 61.

26. Andrés Mario Zervigón, *John Heartfield and the Agitated Image: Photography, Persuasion, and the Rise of Avant-garde Photomontage* (Chicago: University of Chicago Press, 2012), 73–77, 98.

27. Ibid. See also Cornelia Thater-Schulz, ed., *Hannah Höch: Eine Lebenscollage, Band 1, 1889–1918* (Berlin: Argon Verlag, 1989), 57.

28. Jürgen Pech, "'Daβ ich nicht tot bin, freut mich,'" in *Fatagaga-Dada: Max Ernst, Hans Arp, Johannes Theodor Baargeld und der Kölner Dadaismus,* ed. Karl Riha and Jörgen Schäfer (Giessen: Anabas Verlag, 1995), 17.

29. Brigid Doherty, "'See: We Are All Neurasthenics'!; Or, The Trauma of Dada Montage," *Critical Inquiry* 24.1 (1997): 82–132.

30. I follow Leah Dickerman's suggestion that Dada is not a stylistically cohesive artistic movement, but one that reconceptualizes "artistic practice as a form of tactics. That last word with all of its military connotations is helpful. It suggests a form of historical mimicry, a movement from the battlefield to the cultural sphere in which art is imagined in a quasi-military way." Leah Dickerman, "Introduction," in *Dada,* ed. Leah Dickerman (Washington, DC: National Gallery of Art, 2005), 8.

31. See Jula Dech, *Hannah Höch: Schnitt mit dem Kuchenmesser: Dada-Spiegel einer Bierbauchkultur* (Frankfurt: Fischer Verlag, 1989).

32. Raoul Hausmann et al., "Aufruf zur elementaren Kunst," *De Stijl* 4.10 (October 1921): 156.

33. Ibid., 156.

34. Ibid.

35. Ibid.

36. Detlef Mertins and Michael Jennings, "Introduction," in *G: An Avant-Garde Journal of Art, Architecture, Design, and Film, 1923–1926,* ed. Detlef Mertins and Michael Jennings (Los Angeles: Getty Research Institute, 2010), 5.

37. Paul Scheerbart, *Glasarchitektur* (Berlin: Verlag der Sturm, 1914).

38. Ludwig Hilberseimer, "Bildende Kunst," *Sozialistische Monatshefte* 28.4 (March 6, 1922): 242–43.

39. Ibid.

40. Peter Màtyàs [Ernö Kállai], "Moholy-Nagy," *Horizont* 2 (1921): n.p.

41. At this point, *constructive* is meant loosely, without any direct or overt reference to Russian Constructivism; it alludes instead to the rigorous structuring of pictorial space. Ernö Kállai, "Jungungarische Malerei," *Der Ararat* 2.10 (1921): 256.

42. Ibid.

43. Kállai, "Moholy-Nagy."

44. *Vešč-Objet-Gegenstand* 3 (May 1922): 14. Sophie Lissitzky-Küppers, *El Lissitzky: Life, Letters, Texts* (London: Thames and Hudson, 1968), 341–42.

45. Bernd Finkeldey, "Die '1. Internationale Kunstaustellung' in Düsseldorf 28. Mai bis 3. Juli 1922," in *Konstruktivistische Internationale, 1922–1927: Utopien für eine Europäische Kultur*, ed. Bernd Finkeldey (Ostfildern-Ruit: Cantz'sche Verlag, 1992), 23.

46. Ibid., 28.

47. Maria Müller, "Der Kongress der 'Union Internationaler Fortschrittlicher Künstler' in Düsseldorf," in Finkeldey, *Konstruktivistische Internationale*, 20–21.

48. Theo van Doesburg, El Lissitzky, and Hans Richter, "Erklärung," *De Stijl* 5.4 (April 1922): 63.

49. Ibid.

50. Ibid., 62

51. L. Moholy-Nagy, "Produktion-Reproduktion," *De Stijl* 5.7 (July 1922): 98–101.

52. Ludwig Kassák and L. Moholy-Nagy, *Buch neuer Künstler* (Vienna: MA, 1922), n.p.

53. Ibid.

54. Adolf Behne recommended Moholy to Gropius as a possible candidate to replace Johannes Itten. Walter Gropius to Adolf Behne, January 3, 1923, in Janos Frecot and Diethart Kerbs, eds., *Werkbundarchiv: Erstes Jahrbuch* (Berlin: Werkbundarchiv, 1971), 148.

55. Van Doesburg, El Lissitzky, and Richter, "Erklärung," 62.

56. László Moholy-Nagy, "Emaille im Februar 1924," 1. Trans. Doherty, "Constructions in Enamel," 130.

57. Willi Wolfradt, "Berliner Ausstellungen: Moholy-Nagy," *Der Cicerone: Halbmonatsschrift für Künstler, Kunstfreunde und Sammler* 16.4 (1924): 191–92.

58. László Moholy-Nagy, *Malerei, Fotografie, Film*, 1st ed. (Munich: Albert Langen Verlag, 1925), 37.

59. Pepper Stetler has adroitly laid out a cohesive account of how the book form of *Painting, Photography, Film* sustains the physical and psychic effects of modern life. Several of our observations overlap, but my emphasis here is on Moholy's attempt to redeem his experience of technological warfare in peace. Pepper Stetler, *Stop Reading! Look! Modern Vision and the Weimar Photographic Book* (Ann Arbor: University of Michigan Press, 2015).

60. Moholy-Nagy, *Malerei, Fotografie, Film*, 1st ed., 37.

61. The first civilian airline aircraft began operating in 1909. Michael Belafi, *The Zeppelin*, trans. Cordula Werschkun (Barnsley: Pen and Sword Aviation, 2015), 90.

62. Ibid., 63.

63. Moholy-Nagy, *Malerei, Fotografie, Film*, 1st ed., 40–41.

64. Moholy was hardly alone in his faith in the power of machine-captured vision and its ability to overcome human weaknesses in pursuit of objectivity. See Daston and Galison, *Objectivity*, 138–39.

65. Moholy-Nagy, *Malerei, Fotografie, Film*, 1st ed., 39 (emphasis in original).

66. Ibid., 46, 47.

67. Ibid., 44, 45, 56, 57.

68. Ibid., 30.

69. Ibid., 23.

70. Mitchell G. Ash, "Weimar Psychology: Holistic Visions and Trained Intuition," in *Weimar Thought: A Contested Legacy*, ed. Peter E. Gordon and John P. McCormick (Princeton, NJ: Princeton University Press, 2013), 45.

71. Frederic J. Schwartz, *Blind Spots: Critical Theory and the History of Art in Twentieth-Century Germany* (New Haven, CT: Yale University Press, 2005), 70.

72. Moholy-Nagy, *Malerei, Fotografie, Film*, 1st ed., 114. Several recent publications have addressed different aspects of *Dynamic of the Metropolis*, including a history of its publication and Moholy's use of manual print techniques as a proxy for future technologies (Bourneuf); the role of typophoto in generating the experience of industrial modernity (Stetler); and a close reading of the scenario in relation to the cinematic, sociological, and avant-garde discourse of its time (Dimendberg). Annie Bourneuf, "Interfaces and Proxies: Placing László Moholy-Nagy's Prints," *Leonardo* 50.3 (June 2017): 297–302; Stetler, *Stop Reading! Look!*, 21–58; Edward Dimendberg, "Transfiguring the Urban Gray: László Moholy-Nagy's Film Scenario 'Dynamic of the Metropolis,'" in *Camera Obscura, Camera Lucida: Essays in Honor of Annette Michelson*, ed. Richard Allen and Malcolm Turvey (Amsterdam: Amsterdam University Press, 2003), 109–26.

73. Moholy-Nagy, *Malerei, Fotografie, Film*, 1st ed., 114.

74. Ibid.

75. Ibid., 122.

76. Ibid.

77. Ibid.

78. Ibid. (emphasis in original, including rendering of *OUR* in boldface).

79. Walter Benjamin, "The Work of Art in the Age of Its Technological Reproducibility, second version," trans. Edmund Jephcott and Harry Zohn, in *The Work of Art in the Age of Its Technological Reproducibility, and Other Writings on Media*, ed. Michael Jennings, Brigid Doherty, and Thomas Y. Levin (Cambridge, MA: Belknap Press, 2008), 19–55. Version unpublished during Benjamin's lifetime; first appeared in Walter Benjamin, *Gesammelte Schriften VII*, ed. Rolf Tiedemann et al. (Frankfurt: Suhrkamp, 1989), 350–84.

80. Benjamin, "Work of Art," 28, 44.

81. Ibid., 41.

82. Moholy-Nagy, *Malerei, Fotografie, Film*, 1st ed., 120–21.

83. Schwartz, *Blind Spots*, 72.

84. Rosalind Krauss, "When Words Fail," *October* 22 (Autumn 1982): 102.

85. Gottfried Gilbert, *Der Artillerist: Unterrichtsbuch für Rekruten, Kanoniere, Unteroffiziere und deren Lehrer* (Berlin: Offene Worte, 1923), 173–76. This German training manual went into several subsequent editions. It provides an extensive overview of both the complexity of training and coordinating an artillery unit. The book drew upon

the experience of the First World War and reprinted excerpts from existing military resources.

86. The Austro-Hungarian military published training manuals that pertained to the model howitzer assigned to a unit. They include technical information about the weapon and its operation, as well as more general information about the support tasks demanded of individuals within a unit. The manuals detail everything from the dimensions of the howitzers and the care of horses to the setup of artillery telephone stations, standard cartographic markings, and optical signaling techniques. See *Artillerieunterricht: 10 cm Feldhaubitze M.99* (Vienna: K.K. Hof- und Staatsdrukerei, 1909), 97; and *Artillerieunterricht: 10.0 cm M.14 Feldhaubitze* (Vienna: K.K. Hof- und Staatsdruckerei, 1916), 40. The 10 cm Feldhaubitze M.99 was one of the standard howitzers assigned to artillery units at the start of the First World War. The 10.0 cm M.14 Feldhaubitze was a mountain howitzer introduced later in the conflict. Both models were in use in the Carpathian Mountains, where Moholy was stationed during his military service.

87. Gilbert, *Der Artillerist*, 91–98.

88. Ibid.

89. Timothy C. Dowling, *The Brusilov Offensive* (Bloomington: Indiana University Press, 2008), 88.

90. Ibid., 51.

91. Ibid., 35. German general Erich Luddendorff was so unperturbed by reports gathered as early as March 1916 indicating Russian preparations for a large-scale offensive that he went on holiday after dismissing the findings.

92. Ibid., 44.

93. Ibid., 42–47.

94. Ibid., 176.

95. John Schindler, "Steamrollered in Galicia: The Austro-Hungarian Army and the Brusilov Offensive, 1916," *War in History* 10.1 (2003): 59.

96. László Moholy-Nagy, "In Answer to Your Interview," *Little Review* 7.2 (1929): 55.

97. Ibid.

98. Bernhard Siegert, "Luftwaffe Fotografie: Luftkrieg als Bildverarbeitungssystem 1911–1921," *Fotogeschichte: Beiträge zur Geschichte und Ästhetik der Fotografie* 45/46 (1992): 42.

99. Ibid.

100. Benjamin, "Work of Art," 42.

101. Here I draw upon the interrelated categories of mechanical and structural objectivity laid out in Daston and Galison, *Objectivity*, 121, 254.

102. Ibid., 37.

103. Ibid., 37–38.

104. The link between Benjamin's and Moholy's thought on the question of production and reproduction is elegantly addressed by Michael Jennings, Brigid Doherty, and Thomas Y. Levin in their introduction, "Production, Reproduction, and Reception," in Jennings, Doherty, and Levin, *Work of Art*, 11–12.

105. Moholy-Nagy, "Produktion-Reproduktion," 98.

106. Ibid., 99.

107. Ibid.

108. Ibid.

109. Ibid.

110. Ibid.

111. Ibid.

112. Ibid.

113. Ibid.

114. Ibid., 100.

115. Ibid.

116. Stephanie D'Alessandro, "Through the Eye and the Hand: Constructing Space, Constructing Vision in the Work of Moholy-Nagy," in *Moholy-Nagy: Future Present*, ed. Matthew S. Witkovsky, Carol S. Eliel, and Karole P. B. Vail (New Haven, CT: Yale University Press, 2016), 65.

117. Moholy-Nagy, *Malerei, Fotografie, Film*, 1st ed., 23–24.

118. Ibid.

2. PAINTING PRODUCTIVITY

1. László Moholy-Nagy, "Emaille im Februar 1924," *Der Sturm* 15, Monatsbericht (February 1924): 1. Trans. Brigid Doherty, "László Moholy-Nagy: Constructions in Enamel, 1923," in *Bauhaus 1919–1933: Workshops for Modernity*, ed. Barry Bergdoll and Leah Dickerman (New York: Museum of Modern Art, 2009), 130. In this chapter, I extend ideas first developed and published in Joyce Tsai, ed., *The Paintings of Moholy-Nagy: The Shape of Things to Come* (Santa Barbara: Santa Barbara Museum of Art, 2016); and Joyce Tsai, Jay Krueger, and Christopher Maines, "'Transparency and Light, Structure and Substance': Enamel Paints in László Moholy-Nagy's Z VII (1926)," *Journal of the American Institute of Conservation* 52.2 (2013): 236–45.

2. Adolf Behne, "Snob und Anti-Snob," *Die Weltbühne* 20 (1924): 235–36.

3. Ibid., 235. Original quote by Partens in Alexander Partens, "Dada-Kunst," in *Dada Almanach,* ed. Richard Huelsenbeck (Berlin: Erich Reiß Verlag, 1920), 89.

4. Behne, "Snob und Anti-Snob," 235.

5. Wilhelm Ostwald, *Die Farbenfibel* (Leipzig: Verlag Unesm, 1916).

6. "Kommentar," *Das Kunstblatt* 8.3 (March 1924): 96.

7. Wilhelm Wagenfeld's lamps and Marianne Brandt's teapot from 1924 are produced by the German firm Technolumen, www.tecnolumen.com/12/Wilhelm-Wagenfeld-Table-lamp.htm; www.tecnolumen.com/42/Marianne-Brandt-Tea-pot.htm.

8. Walter Gropius, "Grundsätze der Bauhausproduktion," in *Neue Arbeiten der Bauhauswerkstätten* (Munich: Albert Langen Verlag, 1925), 8.

9. See Anna Rowland, "Business Management at the Weimar Bauhaus," *Journal of Design History* 1.3/4 (1988): 155–56; Frederic J. Schwartz, "Utopia for Sale: The Bauhaus and Weimar German's Consumer Culture," in *Bauhaus Culture: From Weimar to the Cold War,*

ed. Kathleen James-Chakraborty (Minneapolis: University of Minnesota Press, 2006), 115–38; and Robin Schuldenfrei, "The Irreproducibility of the Bauhaus Object," in *Bauhaus Construct: Fashioning Identity, Discourse and Modernism,* ed. Jeffrey Saletnik and Robin Schuldenfrei (London: Routledge, 2009), 37–60. This chapter builds upon the research and conclusions of these three scholars, among others.

10. Ute Ackermann, "Einleitung," in *Die Meisterratsprotokolle des Staatlichen Bauhauses Weimar, 1919–1925,* ed. Volker Wahl (Weimar: Verlag Hermann Böhlaus Nachfolger, 2001), 20.

11. Rowland, "Business Management," 155–56.

12. Leah Dickerman, "Bauhaus Fundamentals," in Berdoll and Dickerman, *Bauhaus 1919–1933: Workshops for Modernity,* 15.

13. Michael H. Kater, *Weimar: From Enlightenment to the Present* (New Haven, CT: Yale University Press, 2014), 151.

14. Ackermann, "Einleitung," 20.

15. Victor Margolin, *The Struggle for Utopia: Rodchenko, Lisstizky, Moholy-Nagy, 1917–1946* (Chicago: University of Chicago Press, 1997), 46–47.

16. Vilmos Huszár, "Das Staatliche Bauhaus in Weimar," *De Stijl* 5.9 (1922): 135–38.

17. Ibid., 136.

18. Ibid., 137–38.

19. Ibid., 138.

20. The furor surrounding the Bauhaus in these early years was also due, in no small part, to the perception of it as a breeding ground for socialist, if not Spartacist or Bolshevist, activities. Gropius's 1920 monument to the victims of the right-wing Kapp Putsch, Oskar Schlemmer's explicit description of the Bauhaus in publicity materials in 1923 as "a cathedral of socialism," and the presence of non-German faculty members made it suspect in the eyes of its political enemies. Grant Naylor, *The Bauhaus Reassessed: Sources and Design Theory* (London: Herbert Press, 1985), 60; and Karen Koehler, "The Bauhaus Manifesto Postwar to Postwar," in Saletnik and Schuldenfrei, *Bauhaus Construct,* 19–20.

21. "Protokoll, Meisterrat am 5. Februar 1923," in Wahl, *Die Meisterratsprotokolle,* 291.

22. "Mitteilung an die Formmeister vom 14. März 1923," in Wahl, *Die Meisterratsprotokolle,* 299.

23. Klaus Weber, "'Vom Weinkrug zur Leuchte': Die Metallwerkstatt am Bauhaus," in *Die Metallwerkstatt am Bauhaus,* ed. Klaus Weber (Berlin: Bauhausarchiv, 1992), 17.

24. Ibid., 16.

25. On the history of the Werkbund see Joan Campbell, *The German Werkbund: The Politics of Reform in the Applied Arts* (Princeton, NJ: Princeton University Press, 1972).

26. Barry Bergdoll, "Bauhaus Multiplied: Paradoxes of Architecture and Design in and after the Bauhaus," in Bergdoll and Dickerman, *Bauhaus 1919–1933,* 48.

27. Monika Markgraf, ed., *Archaeology of Modernism* (Berlin: Jovis Verlag, 2006), 163.

28. Walter Gropius, *Staatliches Bauhaus in Weimar, 1919–1923* (Munich: Bauhausverlag, 1923).

29. Walter Gropius, "Idee und Aufbau des Staatlichen Bauhauses," in ibid., 7–8.

30. Ibid., 7.

31. Ibid.

32. Ibid., 8.

33. Ibid., 13.

34. Ibid.

35. Ibid.

36. Ibid., 73.

37. Ibid., 128, 139.

38. Ibid., 117.

39. Ibid., 96.

40. Ibid., 84.

41. Ibid., 91, 107.

42. Ibid., 181–226.

43. Éva Forgács, *The Bauhaus Idea and Bauhaus Politics* (London: CEU Press, 1995), 113.

44. Ibid., 101.

45. Dickerman, "Bauhaus Fundamentals," 23.

46. Rowland, "Business Management," 168.

47. "Protokoll der Bauhausrates," in Wahl, *Die Meisterratsprotokolle,* 317–18.

48. Ibid., 318–19.

49. Ibid., 319.

50. Ackermann, "Einleitung," 26.

51. Schuldenfrei, "Irreproducibility of the Bauhaus Object," 48–49.

52. "Protokoll der Bauhausrates, 22. Oktober 1923," in Wahl, *Die Meisterratsprotokolle,* 317–18.

53. "Ausschreibung von W. Kandinsky, 4. April 1924," in Wahl, *Die Meisterratsprotokolle,* 334–36.

54. "Ausschreibung von J. Hartwig, 4. März 1924," in Wahl, *Die Meisterratsprotokolle,* 336–37.

55. "Ausschreibung von Oskar Schlemmer, 1. März 1924," in Wahl, *Die Meisterratsprotokolle,* 338.

56. Quoted in Weber, "Vom Weinkrug zur Leuchte," 19.

57. Adrian Sudhalter, "Walter Gropius and László Moholy-Nagy: Bauhaus Book Series, 1925–1930," in Bergdoll and Dickerman, *Bauhaus 1919–1933,* 198.

58. László Moholy-Nagy, *Malerei, Fotografie, Film,* 1st ed. (Munich: Albert Langen Verlag, 1925), 19.

59. See advertisement by Jaroslow's Erste Glimmerwarenfabrik, in Karl Strecker, *Jahrbuch der Elektrotechnik: Übersicht über die Wichtigeren Erscheinungen auf dem Gesamtgebiet der Elektrotechnik* 6 (Berlin: R. Oldenbourg, 1917), n.p.

60. László Moholy-Nagy, *Malerei, Fotografie, Film,* 1st ed., 19. Triolin, incidentally, disappears from the list of new materials in Moholy's second revised edition of *Painting, Photography, Film,* perhaps because by the time of its publication in 1927, the material was no longer seen as a viable substitute for linoleum. Studies conducted in the mid-twenties already demonstrated that Triolin was potentially toxic and proved to be more flammable than linoleum. E. Wilke-Dörfurt, A. Simon, and E. Gühring, "Auftreten von Stickoxyd, Kohlenoxyd und Blausäure im Zersetzungsrauch von Triolin," *Zeitschrift für angewandte Chemie* 39 (1926): 196–98; A. Simon, "Über Linoleum und Triolin," *Chemische Umschau* 32.43–44 (1925): 27; Markgraf, *Archaeology of Modernism,* 163; László Moholy-Nagy, *Malerei, Fotografie, Film,* 2nd ed. (Munich: Albert Langen Verlag, 1927), 23.

61. Sudhalter, "Bauhaus Book Series, 1925–1930," 198.

62. Gropius, "Grundsätze der Bauhausproduktion," 8.

63. Ibid., 5–6.

64. Ibid., 7.

65. Ibid., front matter.

66. Ibid., 28.

67. Ibid., 36, 37.

68. Ibid., 102.

69. Ibid., 68, 69.

70. Rowland, "Business Management," 165.

71. Magdalena Droste, *Bauhaus, 1919–1933*, trans. Karen Williams (Cologne: Taschen Verlag, 2002), 78.

72. Frederic J. Schwartz, "Wilhelm Wagenfeld and Carl Jakob Jucker, Table Lamp, 1923–24," in Bergdoll and Dickerman, *Bauhaus 1919–1933*, 138–41.

73. Weber, "Vom Weinkrug zur Leuchte," 20.

74. Rowland, "Business Management," 171.

75. Ibid., 161.

76. The photograph of the reverse of *Z II* (1925) was taken by Caroline Keck in October 1956 prior to the painting being mounted. The previous painting is no longer visible. Conservation file for *Z II* (1925), Museum of Modern Art, New York. Thanks to Corey D'Augustine for discussing the painting with me.

77. Rowland, "Business Management," 171.

78. Weber, "Vom Weinkrug zur Leuchte," 20.

79. Ibid.

80. Gropius, "Grundsätze der Bauhausproduktion," 8.

81. Quoted in Weber, "Vom Weinkrug zur Leuchte," 25.

82. Janet Ward, *Weimar Surfaces: Urban Visual Culture in 1920s Germany* (Berkeley: University of California Press, 2001), 72.

83. Peter M. Kleine, "Light for Working—More Than 'Merely Utilitarian'? Developments and Trends in the First Half of the 20th Century," in Justus A. Binroth et al., *Bauhaus Lighting? Kandem Light! The Collaboration of the Bauhaus with the Leipzig Company Kandem* (Stuttgart: Arnoldsche, 2003), 64–65. Thanks to Corey D'Augustine for discussing the painting with me.

84. Weber, "Vom Weinkrug zur Leuchte," 24.

85. Karin Wilhelm, "Seeing—Walking—Thinking: The Bauhaus Building Design," in *The Dessau Bauhaus Building, 1926–1999*, ed. Margret Kentgens-Craig (Basel: Birkhäuser, 1998), 25; and Walter Scheiffele, "'You Must Go There'—Contemporary Reactions," in Kentgens-Craig, *Dessau Bauhaus Building*, 113.

86. Sebastian Hackenschmidt, "'Form Follows Motion': Stühle in Bewegung," in *Möbel als Medien: Beiträge zu einer Kulturgeschichte der Dinge*, ed. Sebastian Hackenschmidt and Klaus Engelhorn (Bielefeld: Transcript Verlag, 2011), 240.

87. Scheiffele, "You Must Go There," 116.

88. Weber, "Vom Weinkrug zur Leuchte," 27.

89. For an extensive description of Moholy's use of new materials and their properties, see Friederike Waentig and Joyce Tsai, "An Introduction to Moholy's Plastic Materials," trans. Timothy Grundy, in Tsai, *Shape of Things to Come*, 130–45; Julie Barten, Sylvie Pénichon, and Carol Stringari, "The Materialization of Light," in *Moholy-Nagy: Future Present*, ed. Matthew S. Witkovsky, Carol S. Eliel, and Karole P. B. Vail (New Haven, CT: Yale University Press, 2016), 188–202; and Johanna Salvant et al., "Two László Moholy-Nagy Paintings on Trolit: Insights into the Condition of an Early Cellulose Nitrate Plastic," *e-Preservation Science* 13 (2016): 15–22.

90. See Mimi Sheller, *Aluminum Dreams: The Making of Light Modernity* (Cambridge, MA: MIT Press, 2014).

91. Moholy-Nagy, *Malerei, Fotografie, Film*, 2nd ed., 23.

92. László Moholy-Nagy, *Von Material zu Architektur* (Passau: Passiva, 1929), 90.

93. Alexander Nagel, "Leonardo and Sfumato," *RES: Anthropology and Aesthetics* 24 (Autumn 1993): 20.

94. Moholy-Nagy, *Von Material zu Architektur*, 137.

95. Ibid.

96. "Ausschreibung von J. Hartwig," 336–37.

97. Moholy-Nagy, *Von Material zu Architektur*, 132.

98. Ludwig Kassák and L. Moholy Nagy, *Buch Neuer Künstler* (Vienna: MA, 1922), n.p.

99. "Protokoll der Bauhausrates," 319.

100. Scheiffele, "You Must Go There," 115.

101. Ibid., 117.

102. Schuldenfrei, "Irreproducibility of the Bauhaus Object," 44–45.

103. Ibid., 40.

104. Marie Neumüllers, "'... Our Own Space around Us': Life in the Bauhaus," in Kentgens-Craig, *Bauhaus Dessau Building*, 108.

105. Bergdoll, "Bauhaus Multiplied," 55.

106. Rainer K. Wick and Gabriel Diana Grawe, *Teaching at the Bauhaus* (Ostfildern: Hatje Cantz Verlag, 2000), 79.

107. Ernö Kállai, "Das Bauhaus Lebt!," *Bauhaus* 2.2/3 (1938): 2.

108. Schuldenfrei, "Irreproducibility of the Bauhaus Object," 48.

109. László Moholy-Nagy, "Dialog between a Well-Meaning Critic and a Representative of the Bauhaus, Weimar–Dessau," in Krisztina Passuth, *Moholy-Nagy* (London: Thames and Hudson, 1985), 400–401.

110. Ibid.

111. Ibid.

112. Ibid.

113. Hannes Meyer, "Die neue Welt," *Das Werk* 13 (1926).

114. Moholy-Nagy, "Dialog," 400–401.

115. Schuldenfrei, "Irreproducibility of the Bauhaus Object," 44.

116. "Moholy-Nagy's Letter of Resignation to the Meisterrat of the Bauhaus," in Passuth, *Moholy-Nagy*, 398–99.

117. Ibid.

118. Rowland, "Business Management," 154.

3. SORCERER'S APPRENTICE

1. This chapter further develops ideas previously published in Joyce Tsai, "Sorcerer's Apprentice: László Moholy-Nagy and His *Light Prop for an Electrical Stage*," in *Reconsidering the Total Work of Art: On Borders and Fragments*, ed. Anke Finger and Danielle Follet (Baltimore: Johns Hopkins University Press, 2011), 277–304, and Joyce Tsai et al., "Light Prop as Design Fiction: Perspectives on Conservation and Replication," *Leonardo* 50.3 (June 2017): 311–15. *Light Prop* is also commonly referred to as the *Light-Space Modulator*. This title came into usage posthumously, after the work entered the collection of the Busch-Reisinger Museum in 1956. Other titles given to it include: *Stage Lighting Device, Kinetic Light Display Machine, Light Display Machine, Light Modulator Machine,* and *Light Modulator*. See Kimberly Mims, "Title Options," memo from July 12, 2002, in *Lichtrequisit* object file, BR.

2. László Moholy-Nagy, "*Lichtrequisit einer elektrischen Bühne,*" *Die Form: Zeitschrift für gestaltende Arbeit* 5.11–12 (1930): 297.

3. *Art in America* 55.3 (1967): cover.

4. Nan R. Piene, "Light Art," *Art in America* 55.3 (1967): 25. Nan Rosenthal was publishing under her married name at the time but, following her divorce from Otto Piene, she used her maiden name professionally.

5. K. G. Hultén and Hugo Govers, eds., *Bewogen Beweging* (Stockholm: Björkman, 1961).

6. Frank Popper, ed., *KunstLichtKunst* (Eindhoven: Stedelijk van Abbemuseum, 1996).

7. Popper, "Introduction" in *KunstLichtKunst,* n.p.

8. Piene, "Light Art," 27.

9. Heike van den Valentyn, "Utopische, Reale und Lichtkinetische Räume der Zero-Zeit," in *Zero: Internationale Künstler-Avantgarde der 50er/60er Jahre* (Ostfildern: Hatje Cantz Verlag, 2006), 60. See also Valerie Hillings, *Zero: Countdown to Tomorrow, 1950s–60s* (New York: Guggenheim Museum, 204).

10. Judith Wechsler, "György Kepes," in *György Kepes: The MIT Years, 1945–1977* (Cambridge, MA: MIT Press, 1978), 10; Jerome A. Donson, "College Art News," *Art Journal* 27.1 (1967): 98.

11. Emmy Dana, "A History of the Construction and Alteration of Moholy's *Light-Space Modulator,*" *Lichtrequisit* object file, BR.

12. K. G. Pontus Hultén, *The Machine as Seen at the End of the Mechanical Age* (New York: Museum of Modern Art, 1969). The stipulation that the machine not be operated was stated clearly in a letter from Elizabeth Hoover to Jennifer Licht, October 30, 1968, *Lichtrequisit* object file, BR.

13. A letter reminding MoMA of the loan agreement's prohibition on operating the machine was sent after the Busch-Reisinger found out that *Light Prop* was set in motion during the exhibition. See Agnes Mongan to Jennifer Licht, December 16, 1968, *Lichtrequisit* object file, BR. The Busch-Reisinger chief conservator wrote in a memo that the machine, upon return, "jammed and became totally inoperable. Detailed inspection revealed that excessive operation had loosened many parts causing disalignment [*sic*]. The powerful, geared motor exerted considerable force on the loose, disaligned [*sic*] parts, bending them out of shape and, in one place, even breaking a welded joint . . . It is my firmost [*sic*] conviction that, in the interest of the preservation of this work for future generations, it should under no circumstances be loaned away from the Busch-Reisinger Museum." Memo from Arthur Beal to Miss [Agnes] Mongan, "Re Moholy-Nagy Light Space Modulator," May 20, 1969, *Lichtrequisit* object file, BR.

14. Sibyl Moholy-Nagy to Jean Learing, March 23, 1966, *Lichtrequisit* object file, BR. Thanks to Angela Chang for alerting me to this correspondence.

15. Dana, "History of the Construction and Alteration of Moholy's *Light-Space Modulator*."

16. *La Biennale di Venezia: 35a Biennale internazionale d'arte* (Venice: Biennale de Venezia, 1970), xxx, xxiv. I am indebted to Jason di Resta for his translation of the Italian texts.

17. Nan Piene, *Light-Space Modulator* (New York: Wise Gallery, 1970), n.p.; Umbro Apollonio and Dietrich Mahlow, "Proposte per una eposizione sperimentale," in *La Biennale di Venezia*, xxvi–xxviii.

18. Hilton Kramer, "A Replica of a Classic," *New York Times*, November 8, 1970, 133.

19. Hilton Kramer, "One Inventor, One Pasticheur," *New York Times*, November 28, 1965, X15; Hilton Kramer, "In Chicago: A Moholy-Nagy Comprehensive Show," *New York Times*, June 2, 1969, 52; Hilton Kramer, "Utopian Vision of the Arts," *New York Times*, June 8, 1965, D27.

20. Pamela Lee, *Chronophobia* (Cambridge, MA: MIT Press, 2004), 103.

21. Ibid.

22. Ibid.

23. László Moholy-Nagy, *The New Vision, 1928; and, Abstract of an Artist*, trans. Daphne Hoffmann, 4th rev. ed. (New York: Wittenborn, Schultz, 1947), 80.

24. Ibid., 238.

25. Georg Grosz and John Heartfield, "The Art Scab," in *The Weimar Republic Sourcebook*, ed. Anton Kaes, Martin Jay, and Edward Dimendberg (Berkeley: University of California Press, 1994), 483–86.

26. László Moholy-Nagy, "On the Problem of New Content and New Form," in *Moholy-Nagy*, ed. Krisztina Passuth (London: Thames and Hudson, 1985), 286–88.

27. Oliver A.I. Botar, "From the Avant-Garde to 'Proletarian Art': The Émigré Hungarian Journals *Egység* and *Akasztott Ember*, 1922–23," *Art Journal* 52.1 (1993): 34–45.

28. Ibid., 38–43.

29. See Detlef Mertins and Michael W. Jennings, "Introduction: The G-Group and the European Avant-Garde," in *G: An Avant-Garde Journal of Art, Architecture, Design, and Film, 1923–1926*, ed. Detlef Mertins and Michael W. Jennings (Los Angeles: Getty Research

Institute, 2010), 3–20; Walter L. Adamson, *Embattled Avant-Gardes: Modernism's Resistance to Commodity Culture in Europe* (Berkeley: University of California Press, 2007), 181–210; Nancy Troy, "The Abstract Environment of De Stijl," in *De Stijl, 1917–1931, Visions of Utopia*, ed. Hans Jaffé et al. (New York: Abbeville Press, 1982), 165–89.

30. Theo van Doesburg et al., "Manifest I of 'the Style,'" *De Stijl* 2.1 (1918): 4. The manifesto appears in Dutch, French, English, and German on pages 2–5.

31. Theo van Doesburg, "Rechenschaft Der Stylgruppe," *De Stijl* 5.4 (1922): 59–62.

32. Walter Gropius, "Manifesto and Program of the Bauhaus," in Frank Whitford, *Bauhaus* (London: Thames and Hudson, 1984), 202.

33. See also Charles W. Haxthausen, "Walter Gropius and Lyonel Feininger: Bauhaus Manifesto, 1919," in *Bauhaus 1919–1933: Workshops for Modernity,* ed. Barry Bergdoll and Leah Dickerman (New York: Museum of Modern Art, 2009), 64–67.

34. Moholy published several of his works in *De Stijl*, and his most important theoretical essay from the early twenties, "Production-Reproduction," appeared in its pages prior to his arrival at the Bauhaus. L. Moholy-Nagy, "Produktion-Reproduktion," *De Stijl* 5.7 (1922): 98–100. Moholy-Nagy corresponded professionally with van Doesburg initially as a representative of the Hungarian journal *Ma*, but the relationship became already more personal by the summer of 1922. See László Moholy-Nagy to van Doesburg, February 8, 1922; April 2, 1922; and August 10, 1922, Theo and Nelly van Doesburg Archives, Netherlands Institute for Art History (RKD), The Hague.

35. László Moholy-Nagy, *Malerei, Fotografie, Film*, 1st ed. (Munich: Albert Langen Verlag, 1925), 12–14.

36. Moholy-Nagy, *Malerei, Fotografie, Film*, 1st ed., 13 (emphasis in original).

37. Magdalena Droste, *Bauhaus, 1919–1933*, trans. Karen Williams (Cologne: Taschen Verlag, 2002), 54.

38. László Moholy-Nagy, *Malerei, Fotografie, Film*, 2nd ed. (Munich: Albert Langen Verlag, 1927), 15 (emphasis in original).

39. Moholy-Nagy, *Malerei, Fotografie, Film*, 2nd ed., 15–16.

40. Ibid., 11.

41. Ibid., 21–22. These pages correspond to Moholy-Nagy, *Malerei, Fotografie, Film*, 1st ed., 18.

42. Juliet Koss, "Bauhaus Theater of Human Dolls," *Art Bulletin* 85.4 (2003): 724–45.

43. The extent to which Schlemmer tried, but failed, to distinguish his contribution to the book from those of Moholy and Molnár is evident in his correspondence with Gropius. As head of the theater workshop at the Bauhaus, Schlemmer sought, and received, the lion's share of the book's royalties. Schlemmer also requested the use of positive reviews of his essay in particular for the promotion of the book. Gropius refused this on the grounds that any review emphasizing one essay over the others would undermine the coherence of *Die Bühne am Bauhaus* as a Bauhaus book. See Walter Gropius to Oskar Schlemmer, October 9, 1925, Walter Gropius Papers, BHA.

44. Oskar Schlemmer, "Man and Art Figure," in Oskar Schlemmer, László Moholy-Nagy, and Farkas Molnár, *Theater of the Bauhaus,* trans. Arthur S. Wensinger (Middletown, CT: Wes-

leyan University Press, 1961), 17 (translation modified). Original in Oskar Schlemmer, "Mensch und Kunstfigur," in Oskar Schlemmer, László Moholy-Nagy, and Farkas Molnár, *Die Bühne am Bauhaus* (Frankfurt: Oehms Druck KG, 1925), 7.

45. László Moholy-Nagy, "Theater Circus, Variety," in Schlemmer, Moholy-Nagy, and Molnár, *Theater of the Bauhaus*, 49 (translation modified). Original in László Moholy-Nagy, "Theater, Zirkus, Varité," in Schlemmer, Moholy-Nagy, and Molnár, *Die Bühne am Bauhaus,* 45.

46. Moholy-Nagy, "Theater, Zirkus, Varité," 47, 49.

47. Ibid., 54–55 (emphasis in original).

48. Schlemmer's humanism is complex. In his *Triadic Ballet*, he uses elaborate costumes both to mask the identity of individual actors and to circumscribe their movements. As Paul Paret argues, the forms that Schlemmer's characters take in the ballet allude to the transformation of the body in the aftermath of the First World War. They regiment the body, render it anonymous and grotesque, which thus can be seen as a move to dehumanize the body. Paul Paret, "Oskar Schlemmer: Grotesque I, 1923," in Bergdoll and Dickerman, *Bauhaus 1919–1933,* 162–65; and Paul Paret, "Oskar Schlemmer: Study for the *Triadic Ballet,* 1924," in Bergdoll and Dickerman, *Bauhaus 1919–1933,* 168–71. What I want to emphasize here, however, is that Schlemmer's essay for *Theater of the Bauhaus* underscores the ways in which the ludic qualities of the stage enable the audience to envision and enact humanist ideals. Schlemmer, "Man and Art Figure," 17, 32.

49. See Stefan Wöll, *Das Total Theater: Ein Projekt von Walter Gropius und Erwin Piscator* (Berlin: Gesellschaft für Theatergeschichte, 1984).

50. Annemarie Jaeggi, *Werkbund-Austellung, Paris, 1930: Leben im Hochhaus* (Berlin: Bauhaus Archiv, 2007).

51. Moholy-Nagy, *"Lichtrequisit einer elektrischen Bühne,"* 297–99; Jeffrey T. Schnapp, "Border Crossings: Italian/German Peregrinations of the 'Theater of Totality,'" *Critical Inquiry* 21.1 (1994): 96. On Stefan Sebök, see Lilly Dubowitz, *In Search of a Forgotten Architect: Stefan Sebök 1901–1941* (London: AA Publications, 2012).

52. Moholy-Nagy, *"Lichtrequisit,"* 297–99.

53. Ibid., 297.

54. Ibid.

55. See Mona Ozouf, *Festivals and the French Revolution,* trans. Alan Sheridan (Cambridge, MA: Harvard University Press, 1988); and James von Geldern, *Bolshevik Festivals, 1917–1920* (Berkeley: University of California Press, 1993).

56. Moholy-Nagy, *"Lichtrequisit,"* 298.

57. Ibid., 299.

58. Ibid., 297.

59. Ibid., 299.

60. The abridged and very rough French and English translations appear immediately following Moholy's text in *Die Form,* both apparently translated by E.T. Scheffauer, "Installation lumineuse d'une scène électrique, extrait de traduction," *Die Form: Zeitschrift Für Gestaltende Arbeit* 5.11–12 (1930): 298, and *"Lighting Requisit for an Electric*

Stage, Abridged Translation," *Die Form: Zeitschrift Für Gestaltende Arbeit* 5.11–12 (1930): 299.

61. Sigfried Giedion, "Der Deutsche Werkbund in Paris," *Der Cicerone* 13–14 (August 1930): 431.

62. René Chavance, "La section allemand," *Les echos d'art* 59 (June 1930): n.p.

63. Wilhelm Lotz, "Ausstellung des deutschen Werkbunds in Paris," *Die Form: Zeitschrift für gestaltende Arbeit* 5.11–12 (1930): 281–84. Lotz was not the only critic of the privileging of technology in the German section of the show. Several reviewers, even if they were sympathetic to the attempt to introduce a modern, hygienic aesthetic, criticized it for its mechanical coldness. Examples of such criticisms can be found in "Salon des décorateurs," *Studio*, August 1, 1930, n.p.; "In the World of Art: Glass and Metal Furniture, Hygienic but Not Beautiful," *Daily Mail*, May 24, 1930, n.p.; E. Roland, "La section allemande au salon des artistes décorateurs," *La revue de l'habitation* (1930): 20–22; Ernst Tisserand, "Au salon des décorateurs," *L'art vivant*, June 1, 1930, 455–57; Paul Werrie, "Les allemands à Paris: Exposition suggestive, la dicature de Gropius, les tempéraments et l'art des deux pays," *La vingtième siècle*, July 17, 1930, n.p.; Jacques Mesnil, "Le 'Werkbund' et l'exposition des artistes décorateurs," *Le Monde*, July 5, 1930, n.p.; André Salmon, "Exposition du Werkbund au XXe salon des artistes décorateurs," *Art et décoration* (July 1930): 13–16; and G. Rémon, "Le salon des artistes décorateurs," *Mobilier et décoration* 6 (June 1930): 217–24. For a condensed overview of the French reception of the Paris Werkbund exhibition of 1930, see Matthias Noell, "Zwischen Krankenhaus und Mönchszelle: 'Le Nouveau Visage de l'Allemagne'—Die Werkbund-Ausstellung 1930 im Spiegel der französischen Tagespresse," in *Das Bauhaus und Frankreich*, ed. Isabelle Ewig, Thomas W. Gaehtgens, and Matthias Noelle (Berlin: Akademie, 2002), 313–46.

64. Hans Curjel, *Experiment Krolloper, 1927–1931* (Munich: Prestel, 1975), 262.

65. The definition and stakes of Constructivism shifted throughout the twenties and differed among individual practitioners. The inaugural issue of *Vešč-Objet-Gegenstand* in 1922 refers to constructive art as an attempt "not to adorn life but to organize it." *Vešč-Objet-Gegenstand: Commentary and Translations*, trans. Stephen Bann (Baden: Lars Müller, 1994), 56. Moholy was hired by the Bauhaus to represent the Constructivist position in the school, but he sought help to clarify what Constructivism meant at that time. László Moholy-Nagy to Alexander Rodchenko, December 18, 1923, in Passuth, *Moholy-Nagy*, 392–94. Already by 1924, Constructivism had come to be seen by some members of the avant-garde as comprising yet another artistic movement that the art market could assimilate. See H.R. [Hans Richter], "An den Konstruktivismus," *G: Material zur Elementaren Gestaltung* 3 (June 1924): 72.

66. Bie also reviewed the Kroll production of *Madame Butterfly*, which premiered on February 23, 1931. He writes on February 24, 1931, for the *Berliner Börsen-Courier* that the otherwise realistic opera was turned into pure abstraction through the design of the set. In the same review, he also refers to Moholy as a master at the Bauhaus, even though the latter had long left that post. Curjel, *Experiment Krolloper*, 310.

67. The repository for the press clippings that Gropius collected from his various subscriptions can be found in the Walter Gropius Papers, BHA.

68. Jeanpaul Goergen, "Light Play and Social Reportage: László Moholy-Nagy and the German Film Avant-Garde," in *László Moholy-Nagy: The Art of Light,* ed. Doménico Chiappe, Luisa Lucuix, et al. (The Hague: Gemeentemuseum, 2010), 204.

69. Ibid., 204.

70. Ibid.

71. H. Gr., "Filme von Moholy-Nagy," *Berliner Börsen-Courier,* March 5, 1932, 2.

72. Siegried Kracauer, "Einige Filme," *Frankfurter Zeitung,* March 19, 1932.

73. Ibid.

74. Ibid.

75. Sibyl Moholy-Nagy to László Moholy-Nagy, August 24, 1932, Sibyl Moholy-Nagy Papers, AAA.

76. Julien Levy to László Moholy-Nagy, October 10, 1932, Julien Levy Archive, Newtown, Connecticut. Cited in Lloyd C. Engelbrecht, *Moholy-Nagy: Mentor to Modernism* (Cincinnati: Flying Trapeze Press, 2009), 438.

77. László Moholy-Nagy to František Kalivoda, *Telehor* 1–2 (November 1936): 30.

78. Ibid., 32.

79. Wilhelm Lotz had links to the Bauhaus and was intimately involved in the activities of the Deutscher Werkbund. In 1927, he became an editor at Hermann Reckendorf, publisher of Werkbund books and journals, where he put together a book on lighting design. Wilhelm Lotz et al., *Licht und Beleuchtung: Lichttechnische Fragen unter Berücksichtigung der Bedürfnisse der Architektur* (Berlin: Hermann Reckendorf, 1928). During the Third Reich, Lotz continued writing on design and architecture, and served as the *Hauptschriftleiter* of the series *Schönheit der Arbeit,* published by the National Socialist Verlag der Deutschen Arbeitsfront. It is unclear what happened to Lotz, although Wilhelm Niemann claims that he was shot by the Nazis during the war. See Sonja Günter, "Nachwort," in Wilhelm Lotz, *Wie richte ich meine Wohnung ein* (Berlin: Mann, 1999). For a more detailed history of the fates of the Werkbund as well as Lotz in the Third Reich, see Joan Campbell, *The German Werkbund: The Politics of Reform in the Applied Arts* (Princeton, NJ: Princeton University Press, 1972), 243–87.

80. Wilhelm Lotz, "Das Reichsparteigelände und seine Bauten," *Der Baumeister* 35 (1937): 309.

81. Walter Gropius, "Manifesto and Program of the Bauhaus," in Whitford, *Bauhaus,* 202.

82. Albert Speer, *Erinnerungen* (Berlin: Propyläen, 1969), 71–72.

83. Sibyl Moholy-Nagy, *Experiment in Totality,* 1st ed. (New York: Harper and Brothers, 1950), 132.

84. Eric Michaud highlights sources of National Socialist aesthetic ideology in the history of German thought that center on the notion of the total work of art. Among the figures included in his account is Moholy, along with Gropius and the Bauhaus more generally. Michaud identifies the dangers implicit in Moholy's commitments to the aesthetic, biological transformation of man. Eric Michaud, "Oeuvre d'art totale et totalitarisme," in *L'oeuvre d'art totale,* ed. Jean Galard and Julian Zugazagoitia (Paris: Gallimard, 2002), 35–65. Also see Schnapp, "Border Crossings," 80–123.

85. Martin Pawley, "The Rise and Fall of the Reichstag," in *Rebuilding the Reichstag,* by Norman Foster (Woodstock, NY: Overlook Press, 2000), 52.

86. Moholy-Nagy, *The New Vision,* 80.

87. Sibyl Moholy-Nagy, *Experiment in Totality,* 67.

88. Rosalind E. Krauss, "Mechanical Ballets: Lights, Motion, Theater," in Rosalind E. Krauss, *Passages in Modern Sculpture* (New York: Viking Press, 1977), 208.

89. Ibid., 209.

90. Alex Potts, "László Moholy-Nagy: *Light Prop for an Electric Stage,* 1930," in Bergdoll and Dickerman, *Bauhaus 1919–1933,* 277.

91. Charles Kuhn, director of the Busch-Reisinger in 1965, wrote in a letter to György Kepes regarding the repair and reconstruction of *Light Prop*: "The machine is in shocking condition in part because of its European travels with the Exhibition of Kinetic Art a few years ago." Charles Kuhn to György Kepes, July 7, 1965, *Lichtrequisit* object file, BR.

92. Memo from Arthur Beal to Miss [Agnes] Mongan, *Lichtrequisit* object file, BR.

93. Achim Borchardt-Hume, curator at the Tate Modern, initiated discussions with the Busch-Reisinger Museum about producing a third replica for the 2005 exhibition *Albers and Moholy-Nagy: From the Bauhaus to the New World* because both Van Abbemuseum and the Bauhaus Archiv refused to loan their replicas due to conservation problems. By July 2005, arrangements were underway to produce a traveling copy that the Busch-Reisinger later acquired; *Lichtrequisit* object file, BR.

94. William Moritz, *Optical Poetry: The Life and Work of Oskar Fischinger* (Bloomington: Indiana University Press, 2004), 70.

95. László Moholy-Nagy, *Vision in Motion* (Chicago: Paul Theobald, 1947), 168.

96. Richard Schickel, *The Disney Version: The Life, Times, Art, and Commerce of Walt Disney* (New York: Simon and Schuster, 1985), 229–26.

97. Walt Disney, "Disney's Cinesymphony," *Time,* November 18, 1940, 55. Walt Disney was eager to dispel the impression that the studio was embarking on an exercise in high culture with *Fantasia.* The film did not do well initially, which was especially troubling given the enormous resources that had been invested in its production. The dismal box-office performance was due in part to the fact that members of the general public found the prospect of an animated film about classical music daunting. Schickel, *The Disney Version,* 230, 247.

98. Moholy-Nagy, *Vision in Motion,* 30.

99. Moholy-Nagy, *The New Vision,* 80.

4. PAINTING AFTER PHOTOGRAPHY

1. Oskar Schlemmer to Otto Meyer, December 1925, in Oskar Schlemmer, *Dairies and Correspondences,* ed. Tut Schlemmer, trans. Krishna Winston (Middletown, CT: Wesleyan University Press, 1972), 184. This chapter draws upon three previously published studies: Joyce Tsai, "Excavating Surface: On the Repair and Revision of László Moholy-Nagy's *Z VII* (1926)," in *Bauhaus Construct: Fashioning Identity, Discourse and Modernism,* ed. Robin Schuldenfrei and Jeffrey Saletnik (London: Routledge, 2009), 142–62; Joyce Tsai, Jay

Krueger, and Christopher Maines, "'Transparency and Light, Structure and Substance': Enamel Paints in László Moholy-Nagy's *Z VII* (1926)," *Journal of the American Institute of Conservation* 52.2 (2013): 236–45; and Joyce Tsai, *The Paintings of Moholy-Nagy: Shape of Things to Come* (New Haven, CT: Yale University Press, 2015).

2. Arthur Lehning, "Introduction," in *Internationale Revue: i10, 1927–1929* (Nendeln: Kraus Reprint, 1978), n.p.

3. László Moholy-Nagy, "Diskussion über Ernst Kallai's Artikel 'Malerei und Fotografie,'" *i10* 1.6 (1927): 233.

4. Walter Benjamin, "Little History of Photography" (1931), in *Walter Benjamin: Selected Writings, Volume 2, Part Two, 1931–1934*, trans. Rodney Livingstone et al., ed. Michael W. Jennings, Howard Eiland, and Gary Smith (Cambridge, MA: Belknap Press, Harvard University Press, 1999), 527.

5. Ute Eskildsen and Jan-Christopher Horak, eds., *Film und Foto der zwanziger Jahre* (Stuttgart: Gerd Hatje,1978).

6. Annemarie Jaeggi, *Werkbund-Ausstellung, Paris, 1930: Leben im Hochhaus* (Berlin: Bauhaus Archiv, 2007).

7. Alexander Dorner to Moholy-Nagy, November, 5, 1930, Alexander Dorner Papers, Archives of the Sprengel Museum, Hannover. On the *Raum der Gegenwart,* see Jennifer King, "Back to the Present: Moholy-Nagy's Exhibition Designs," in *Moholy-Nagy: Future Present,* ed. Matthew S. Witkovsky, Carol S. Eliel, and Karole P. B. Vail (New Haven, CT: Yale University Press, 2016), 140–50; and Noam M. Elcott, "Review: *Raum der Gegenwart* (*Room of Our Time*) by Schirn Kunsthalle," *Journal of the Society of Architectural Historians* 69.2 (June 2010): 265 69.

8. *Lightplay* ran in Berlin in 1932, in New York and London in 1933, and on several occasions in the Netherlands in 1934, among others. See "Pictorial Backgrounds," *New York Times,* February 26, 1933, X5; "The Film Society," *The Times* (London), December 1, 1933, 12; "Filmstudiegroup," *Het Vaderland,* March 1, 1934, evening ed., 3; "Filmnieuws," *Het Vaderland,* November 12, 1934, evening ed., 9.

9. Christopher Frayling, *Things to Come* (London: BFI Film Classics, 2008), 72–73. For an account of how *Lightplay* shaped the reception of *Light Prop* by serving as a particularly fruitful design fiction, see Joyce Tsai et al., "Light Prop as Design Fiction: Perspectives on Conservation and Replication," *Leonardo* 50.3 (June 2017): 311–15.

10. László Moholy-Nagy to Sibyl Moholy-Nagy, October 9, 1934, Sibyl Moholy-Nagy Papers, AAA.

11. "Mr. Moholy-Nagy," *The Times* (London), January 2, 1937, 8.

12. Ibid.

13. Whitney Halstead, "Chicago: Exhibition Organized by the Museum of Contemporary Art and the Guggenheim Museum," *Artforum* 8 (September 1969): 68.

14. Ibid.

15. Fr. Kalivoda, "Postscript," trans. F.D. Klingender, *Telehor* 1–2 (1936): 45.

16. Ibid., 46.

17. Oliver Botar, *Technical Detours: The Early Moholy-Nagy Reconsidered* (New York: Art Gallery of the Graduate Center), 55.

18. Existing pictures from the *Z* group are as follows: *Z I*, 1922, oil on canvas, 75 × 96.5 cm, BHA; *Z II*, 1925, oil on canvas, 95.4 × 75.1 cm, Museum of Modern Art; *Z III*, 1922, oil on canvas, 96 × 75.5 cm, location unknown; *Z IV*, 1923, oil on canvas, 96 × 78 cm, last known location Marlborough Fine Art, no. XLOL 3449; *Z VI*, 1925, oil on canvas, 95.2 × 75.6 cm, Busch-Reisinger Museum; *Z VII*, 1926, oil on canvas, 75 × 96.5 cm, National Gallery of Art, Washington, DC; *Z VIII*, 1924, tempera on unprimed canvas, 114 × 132 cm, Neue National-galerie Berlin; *Z IX*, 1924, oil on canvas, 136 × 115.5 cm, Kunsthalle Mannheim.

19. László Moholy-Nagy, *Painting, Photography, Film*, trans. Janet Seligman (Cambridge, MA: MIT Press, 1969), 11–12.

20. Tsai, Krueger, and Maines, "'Transparency and Light, Structure and Substance.'"

21. "Appraiser's list of work owned by Sibyl Moholy-Nagy," December 20, 1952, Sibyl Moholy-Nagy Papers, AAA.

22. Sibyl Moholy-Nagy, *Experiment in Totality*, 1st ed. (New York: Harper and Brothers, 1950), 132.

23. Sibyl Moholy-Nagy to Lucia Moholy-Nagy, November 15, 1947, BHA. Original in English. "[Moholy] did in England a good deal of repairing on earlier paintings because so many had been left behind in Berlin through my personal ignorance. We knew that we had lost them and so he felt he should preserve what he had. That might be responsible for the newer look [of pictures from the twenties]."

24. Pretreatment photograph of *Z VII* under ultraviolet light, August 2007, object file for *Z VII* (1926), National Gallery of Art, Washington, DC.

25. Moholy-Nagy, *Painting, Photography, Film*, 25–26, 44.

26. László Moholy-Nagy, *Von Material zu Architektur* (Passau: Passiva, 1929), 90.

27. Ibid.

28. László Moholy-Nagy, "Geradelinigkeit des Geistes, Umwege der Technik," *Internationale Revue i10* 1 (1927): 35–37.

29. Ibid., 35.

30. Ibid., 36.

31. Ibid.

32. Ibid.

33. Ibid., 37.

34. László Moholy-Nagy, "Fotogramm und Grenzgebiete," *International Revue i10* 2.21–22 (1929): 190. The text was also published in *Die Form* 4.10 (May 1929): 256–59.

35. Moholy-Nagy, "Fotogramm und Grenzgebiete," 190.

36. László Moholy-Nagy, "Einleitung zum Vortrag 'Malerei und Fotografie,' Köln Dezember 1931," *a bis z: Organ der Gruppe Progressive Künstler* 3 (April 1932): 89.

37. Ibid.

38. See Lynette Roth, *Painting as a Weapon: Progessive Cologne, 1920–33: Seiwert—Hoerle—Arntz* (Cologne: Walther König, 2008).

39. Sibyl Moholy-Nagy to László Moholy-Nagy, October 9, 1934, Sibyl Moholy-Nagy Papers, AAA.

40. František Kalivoda, Postcard announcing lecture showing of films by L. Moholy-Nagy and lecture by Fr. Kalivoda: "Outsider Fotofilmu" (Outsider Fotofilm), on March 5, 1934, at Masaryk University, Brno, Museum of Modern Art, 693.1999.

41. L. Moholy-Nagy, "Offener Brief: An die Filmindustrie und an alle, die Interesse an der Entwicklung des guten Films haben," *Ekran* 1.1 (November 15, 1934): 14–15.

42. Ibid.

43. František Kalivoda, "L. Moholy-Nagy, Künstlerhaus, Brno, June 1–16, 1935," poster for an exhibition of works by Moholy-Nagy at the Moravian Künstlerhaus, Brno, sponsored by *Telehor,* 1935, Museum of Modern Art, 881.1979.

44. L. Moholy-Nagy, "Dear Kalivoda," *Telehor* 1–2 (1936): 30.

45. Ibid.

46. Ibid., 31.

47. Ibid.

48. Ibid.

49. Ibid.

50. Ibid.

51. Ibid., 30.

52. Patrick Rössler, *The Bauhaus at the Newsstand: Die Neue Linie, 1929–1942* (Bielefeld: Kerber Verlag, 2009), 39.

53. Ibid., 35. "Deutscher Geist in Paris," *die neue linie* 1.11 (July 1930): 12–13. "Unsere Mitarbeiter stellen Sich vor," *die neue linie* 3.4 (December 1931): 22–23.

54. Walter Gropius, "Wie Sollte der Großstädter Wohnen?," *die neue linie* 2.5 (January 1931): 22–23.

55. László Moholy-Nagy, cover, *die neue linie* 2.9 (May 1931).

56. H.K. Frenzel, "Where Is Advertising Going?" *Gebrauchsgraphik, International Advertising Art* 8.5 (May 1931): 31, 35.

57. Ibid., 43.

58. Bernd Widdig, *Culture and Inflation in Germany* (Berkeley: University of California Press, 2001), 223.

59. Rössler, *Bauhaus at the Newsstand,* 13.

60. Lloyd C. Engelbrecht, *Moholy-Nagy: Mentor to Modernism* (Cincinnati: Flying Trapeze Press, 2009), 393–98.

61. László Moholy-Nagy to Sibyl Moholy-Nagy, November 1933, Sibyl Moholy-Nagy Papers, AAA.

62. László Moholy-Nagy to Sibyl Moholy-Nagy, August 1934, Sibyl Moholy-Nagy Papers, AAA.

63. Oliver A.I. Botar and Klemens Gruber, "Commentary," in *Telehor L. Moholy-Nagy: Commentary and Translations,* ed. Oliver A.I. Botar and Klemens Gruber (Zurich: Lars Müller, 2013), 17.

64. *Telehor* 1–2 (1936): 81–84.

65. Ibid., 70, 71, 74.

66. Julie Barten, Sylvie Pénichon, and Carol Stringari, "The Materialization of Light," in Witkovsky, Eliel, and Vail, *Future Present,* 193.

67. László Moholy-Nagy to Franz Roh, March 23, 1934, Franz Roh Papers, Getty Special Collections, Getty Research Center, Los Angeles.

68. Botar and Gruber, "Commentary," 27.

69. *Telehor* 1–2 (1936): 68.

70. Ibid., 70.

71. Tsai, Krueger, and Maines, "'Transparency and Light, Structure and Substance.'"

72. Fr. Kalivoda, "Postscript," *Telehor* 1–2 (1936): 46.

73. Ibid.

74. Thanks to Graham Bader, Gordon Hughes, and Harry Cooper for helping me articulate the significance of the rotation of the picture.

75. Inquiring about a batch of color images for use in the volume sent in May of 1935, Moholy-Nagy asked his editor if his palette could be adequately reproduced through the four-color process or if that would require different print technology. Note in László Moholy-Nagy's handwriting on color proof of *AL 6,* May 5, 1934, Brno City Archives, Brno.

76. Botar and Gruber, "Commentary," 25.

77. László Moholy-Nagy to Paul Citroën, June 16, 1936, BHA.

78. Jeannine Fiedler, "Moholy-Nagy's Color Camera Works: A Pioneer of Color Photography," in *László Moholy-Nagy: Color in Transparency; Photographic Experiments in Color, 1934–1946,* ed. Jeannine Fiedler and Hattula Moholy-Nagy (Göttingen: Steidl, 2006), 20.

79. László Moholy-Nagy, "A felszabadult szín-fényképezés felé," *Korunk* 12 (1936): 1014–17, trans. and repub. as "Paths to the Unleashed Color Camera," in Fiedler and Hattula Moholy-Nagy, *Color in Transparency,* 35–38.

80. Ibid., 36; L. Moholy-Nagy, "Produktion-Reproduktion," *De Stijl* 5.7 (July 1922): 98–101.

81. Moholy-Nagy, "Paths to the Unleashed Color Camera," 38.

82. Ibid., 37.

83. Ibid.

84. Terence A. Senter, "Moholy-Nagy: The Transitional Years," in *Albers and Moholy-Nagy: From the Bauhaus to the New World,* ed. Achim Borchardt-Hume (London: Tate, 2006), 88.

85. Ibid., 89; David Burke, *The Lawn Road Flats: Spies, Writers and Artists* (Woodbridge, Suffolk: Boydell Press, 2014), 62–64.

86. Sibyl Moholy-Nagy to László Moholy-Nagy, January 27, 1937, Sibyl Moholy-Nagy Papers, AAA.

87. Merriam-Webster online, s.v. "modulate," www.merriam-webster.com.

88. Sydney Alexander Mosley and Herbert McKay, *Television: A Guide for the Amateur* (Oxford: Oxford University Press, 1936), 64.

CONCLUSION

1. Lloyd C. Engelbrecht, *Moholy-Nagy: Mentor to Modernism* (Cincinnati: Flying Trapeze Press, 2009), 221. Recording included in DVD accompanying the book as sound clip 2.

2. Ibid. For an account of Moholy's exhibitions in America, see Karole P. B. Vail, "Bridging the Atlantic," in *Moholy-Nagy: Future Present*, ed. Matthew S. Witkovsky, Carol S. Eliel, and Karole P. B. Vail (New Haven, CT: Yale University Press, 2016), 256–64.

3. László Moholy-Nagy, "Abstract of an Artist," in *The New Vision, 1928; and, Abstract of an Artist*, trans. Daphne Hoffmann, 4th rev. ed. (New York: Wittenborn, Schultz, 1947), 67.

4. Ibid., 68.

5. Ibid.

6. Ibid.

7. Ibid.

8. Friederike Waentig and Joyce Tsai, "An Introduction to Moholy's Plastic Materials," trans. Timothy Grundy, in *The Paintings of Moholy-Nagy: The Shape of Things to Come*, ed. Joyce Tsai (Santa Barbara: Santa Barbara Museum of Art, 2015), 140–41.

9. Julie Barten, Sylvie Pénichon, and Carol Stringari, "The Materialization of Light," in Witkovsky, Eliel, and Vail, *Future Present*, 201.

10. Moholy-Nagy, "Abstract of an Artist," 84.

11. Ibid., 86.

12. Ibid., 84.

13. Hal Foster, "The Bauhaus Idea in America," in *Albers and Moholy-Nagy: From the Bauhaus to the New World*, ed. Achim Borchardt-Hume (London: Tate Modern, 2006), 96.

14. Ibid., 97. Another assessment of Moholy's time in America that similarly addresses his willingness to accommodate American capitalism is offered in Sheri Bernstein's brief but illuminating essay on Moholy's period in the United States. She concludes with the remark that "Moholy, who had once declared himself a communist as a young man, was in essence fully compliant with the American political and economic system as a middle-aged artist and teacher. Although he had to compete in the capitalist market to promote his school and sell his designs, the United States offered him the freedom in his art to eschew politics and the cataclysmic events of his day and to escape instead to a realm of personal creative exploration." Sheri Bernstein, "Pragmatism and Purism," in *Exiles + Emigrés: The Flight of European Artists from Hitler*, ed. Stephanie Barron and Sabine Eckmann (New York: Harry N. Abrams, 1997), 268.

15. Barbara Jaffe, "Before the New Bauhaus: From Industrial Drawing to Art and Design Education in Chicago," *Design Issues* 21.1 (Winter 2005): 44.

16. Elizabeth King Morey and Frances L. Youtz, "Modern Trends in the Creative Arts: Selected Bibliography," *Progressive Education* 11 (April–May 1934): 255.

17. Moholy already had laid out his plans for revision of *The New Vision* and for starting the New Bauhaus Book series in his initial discussions with the Association of Arts and Industry in the summer of 1937. László Moholy-Nagy to Sibyl Moholy-Nagy, Chicago, August 5, 1937, Sibyl Moholy-Nagy Papers, AAA.

18. Walter Gropius, "Idee und Aufbau des Staatlichen Bauhauses," in Walter Gropius, *Staatliche Bauhaus in Weimar, 1919–1923* (Weimar: Bauhaus Verlag, 1923), 8. The text was translated and published in 1938 in the Museum of Modern Art catalog for its exhibition *Bauhaus,*

1919–1928. Walter Gropius, "The Theory and Organization of the Bauhaus," in *Bauhaus, 1919–1928,* ed. Herbert Bayer, Ise Gropius, and Walter Gropius (New York: Museum of Modern Art, 1928), 23.

19. László Moholy-Nagy, *The New Vision,* trans. Daphne M. Hoffmann, 2nd rev. and enlarged ed. (New York: W. W. Norton, 1938), 22.

20. In his early negotiations with the Association of Arts and Industry in Chicago, Moholy was cautiously optimistic about the possibility of securing sufficient funding for the programming he developed for the New Bauhaus. László Moholy-Nagy to Sibyl Moholy-Nagy, Chicago, July 17, 1937, Sibyl Moholy-Nagy Papers, AAA.

21. Engelbrecht, *Mentor to Modernism,* 582.

22. Nathalie Swan, "To the Art Editor," *New York Times,* December 18, 1938, 162.

23. Stephanie Barron, "European Artists in Exile: A Reading between the Lines," in Barron and Eckmann, *Exiles + Emigrés,* 19.

24. Alfred Barr, "Bauhaus in Controversy: Alfred H. Barr, Director of the Museum of Modern Art, Answers Criticism," *New York Times,* December 25, 1938, 112. László Moholy-Nagy, "The Bauhaus in Chicago: Moholy-Nagy Explains," *New York Times,* January 1, 1939, 103.

25. Engelbrecht, *Mentor to Modernism,* 583.

26. Ibid., 587–88.

27. See Robin Schuldenfrei, "Assimilating Unease: Moholy-Nagy and the Wartime/Postwar Bauhaus in Chicago," in *Atomic Dwelling: Anxiety, Domesticity, and Postwar Architecture,* ed. Robin Schuldenfrei (London: Routledge, 2012), 87–126. Schuldenfrei has offered an important account of how Moholy attempted to find innovative ways to redirect his pedagogy and philosophy to accommodate the profound challenges during the Second World War and the period that followed. My own reading of his time in exile builds upon her foundation.

28. Ibid., 104.

29. László Moholy-Nagy to Sgt. Robert Jay Wolff, October 6, 1942, Robert Jay Wolff Papers, AAA.

30. Schuldenfrei, "Assimilating Unease," 96.

31. Ibid., 94–95.

32. Lieutenant Robert Jay Wolff to Major Robert Dahlstrom, January 20, 1944, Robert Jay Wolff Papers, AAA.

33. Schuldenfrei, "Assimilating Unease," 102–4; Elizabeth Siegel, "The Modern Artist's New Tools," in Witkovsky, Eliel, and Vail, *Future Present,* 230.

34. Sibyl Browne et al., *Art and Materials for the Schools; Activities to Aid the War and the Peace* (New York: Service Center Committee, Progressive Education Association, 1943), 13.

35. Ibid., 22.

36. Benjamin Buchloh, *Neo-Avantgarde and Culture Industry: Essays on European and American Art from 1955 to 1975* (Cambridge, MA: MIT Press, 2000), 446.

37. Joan Campbell, *The German Werkbund: The Politics of Reform in the Applied Arts* (Princeton, NJ: Princeton University Press, 1978), 292

38. Jonathan Petropoulos, *Artists under Hitler: Collaboration and Survival in Nazi Germany* (New Haven, CT: Yale University Press, 2014), 76–80.

39. Paul Betts, *The Authority of Everyday Objects: A Cultural History of West German Industrial Design* (Berkeley: University of California Press, 2004), 79.

40. Eva Díaz, *The Experimenters: Chance and Design at Black Mountain College* (Chicago: University of Chicago Press, 2015), 68.

41. Karen Koehler, "The Bauhaus Manifesto Postwar to Postwar: From the Street to the Wall to the Radio to the Memoir," in *Bauhaus Construct: Fashioning Identity, Discourse and Modernism*, ed. Jeffrey Saletnik and Robin Schuldenfrei (London: Routledge, 2009), 23–24.

42. Patrick Coffey, *American Arsenal* (Oxford: Oxford University Press, 2014), 96, 97.

43. *Dialectic of Enlightenment*, drafted during the war while Max Horkheimer and Theodor Adorno were in exile in the United States, was first published in 1944 in America. The first version of the text appeared as Max Horkheimer and Theodor Adorno, *Philosophische Fragmente* (New York: Social Studies Association, 1944). After the war, the authors added a chapter entitled "Elements of Anti-Semitism" and published the book as *Dialektik der Aufklärung: Philosophische Fragment* (Amsterdam: Querido Verlag, 1947). It only circulated more broadly after its publication in Germany as *Dialektik der Aufklärung: Philosophische Fragmente* (Frankfurt: Suhrkamp Verlag, 1969). The first English translation appeared in 1972 as *Dialectic of Enlightenment: Philosophical Fragments*, trans. John Cumming (New York: Herder and Herder, 1972). The authoritative English edition of the work is now the 2002 translation by Edmund Jephcott: *Dialectic of Enlightenment: Philosophical Fragments*, ed. Gunzelin Schmid Noerr (Stanford, CA: Stanford University Press, 2002), which is the version to which my text refers.

44. Horkheimer and Adorno, "Preface," in Noerr, *Dialectic of Enlightenment*, xiv.

45. Clement Greenberg, "Avant-Garde and Kitsch," *Partisan Review* 6.5 (Fall 1939): 38.

46. Ibid.

47. László Moholy-Nagy to Walter Gropius, June 8, 1938, BHA; László Moholy-Nagy to Sigfried Giedion and Carola Giedion-Welcker, August 5, 1946, Archives of the GTA, Institute for the History of Theory of Architecture, ETH Zurich, cited in Matthew Witkovsky, "Elemental Marks," in Witkovsky, Eliel, and Vail, *Future Present*, 33.

48. This is a line of thought present in Kantian aesthetics, upon which Adorno would draw in his own *Aesthetic Theory*. See J. M. Bernstein, *The Fate of Art: Aesthetic Alienation from Kant to Derrida and Adorno* (University Park: Pennsylvania State University Press, 1992). Theodor Adorno, *Aesthetic Theory*, ed. Gretel Adorno and Rolf Tiedemann, trans. Robert Hullot-Kentor (Minneapolis: University of Minnesota Press, 1997), 1–14.

49. "Education in Art Put on New Basis," *Christian Science Monitor*, March 18, 1939, 3; Robert M. Yoder, "Are You Contemporary?," *Saturday Evening Post*, July 3, 1943, 16–17, 89; Phyllis Ford, "Moholy-Nagy Brings Life of Future—Today," *Chicago Sunday Tribune*, August 1, 1943, part 3, n.p.

50. László Moholy-Nagy to N. Pevsner, March 18, 1943, BHA.

51. Yoder, "Are You Contemporary?," 89.

52. László Moholy-Nagy to Galka Scheyer, August 26, 1939, Galka Scheyer Papers, Norton Simon Museum, Pasadena.

53. Many of Moholy's works on plastics, especially on clear cellulose acetate (celluloid and Rhodoid), have deteriorated dramatically and can no longer be shown. See, for example, László Moholy-Nagy, Abstract composition of oil and etched lines and shapes on cellulose acetate, 1938, oil on cellulose acetate, Historic New England. The painted Rhodoid disc on *Space Modulator Experiment, AL 5* cracked and was shown in the Guggenheim's 2016 *Moholy-Nagy: Future Present* exhibition with an unpainted clear piece of plastic. Witkovsky, Eliel, and Vail, *Future Present,* 204. For a study of the deterioration of one example of Moholy's cellulose acetate paintings, see Isabelle Duvernois, "Moholy-Nagy's 'Vision in Motion' Stilled: A Study of Wire Mesh Plastic Laminate Deterioration" (master's thesis, New York University, 2003).

54. László Moholy-Nagy to Robert Jay Wolff, June 7, 1942, Robert Jay Wolff Papers, AAA. In this letter to Wolff, former faculty member at the New Bauhaus and School of Design, who was then serving in the military, Moholy advises him on the properties of different brands of plastic. Regarding how best to heat Plexiglas in preparation for molding, Moholy remarks: "You could use a normal kitchen oven compartment [with] a thermostat control."

55. Merriam-Webster online, s.v. "domesticate," www.merriam-webster.com.

56. Sibyl Pietzch to László Moholy-Nagy, August 19, 1935, Sibyl Moholy-Nagy Papers, AAA.

57. Sibyl Moholy-Nagy to László Moholy-Nagy, August 10, 1937, Sibyl Moholy-Nagy Papers, AAA.

58. Sibyl Moholy-Nagy, diary entry, May 13, 1945, Sibyl Moholy-Nagy Papers, AAA.

59. Hannah Arendt, "We Refugees," *Menorah* 30.1 (1943): 69–77, repr. in *Altogether Elsewhere: Writers on Exile,* ed. Marc Robinson (Boston: Faber and Faber, 1994), 110–11.

60. Ibid.

61. Sibyl Moholy-Nagy, diary entry, May 13, 1945.

62. Engelbrecht, *Mentor to Modernism,* 507.

63. C.D. Carter, Superintendent of the Education Department, War Relocation Authority, Central Region, Heart Mountain, WY, to Registrar, Chicago School of Design, October 1, 1942, Robert Jay Wolff Papers, AAA.

64. Murry N. DePillars, "Chicago's African American Visual Arts Renaissance," in *The Black Chicago Renaissance,* ed. Darlene Clark Hine and John McCluskey Jr. (Chicago: University of Illinois Press, 2012), 194.

65. László Moholy-Nagy to Sibyl Moholy-Nagy, Chicago, July 17, 1937, Sibyl Moholy-Nagy Papers, AAA.

POSTSCRIPT

Epigraph: Theodor Adorno, *Minima Moralia: Reflections on a Damaged Life,* trans. E.F.N. Jephcott (London: Verso Books, 2005), 247. First published as Theodor Adorno, *Minima Moralia: Reflexionen aus dem beschädigten Leben* (Frankfurt: Suhrkamp Verlag, 1951). Thanks to Jeremy Arnold, Jennifer Buckley, Benjamin DeVane, and Martin Shuster for their comments.

1. László Moholy-Nagy, *Vision in Motion* (Chicago: Paul Theobald, 1947), 29.
2. Ibid., 30.
3. Ibid., 24.
4. Ibid., 360–61.
5. Ibid., 361.
6. Ibid.
7. David Jenemann, *Adorno in America* (Minneapolis: University of Minnesota Press, 2007), 194n11.
8. Hannah Arendt, *The Human Condition* (Chicago: University of Chicago Press, 1958), 9.
9. Patricia Bowen-Moore, *Hannah Arendt's Philosophy of Natality* (London: Palgrave Macmillan, 1989), 2; Jeremy Arnold, "Figures of Finitude: Sovereignty and the Tragic Tradition of Political Thought" (PhD diss., Johns Hopkins University, 2008), 221.
10. László Moholy-Nagy, "Abstract of an Artist," in *The New Vision, 1928; and, Abstract of an Artist,* trans. Daphne Hoffmann, 4th rev. ed. (New York: Wittenborn, Schultz, 1947), 67.

ILLUSTRATIONS

INDEX

Page numbers in italics indicate illustrations.

National Socialism, 107, 153, 159, 186n79, 186n84; Third Reich, 152–53, 160, 186n79; Saxony, 63; Thuringia, 56, 63–64. *See also* Berlin; Deutscher Werkbund

Gesamtkunstwerk (total work of art), 82, 92, 93, 94, 102, 186n84

Gesamtproblematik, 114, 117, 124

Gesamtwerk (total work), 89, 93, 94, 102, 108, 111

Giedion, Sigfried, 101, 155

Giedion-Welcker, Carola, 155

Glass Architecture (Moholy), 24

Glass Architecture (Scheerbart), 24, 75

Goethe, Johann Wolfgang von, 54, 108

Gogh, Vincent van, 143

Gräff, Werner, 41, 150

Great Art Exhibition of Düsseldorf, 25

Great Depression, 10, 105, 117, 146, 155

Greenberg, Clement, 155

Gropius, Isa, 81

Gropius, Walter, 66–67, 81, 102, 127, 152, 155, 177n20; at Harvard, 153; Piscator/*Total Theater* and, 96, 101, 186n84; Werkbund and, 96, 97, 152

Grosz, George, 18, 19, 20; "Art Scab, The," 89–90; *Petit-Bourgeois Philistine Heartfield Gone Wild, The*, 20, 20

Halstead, Whitney, 115–16

Hartwig, Josef, 64, 80

Harvard University, 87, 153. *See also* Busch-Reisinger Museum

Haus am Horn (Meyer and Muche), 57–58, 58, 59, 65, 66, 67

Hausmann, Raoul, 18; "Call to Elemental Art," 21–23, 24

Heartfield, John, 18, 19, 20, 111; "Art Scab, The," 89–90; *Petit-Bourgeois Philistine Heartfield Gone Wild, The*, 20, 20

Herzfelde, Wieland, 19

Hevesy, Iván, 15, 17, 18

Heyne, Renate, 4

Hilberseimer, Ludwig, 24

Hitler, Adolf, 107, 159

Höch, Hannah, 18, 19; *Cut with the Kitchen Knife through the Last Weimar Republic Beer-Belly Cultural Epoch in Germany*, 21, 23

Hoffman, Heinrich, *106*

Horizont, 24

Horkheimer, Max, 153–54, 166, 194n43

Human Condition, The (Arendt), 166

Hungary, 15, 16, 56, 87, 90, 141, 161, 183n34

Huszár, Vilmos, 56, 57

Impressions of Old Marseilles (Moholy), 103, 104

industrial design, 23, 57, 81, 146, 150, 151; Deutscher Werkbund and, 57, 152; painting and, 116, 122, 171n6

industry/industrial, 32, 65, 77, 80, 83, 116, 146, 153, 165, 166–67; Bauhaus's commitment to, 29, 55, 57, 58, 59, 64, 69, 71, 73, 74–75, 82; materials, 24, 57, 65, 66, 76, 77, 78, 80, 117, 141; partnerships with, 9, 10, 55, 70, 81, 82, 89, 105

inherent vice, 88, 110, 154, 157

International Artist's Congress, 91

International Dadaist-Constructivist Congress, 27, 57, 150, 152

International Revue i10, 113–14, 122; "Directness of Spirit, Detours of Technique," 122–23; "Photogram and the Frontier," 123

International Textiles, 130

Itten, Johannes, 56, 57, 93, 173n54

Jaffe, Barbara, 146

Jennings, Michael, 23

Jewell, Edward Alden, 147

Judd, Donald, 13

Junkers, 74, 75

Kahnweiler, Daniel-Henry, 18

Kalivoda, František, 116, 124–25, 136; Moholy's letter to, 116, 125–27, 130

Kállai, Ernö, 24, 82, 172n41

Kandinsky, Wassily, 63, 64